# Art Workers Guild 125 years

# Art Workers Guild 125 years

Unicorn Press

*In memory of Janet MacLeod and William Phipps*

Unicorn Press
47 Earlham Road
Norwich
NR2 3AD

www.unicornpress.org

First published by Unicorn Press 2009

ISBN 978 1 906509 05 7

Designed by Karen Wilks
Printed in Slovenia for Latitude Press

Front cover: Stephen Gottlieb, Lute Maker

# Contents

# The Art Workers Guild at 125
## by Alan Powers

EVERY OTHER THURSDAY EVENING, THROUGH THE MONTHS OF THE YEAR THAT correspond to school terms, an assorted group of people pass through the door of a Georgian house in Bloomsbury and sit on rush-seated chairs in a large hall at the back. A man or woman robed in red enters the room and they stand up. Various business is conducted by two other black-robed figures. Then there is a lecture, after which drinks and sandwiches are consumed. Some of these people are the ones whose faces and workplaces are pictured in this book, and they will be as surprised to find out more about many of their fellow members as any reader who comes to the subject less well prepared.

In the baldest terms, the Art Workers Guild may sound rather staid and traditional, yet it would be hard to read through the verbal snapshots of these 130 members and fail to register surprise at the range of skills that has brought them together to perpetuate an institution whose survival could never be taken for granted. Collectively, they make a major impact on the cultural life of Britain.

The words 'brotherhood' and 'secret' are often linked together. By tradition, members of the Art Workers Guild address each other as 'brother', 'master' or 'past master' (regardless of gender). This members' organisation, while not exactly occult, is not very widely known either – collective reticence has been part of the Guild's character since its foundation in the 1880s. At an early stage, it became clear that the mutual trust between the members, which allowed them to debate the artistic issues of the day with freedom, would vanish if they allowed their proceedings to be reported, or if they became too involved in public campaigns under the name of this organisation. Other bodies existed for these purposes, and for its members the Guild became a kind of home with an extended family of like-minded souls, rather than a point of entry to a wider world.

This may begin to explain why the Guild is so little known, and yet why it is important historically and remains important today. Around the time it was founded by a collection of young designers and artists, the historian Frederick Maitland explained that the English tendency to operate

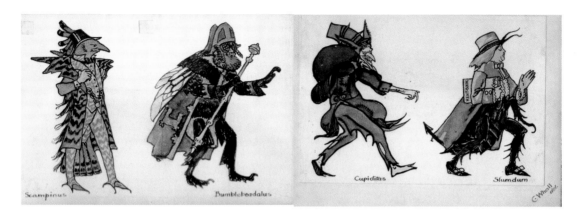

Scampinus    Bumblebeadalus    Cupiditas    Slumdum

Costumes for Demons, designed by Christopher Whall for *Beauty's Awakening*, a *Masque of Winter and of Spring*, written and presented by members of the Art Workers Guild at the Guildhall of London in 1899. The demons represented various forms of greed and hypocrisy, and were driven away by the hero, the knight Trueheart who came to rescue London. The verses for the demons to sing were written by C. R. Ashbee, but were omitted from the performance for fear of causing offence.

through membership associations was a uniquely national characteristic. Gentlemen's clubs are one example, and in some ways the Guild resembles these, as in its election procedure that requires new members to be introduced by two existing ones. In addition, however, members must show examples of their work, and it is on these that they are judged. The main body of members consists of practitioners in a variety of visual arts, while there are also associate members who are non-practitioners with related concerns, so they have shared professional interests and values.

The Guild was founded at the beginning of 1884 to fill a gap in the existing coverage of art organisations. The need was felt for a collective organisation that broke down the barriers in status between what were accepted as 'Fine Arts' (painting, engraving, sculpture and architecture, in the case of the Royal Academy) and the other arts of design that were thriving at the time, including furniture, stained glass, and metalwork. These 'artistic crafts' were often closely associated with architecture, and the incorporation of murals, carvings, mosaics and glass were a feature of the Victorian period that carried on, regardless of changes in taste and fashion. The great civilisations, from the ancient world to Renaissance Italy and Bourbon France, had shown that only through 'the unity of the arts' could a culture be truly great, but somewhere along the way the Fine Arts had pulled up the ladder behind them and cut off rest. In Britain, the rise of industry added to the problem. In 1851, the Great Exhibition at the

Crystal Palace was meant to show the progress of design and appealed to a mass public, but the objects on show were a very mixed bag. The teenage William Morris refused to join his family in this celebration of matter over mind and sulked outside. Ten years later, he set up his own company, with a group of artist friends, with the idea of changing the world through design.

While Morris, though a member, was not one of the founders of the Guild – they were doubtful about admitting him because of his Socialism – his activity exemplifies much of what the Guild has been about. Morris was both a designer and technician, drawing patterns and plunging elbow-deep in the indigo vat to recover a traditional dyeing technique and thus replace the lurid chemical blues and greens of industry with natural colours. Later he learnt about type design and printing and set up the Kelmscott Press. Morris had begun training as an architect, before turning to painting. Much of the work of Morris and Company was commissioned by architects for churches and houses, old or new. In 1877, Morris was the public spokesman for a new movement for preserving ancient buildings, respecting their age rather than trying to rejuvenate them, still active as the Society for the Protection of Ancient Buildings (SPAB).

Morris therefore exemplifies the fundamental roles undertaken by members of the Guild – design and making carried out in a professional way – and also some of the secondary ones – cross-disciplinary collaboration with other designers, site-specific commissioned work, and interaction with the past whether through the reconstruction of lost techniques or intervention in historic artefacts. He exemplified a new kind of craftsman, often university-educated, with sources of income other than from craft work, more like a fine artist in his social role and independence, but still dedicated to the 'lesser arts' because, in his view, they contributed more to the quality of life and were an active form of resistance to the dehumanising trend of industry.

Much has been written in criticism of the contradictions of Morris's position. He was painfully aware of them himself. The model of his life story does not match that of all other Guild members, although it does

help to explain why, in the 1880s, there was a new body of people in Britain, sharing his values, who thought and acted like fine artists while wanting to reconfigure the institutional map so that all the arts were on an equal footing, choosing as their motto 'Art is Unity'.

The choice of the word 'Guild' is a typical archaism of the period, since the AWG is not a proper Guild in the historic sense of regulating training and entry to specific craft or trade, exercising a local monopoly or controlling prices and rates of pay. Nor, for a number of reasons, is it the equivalent of a City livery company. Indeed it is easier to say what it is not than what it is. It is not an exhibiting body, having decided in 1888 to assign that function to the Arts and Crafts Exhibition Society. While its mission is described as education, its main activities extend only to its members. It represents an unchanging commitment to an ideal rather than a particular objective or method.

The idea of these practitioners meeting as equals was more radical than we might now imagine. Through lengthy efforts, fine artists and architects had established their status as professional gentlemen rather than tradesmen, and the demarcation, strictly policed, mattered in the hierarchical society of Victorian Britain. The 1880s was a decade of political as well as artistic revolution, however. The choice of the word 'Worker' speaks of the age of John Ruskin and William Morris, and the Art Workers Guild was rebellious. The criterion of entry was, and still is, to be a designer, to which may be added the skills of a maker, although not the reverse. Many of the founders were architects, from the office of Richard Norman Shaw, including leaders in what became known as the Arts and Crafts Movement, such as W. R. Lethaby and E. S. Prior, while others were practitioners and teachers of the newly emerging art of design, applied to patterns, furniture or graphics by figures such as Lewis F. Day and Walter Crane. Politically, many of them were conservative, and resented Morris's revolutionary activities, yet they shared his concern that people in their time were increasingly encouraged to see themselves as the equivalent of machines.

The early architect members made a public protest (not, however, under the name of the Art Workers Guild) when in 1891 there was a

John Cooke, Triple portrait of George Blackall Simonds, Gerald Horsley and Mervyn Macartney, 1909. The painting shows the first Master of the Guild, a sculptor, with the first two Honorary Secretaries, both architects who were trained in the office of Norman Shaw. It commemorates the 25th anniversary of the first Guild meeting in the hall of Cliffords Inn. Simonds sits in the Master's chair, one of a pair made to designs by W. R. Lethaby and given to the Guild after the failure of the furniture business, Kenton & Co., in which Lethaby and other Guild members were briefly involved. The table, made to a design by W. A. F. Benson, and the reading stand (author unknown) remain in regular use at the Guild. Simonds wears the Master's chain of office with its jewel modelled and presented by George Frampton.

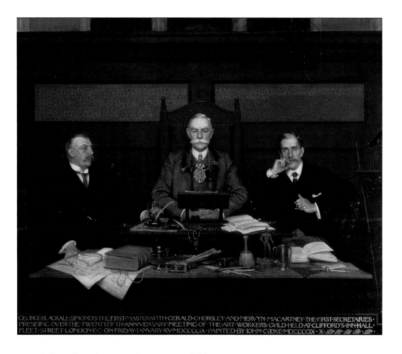

possibility that their profession would be open only to those who passed an exam. They believed that the sensitivity required to be a good architect could never be taught in a curriculum, and proposed instead that the existing methods of 'learning by doing' in architects' offices should be supplemented by more direct experience of actual building. Several of them, including Lethaby, were already involved in creating radical alternatives to Victorian art education. For years, aspirant artists had progressed like snails through line drawing, shading and colouring, copying printed examples and never drawing anything real. Thanks to the new political climate of the 1880s, local authorities could start funding art teaching out of the rates and do it differently. With Lethaby's advice, the London County Council led the way, quickly followed by Birmingham, Leicester, Glasgow and other cities. The name boards of members that form the frieze in the Hall at 6 Queen Square record many who are forgotten as artists, yet who helped to spread a new method of learning,

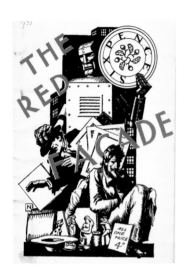

Harold Nelson, programme cover for *The Red Façade*, 1930. This programme, designed, printed at the Curwen Press, is for the Guild's Shrovetide Revels, a regular sequence of amateur dramatic performances with topical and satirical content, that followed on from *Beauty's Awakening*. The redundancy of the artist in the face of modern mechanisation and economic depression are vividly portrayed.

in which the clay, the yarn or the coloured glass were involved at the beginning, with drawing as an adjunct.

One of Lethaby's greatest moments was the flash of inspiration that led him to recommend lettering as a special pursuit to a shy and confused applicant at the Central School of Arts and Crafts. The student's name was Edward Johnston, and with Lethaby's encouragement, in ten years he had single-handedly launched the revival of lettering in Britain and Germany that lies behind the work of countless type designers and letter cutters today, several of them members of the Guild whose lines of artistic descent stretch back to Johnston's first pupil, Eric Gill.

The word was not current in the 1880s, but we can now recognise the Art Workers Guild as a typical networking organisation. It offered a basis for mutually supportive professional contacts over a long period of time, as a result of which many of its members collaborated as designers, educators or policy-makers. Its significance then as now lay less in the actual activities that it conducted as a body than in the interactions between its members and the rest of the world. Many of its members wrote artistic theory, yet this never counted for as much as the spontaneous spoken word. The members also enjoyed playing the fool – performing theatricals and skits in the 'Revels' that were a feature of its calendar between the wars.

Many of the Guild founders were still in their twenties in 1884. The institution grew up, and finally acquired its own property, where it still resides, in the nick of time before the outbreak of the First World War. The creation of a Junior Guild in 1896 indicated their sense of growing older, but in the 1920s, the young were no longer attracted, and it faded away. The Arts and Crafts vision of homely simplicity and civic decency remained at the centre of official thinking, however, and when the Arts and Crafts Exhibition Society put on its largest show at the Royal Academy in 1916, it offered a vision of a better future once Germany had been defeated, and was attended by thousands of visitors. The detailed schemes of the time mostly failed to happen, but the wider vision of design in the service of society underlay the design policy of the London Underground, for example, in which the architect Charles Holden, whose smouldering

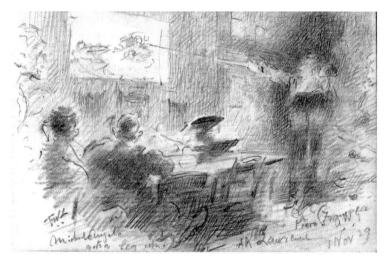

portrait by Francis Dodd is one of the Guild's treasures, played a key role.

As in the 1880s and 90s, in the early twentieth century, the members of
the Guild made their impact most forcibly through other organisations.
Almost all the founders of the Design and Industries Association in 1915
were Guildsmen, and 6 Queen Square was their founding address. This
body was dedicated to raising standards in industrial design, grappling
directly with 'the machine' that was the historic enemy of the crafts and
hoping to tame it. Avid talk of reforming society through crafts, organic
agriculture, rural reconstruction and Social Credit were a feature of the
inter-war years and many Guild members played their part in a loose
network of organisations all trying to reverse or stem the influence of
materialism and its destructive effect on humanity and nature. On a
different scale of progressive aesthetic achievement, they were no longer
at the forefront of the crafts, if measured by Tanya Harrod's assessment
in *The Crafts in Britain in the 20th Century* where the Guild receives scant
mention.

Was the Guild a backwater between the wars? It appeared quaint, as it still
does in many people's eyes. In the 1930s, you might have found figures

such as the architects C. F. A. Voysey and C. R. Ashbee, the firebrands of
the 1890s long withdrawn from direct engagement with architecture and
the crafts, occupying the rush-seated chairs alongside George Bernard
Shaw or the young John Betjeman, who treasured them as survivors of
a long-lost age. Longevity and continuity are strong points, however, if
one considers that art's direction of travel cannot always be foreseen.
Some Guild members were violently opposed to modernism, such as the
architects Sir Edwin Lutyens and Sir Albert Richardson, yet won respect
even from their opponents for their skill as designers. Some members
applied their traditional skills with a modern twist, as we see on the walls
of the Guild in Meredith Frampton's almost glacial portraits of Voysey and
Lutyens from the 1930s. Two of the most advanced modern architects in
London, Berthold Lubetkin and Serge Chermayeff, came as speakers, the
first invited by Shaw, the second by Hamilton T. Smith, a furniture designer
at Heals, who recorded that 'on the rare occasions when the Guild has
had an evening on modernist tendencies, those who have been invited
to speak from the modernist viewpoint have done so with courtesy and
moderation, confining themselves to an exposition of the matter in hand,
and, so far as I could see, taking care not to tread on the corns of those of
the opposite school. I only wish it could be truthfully said that they met
with the same courtesy and consideration from all members of the Guild.'

After World War II, the Guild contained a wide range of styles and
opinions. Milner Gray and Misha Black, two directors of the Design
Research Unit, a novel interdisciplinary organisation, were among Guild
members who had a major influence on the friendly modernism of the
Festival of Britain. John Farleigh, the wood engraver and educator, was the
driving force behind the Crafts Centre that opened in Hay Hill, Mayfair,
in 1950, and other Guild members, including Gordon Russell, David
Kindersley and Edward Barnsley, were closely involved in its subsequent
evolution into the Crafts Council. The creation of an officially funded body
for the crafts went some way to fulfilling the mission of the Guild, as the
Design Council did in its field, and allowed the Guild to continue in its
individualistic way.

The Summer Outing, 1942. Summer Outings remain a feature of the Guild calendar, planned by each Master. The 1942 outing was to Ampthill, Bedfordshire, where the Master, the architect Sir Albert Richardson, lived in a fine Georgian house without electricity, and delighted in collecting relics of the 18th and early 19th centuries. In the background is a horse-drawn coach, with some suitably dressed people sitting on top. Richardson himself stands in the centre of the group holding his hat in front of him.

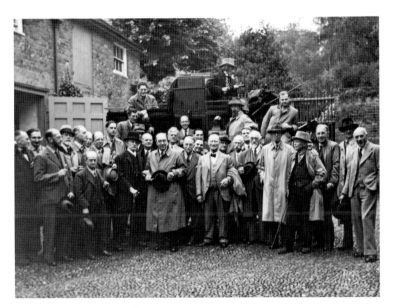

In 1950, when the stained-glass artist Leonard Walker was Master, the Summer Outing was a boat trip on the Thames. Not all the figures are identified, but the second from the left is Gerald Cobb (1899-1986), a herald painter at The College of Arms) and historian of churches and cathedrals who was a constant attender at Guild meetings up to the time of his death, and always liable to interrupt from the back row with a correction of fact.

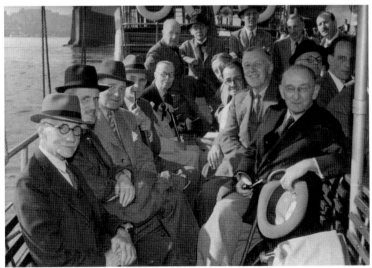

Tanya Harrod's history includes plenty of coverage of Coventry Cathedral, where several Guild members, including the architect Sir Basil Spence and the stained glass artists Keith New and John Piper, were heavily involved. As yet, however, no general survey of the arts in the 1950s describes another notable Guild collaboration, the new high altar at St Paul's Cathedral that replaced the bomb-damaged one by G. F. Bodley, and fits in as if it were an original design by Sir Christopher Wren. It was commissioned by the Surveyor, W. Godfrey Allen from his fellow architect Stephen Dykes-Bower, with stained glass in the east windows by Brian Thomas. These three were among many architects and artists in the Guild who found outlets for their talents in the reconstruction of war-damaged City churches. In the secular field, Donald McMorran, Master in 1956, developed a simple but sophisticated version of classical architecture and designed a run of fine police stations, university buildings and housing schemes, receiving more abuse than praise from architectural magazines when they deigned to notice his work. John Brandon-Jones was another architect swimming against the tide and a pioneering archivist and historian of the generation of the Guild founders.

It was the presence in the Guild of these non-conformists, who were ready with tirades against the absurdities of modernism, that attracted a younger generation, such as the architects Anthony Ballantine and Roderick Gradidge at the end of the 1960s. They in turn brought in Gavin Stamp, Glynn Boyd Harte and other new members who saw the Guild as a precious link with an almost-forgotten alternative version of the past, which they did much to re-illumine, with the flair of a media-conscious age, offering it as an alternative future to a public that was depressed by Puritanism and grey concrete. Women members were admitted for the first time, with the wood engraver Joan Hassall becoming the first woman Master in 1966.

The Guild celebrated its centenary in 1984 with an exhibition at Brighton Museum. Gavin Stamp wrote in the catalogue, 'it is an anachronism which outsiders may find absurd, but artists and craftsmen continue to find the Guild to be congenial, useful, valuable and even inspiring.' This was the year in which the Prince of Wales, an Honorary Member, like his father,

made his first public statement condemning modernism in architecture. It was not a new position, but achieved unprecedented media attention. One of the consequences of this was the foundation in 1992 of the Prince of Wales's Institute of Architecture as a teaching organisation whose tutors and students have crossed over with the membership of the Guild at many points. The emphasis in its curriculum on drawing, painting and craftwork as fundamental to an architect's creative mind, and the belief that a grounding in architecture was valuable for all artists and designers, were identical to the Guild's position, and although the experiment barely endured for a decade it has a form of afterlife at the Guild.

To present the Guild purely as a reactionary grouping would, however, be false, as a quick flick through the pages of this book will confirm. The idea of pluralism has prevailed and if old-fashioned notions of art's evolutionary progress or the inevitable rightness of one style over all others are still at large, then the Guild has managed to put them at arm's length, serving no specific artistic sect. Given the way that the worlds of art are still subject to fashion and prejudice, this is an achievement. It probably helps that some activities strongly represented in the Guild, such as lettering or making musical instruments, have relatively unvarying standards of excellence.

The nature of the Guild's elective system means that members are proposed and accepted on grounds that are not primarily about style, while diversity becomes self-re-enforcing. When the work of aspirant members is shown to the committee of the Guild, a number of criteria are used in making decisions. Probably the most consistent is the sense of personal commitment in the form of training and career, involving the acquisition of skill and the creation of a body of work. Each form of artistic activity has its own standards, so it is hard to generalise. Positive points include working to commission (almost inevitable in areas such as architecture, but less obvious for a painter or sculptor), and collaboration with other artists and designers. From these, one can infer that the Guild prefers the idea of artistic service to that of artistic ego, these being style-neutral qualities, although they involve negotiation with clients and the public that require persuasion and justification of the work, and the ability to adapt.

Lara Platman's initiative in photographing Guild members in their workplaces and taking vivid verbal snapshots of their experiences and ideas gives readers of this book the opportunity to judge for themselves what the overall shape and direction of this collection of individuals might be, in a way that has never been possible before. Portraiture is one of the Guild's ways of remembering, with its collection of paintings, drawings and sculptures of all the Masters since the foundation displayed on the walls at Queen Square. A few portraits show their subjects against the background of their workplace, but never with the revealing detail of the photographs. Only about half the existing members are represented, but in view of the amount of travelling needed to reach even this half-way mark, we can understand why this has only now been done for the first time.

The individual stories of the Guild members are about choosing what to do in your life, with results that no Job Centre or school careers master is ever likely to suggest. Recently, writers such as the sociologist Richard Sennett and the journalist Libby Brooks have re-stated the view that happiness comes from doing what you believe in, especially if it involves the practice of a skill, although the contribution this makes to society as a whole is largely hidden from view. These writers have stressed the importance of this kind of rooted self-development at a time when so much in the world has gone fluid and disasters threaten. If it seemed in 1884 that a home was needed for those who wanted to use their skills in the arts to stabilise and repair the soul of the world, then this need has only increased.

The survival of the Guild owes much to the durability of its basic ideas, but it would probably not have lasted through thin times without owning a building 6 Queen Square has provided enough income to keep the Guild going, and has acted as a refuge for the meetings of homeless bodies with similar aims. The 95 years of use by generations of like-minded people have left their mark, and yet have not necessarily been a brake on new thinking, and it is through the building as much as anything that the Guild can engage with the world, for many other organisations use it for all kinds of events, and an annual public display of Guild work is held for Open

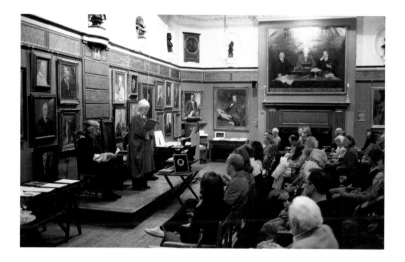

House weekend in September. Legacies and donations from members
around the turn of the millennium enabled a campaign of refurbishment
and upgrading to the building, masterminded by Luke Hughes as Chairman
of Trustees, that have brought a chain of beneficial consequences, financial
and organisational. The Guild occupied the rooms on the first floor for the
first time, providing new library space and a meeting and exhibition room.
The essentials remained unchanged. The work is only half-way done, for
permission exists to glaze over the courtyard, creating full disabled access
to the three lower floors of the building, and to complete the cycle of
repairs as soon as funding is in place.

The building is a background to changing and developing activity. The
role of the Secretary was enlarged and changed from a retirement post to
a full-time job, with a Steward to manage the bookings and the building.
The World Wide Web proved a blessing to a body that wants to be heard
without shouting, and the display of members' work allows the public
to contact individual makers and designers for commissions. The Guild
has also used its website to collate information about apprenticeships for
aspirant craftsmen, an area of long-standing concern but one that was
difficult for it to engage with before the internet.

ANIMATOR
ARCHITECT
ARCHITECTURAL DESIGNER
ARCHITECTURAL HISTORIAN
ARCHITECTURAL PAINTER
ARCHITECTURAL SCULPTOR
ART HISTORIAN
ARTIST
BLACKSMITH
BOOK DESIGNER
BOOK ILLUSTRATOR
BOOKBINDER
BOTANICAL ILLUSTRATOR
BOW MAKER
BROADCASTER
CABINET MAKER
CALLIGRAPHER
CARTOONIST
CERAMICIST
CONSERVATOR
DECORATIVE ARTIST
DESIGNER
DRAUGHTSMAN
EMBROIDERER
ETCHER
EXHIBITION DESIGNER
FILM PRODUCTION DESIGNER
FURNITURE DESIGNER
FURNITURE MAKER
FURNITURE RESTORER
GLASS ARTIST
GLASS ENGRAVER
GRAPHIC DESIGNER
HERALDIC ARTIST
ILLUSTRATOR
INSTALLATION ARTIST
INTERIOR DESIGNER
JEWELLER
JEWELLERY DESIGNER
LEATHERWORKER
LETTER CARVER
LETTER CUTTER
LETTER DESIGNER
LETTERER
LETTERING CRAFTSMAN
LUTE MAKER
MARINE ARTIST MODELLER
MASTER DECORATOR
MEDALIST
METALWORKER
MODELMAKER
MOSAICIST
MURAL PAINTER
MUSEUM DESIGNER
MUSIC CRITIC
MUSICAL INSTRUMENT MAKER
ORGAN BUILDER
PAINTER
PHOTOGRAPHER
PORTRAIT PAINTER
POTTER
PRINTER
PRINTMAKER
QUILT MAKER
RESTORER
SCULPTOR
SILVERSMITH
STAINED GLASS ARTIST
STAINED GLASS DESIGNER
STONE CARVER
STONE WORKER
SURVEYOR
TEACHER
TELEVISION DESIGNER
TEXTILE DESIGNER
THEATRICAL COSTUME DESIGNER
TYPOGRAPHER
VIOLIN MAKER
WALLPAPER DESIGNER
WATERCOLOURIST
WEAVER
WOOD CARVER
WOOD ENGRAVER
WOODMETAL WORKER
WOODWORKER
WRITER

# Guild Members

# Robert Adam
## Architect

ROBERT ADAM STUDIED AT THE REGENT STREET POLYTECHNIC
and won a scholarship for a year of study at the British
School in Rome, where he subsequently served as
Chairman of the Faculty of Fine Arts. In the 1980s,
when he became a Brother of the AWG, he won a
reputation as the most vocal of a new generation of
architects opposing the modernist mainstream by
promoting classical and traditional design. Robert and
his team, including several other Brothers, are now the
largest practitioners of traditional design in Europe.

He sees the office as a place of education. 'We have a
duty to the profession and to our kind of architecture to
give students the experience of working with traditional
design.' Although others work on computers, Robert
draws and sketches and always encourages young
architects to maintain the direct connection between
drawing the visual world and building.

Robert has published books and articles to advance an
understanding of tradition and overcome the negative
attitude to it in the design professions. 'Tradition gives
us our identity in society. It functions as the collective
memory of nations, communities, families and all other
groups. History is the forever past, tradition is the past
living through us. Tradition adapts to accommodate
the development of society, technology and the
environment, but because this is change by evolution,
not revolution, the past is always visible within it.

'Architecture, urban design, design and art are always
irrevocably connected to the social political and
economic condition of the time. Understanding this fact
helps us to see what we do more clearly.'

# Mark Adams
## Furniture Designer and Teacher

MARK ADAMS TEACHES AT CHURCHER'S COLLEGE, AN independent school in Petersfield, Hampshire. I interviewed him there in the well-equipped workshop where he inspires his students to become excellent designers and makers in a range of materials.

Mark worked for a number of years as a furniture maker with Brother Luke Hughes, creating one-off pieces and prototypes. As the company grew, however, the nature of his work changed, and he felt the need for a change of direction. Ideally he wanted to combine his passion for making things in wood with the training element that he had enjoyed during twelve years service in the Territorial Army. He started teaching at Churcher's eleven years ago, and has clearly found his true vocation here.

Students choose Mark's course because they enjoy the subject, although they soon find that it is not a soft option. A good deal of analysis and decision-making is involved, as well as design and practical work, and all decisions have to be fully explained and justified. In return they gain a huge amount of satisfaction from completing a project. 'It's an immediate joy to see their excitement when they put the finished piece on the table,' Mark tells me with the enthusiasm of a dedicated craftsman and a born teacher.

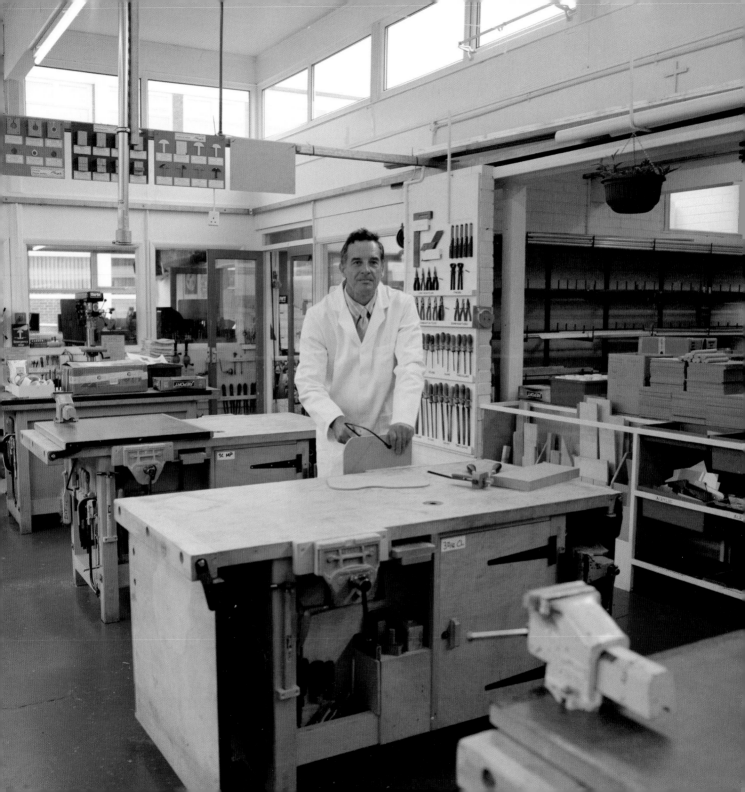

# Emma Alcock

## Painter

I visit Emma Alcock in her studio at Lots Road, on the north bank of the River Thames. The building opposite has just been demolished, and Emma is enjoying her newly reclaimed view. On the far side of the river you can see St Mary's, Battersea, the church where William Blake was married, which also appears in a number of Turner's paintings. Henry James, Whistler, Turner and Rossetti all lived on nearby Cheyne Walk. 'I felt instantly that I belonged here,' Emma tells me.

The area is key to Emma's work, but she does not set out merely to paint what she sees. Her subjects are all things with which she feels a personal connection – a chair she sits in every day, for example, or a landscape she has walked through countless times. She can express herself through them because they have become part of her.

Before she can start painting there is a process to go through. Sometimes she will sit in her studio chair for hours, staring out of the window, or repeating the lines of a poem, and then spring up for half an hour to paint. The paintings can take months to finish. 'I work on them slowly,' she says, 'and think about them a lot. Sometimes I put them away, and then revisit them later. It's as someone once said: "The more you put into a piece, the more it gives you back." '

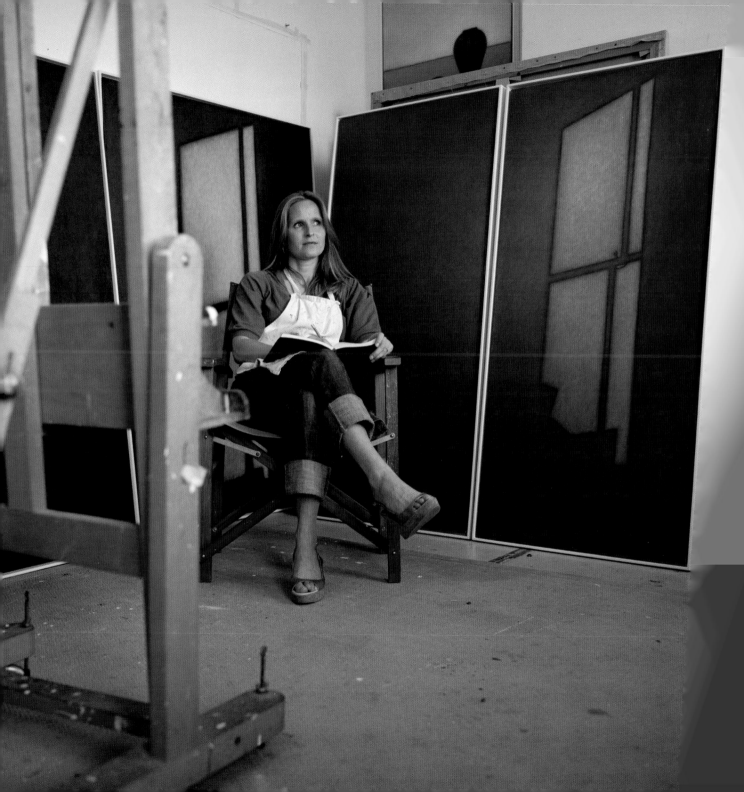

# Marthe Armitage
## Wallpaper Designer and Printer

MARTHE ARMITAGE PAINTS AT HER EASEL, IN A LIGHT-FLOODED room papered with her own 'Bamboo' design.

Marthe trained at the Chelsea School of Art just after World War 2. Her teacher Ceri Richards was influenced by the 'School of Paris', the movement dominated by Picasso and Matisse, but retained a 'Britishness' which in turn influenced her. Etching, lithography, lettering and printing all went on in the same warm bright classroom. Marthe especially enjoyed being taught lettering by M.C. Oliver, a student of the famous Edward Johnston. Frances Richards, Ceri Richards' wife, taught block printing on fabrics.

Afterwards she married and followed her architect husband out to India with their first child. 'I was completely at sea as a young woman,' she confesses, 'but once the babies were no longer babies I had the idea of printing wallpaper.' She had seen a 'heavenly botanical black and white print' and decided to have a go herself.

Using a tiny school roller and some lining paper, Marthe began printing on the kitchen floor. When this became too arduous, she used an old lithographic offset proofing press which she found in a warehouse in Brixton.

Marthe has lived on the banks of the Thames for most of her life, and much of her inspiration comes from her immediate surroundings. Her wallpapers, which can be bought in a few select shops in London, are still hand-printed with help from her daughter.

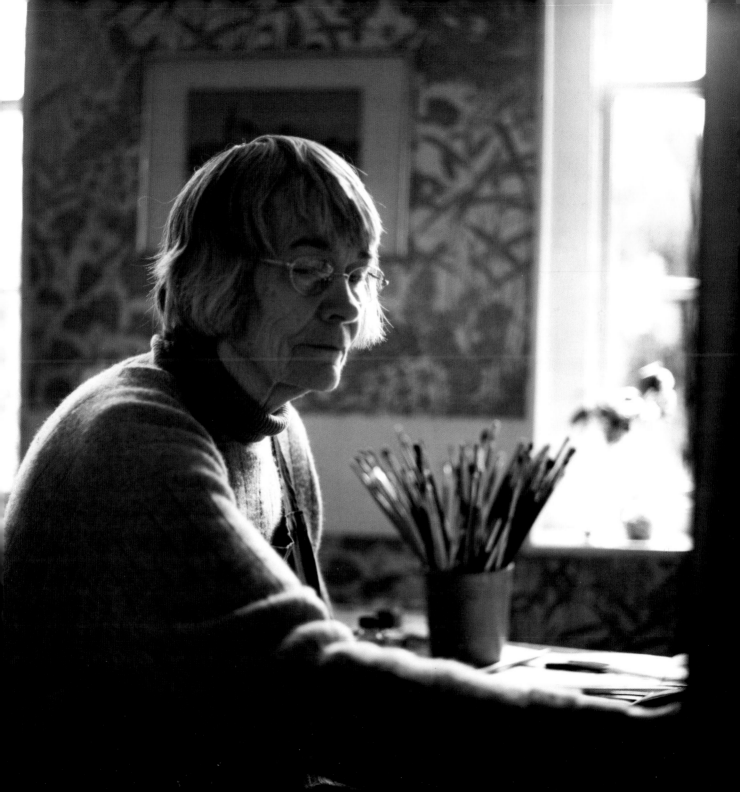

# Keith Bailey
## Sculptor and Letterer

KEITH BAILEY WORKS FROM A BRIGHTLY LIT STUDIO AT THE back of his Cambridge home.

After studying calligraphy at Liverpool and sculpture at Manchester, he initially thought of pursuing a career as a sculptor. After National Service he worked for a year in a London bronze foundry, then in 1954 got a job assisting the letter cutter David Kindersley carve a thirty-foot relief map at the American Cemetery at Madingley outside Cambridge. He now saw that letter cutting was his vocation, and in 1957 he started out on his own.

Keith and I look through the records of his many designs and monuments. A particularly striking one shows musical notes on a stone column for Gresham's School at Holt. The music is by Benjamin Britten, with words by W. H. Auden. At thirteen feet high it was too big for his studio, and Keith had to work on it in a mason's yard, carving one section at a time. It was, he says, a really exciting piece to make.

Keith was soon collaborating with Ian Hamilton Finlay in his garden Stonypath in the Scottish lowlands, making sundials and other works suited to his bold and fluid style.

Although he now needs help to move stones around, he is still patiently working in the medium that he was first drawn to 55 years ago.

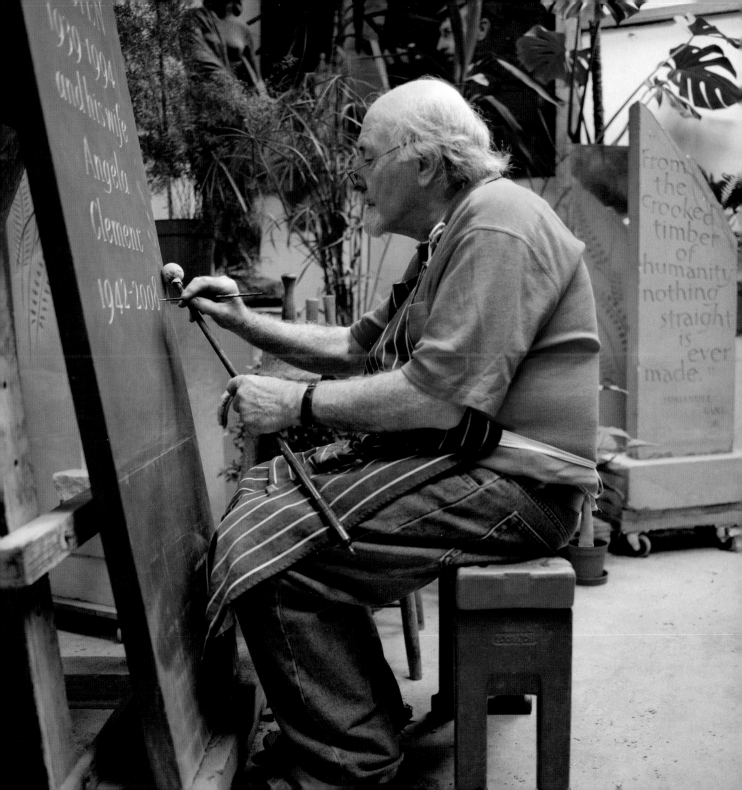

# Juliet Barker
## Violin and Viola Maker

JULIET BARKER'S VIOLIN-MAKING WORKSHOP AT Cambridgeshire Technical College is busy but calm as students gouge, glue purfling, or chat with a cup of tea among the wood chippings, with tools neatly sorted in racks and on shelves.

Since the age of 20 Juliet has only wanted to make violins. Her mother played the violin and gave her a book about how they are made when she was quite young. In 1953 she visited William Beare, who had recently travelled to the violin-making school in Mittenwald in Bavaria looking for workers for his London business. The school was the only one of its kind, and Juliet enrolled there to learn the basics, and came back to London to work briefly for J & A Beare. She then had to leave and look after her family, but it was enough of a grounding for her to begin building up a small business.

In 1960 Cambridgeshire Technical College asked Juliet to start a violin-making evening class, which by 1986 had grown so large that it moved to its own workshop. She receives a steady stream of amateurs who simply want to make instruments for their children or their quartet groups. Most music schools encourage their students to buy old violins rather than new ones, because their tonal qualities are preferred. New hand-made violas are more in demand because there are fewer existing ones.

It takes Juliet around 100 hours to make a viola. The sound quality depends on the wood and shape of the arching. Each violin maker can be identified by their particular choice of models. In fact, every instrument is as much an individual as its player.

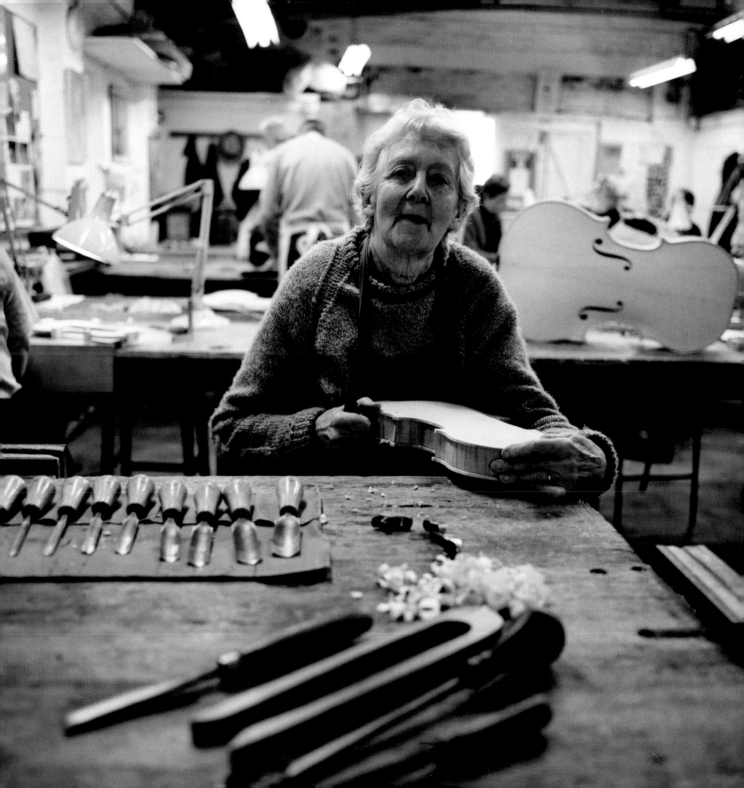

# Angela Barrett
## Illustrator

BEHIND A GRAND ANTIQUE LEATHER-TOPPED WOODEN DESK in her mansion-block apartment high above Grays Inn Road, Angela Barrett carefully works on the sky area of an illustration for her next book. Creating whole-page images like this is what she most enjoys.

Angela trained first at Maidstone, on one of the very few illustration courses offered in Britain at that time, and subsequently at the Royal College of Art. Initially fearful of clients' deadlines and demands, she came to find in the discipline of illustration a kind of liberation.

Amongst Angela's clients are Walker Books, Random House, David Fickling and the Folio Society, who have just published her illustrations in a new edition of *Anna Karenina*. She sets the size at the outset, always working to the same scale as the printed page, and preferring square or horizontal formats to vertical ones. Gesturing expressively, she adds that the portrait shape can lend itself well to illustrations involving two people or more.

Angela's work is characterised by muted colours and small significant details. She considered studying fashion before choosing illustration, and remains fascinated by the way people dress up in order to play their roles in life. Her illustrations often reveal the darker side of human nature that she finds in this transformation. Her vision of the relationship between people's appearance and their inner lives keeps her passion for drawing alive.

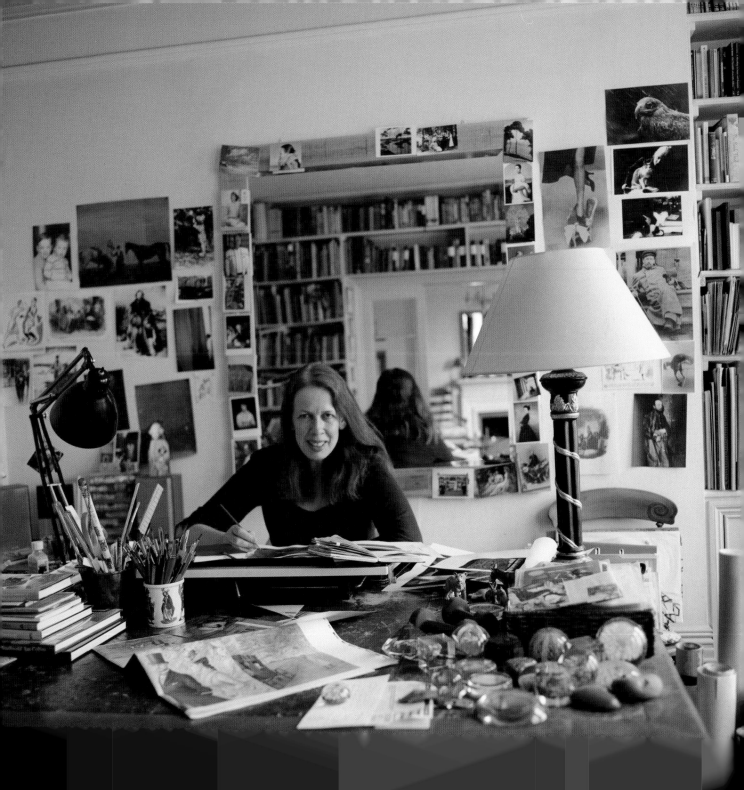

# Karen Beauchamp
## Wallpaper Designer and Printer

KAREN BEAUCHAMP ARRIVED AT HER CAREER AS A WALLPAPER designer almost by accident. Having trained in architecture, she changed direction and worked as a graphic designer in the Isle of Man, experimenting with hand screen print. In response to a challenge to print wallpaper she invented her own way of deploying screen print, and fell in love with the whole process.

In 2000 Guild member Lucinda Lambton made a television programme about the imminent closure of the venerable wallpaper printers Cole & Son. Karen and two of her colleagues instantly took up the challenge. They had an extensive archive of wallpaper designs dating from 1760 to the late 1980s to draw upon, and following the minimalism of the 1990s the time was ripe for reviving those from the 1950s and 1960s. The strategy worked, and the company was rescued from the brink of disaster.

In the factory the history of the company is displayed in rolls dating right back to the early days. The company now produces designs from the archive as well as new designs created in Karen's spacious studio. This is right beside the production floor where traditional surface printing, dye coating and block printing rub shoulders with more modern techniques like screen print. As well as allowing mass production, these processes can all print short runs and bespoke wallpapers to order.

Karen's perspective is the assertion of individuality and her current mantra is, 'In our crowded world space is a luxury and space in design gives a sense of calm.'

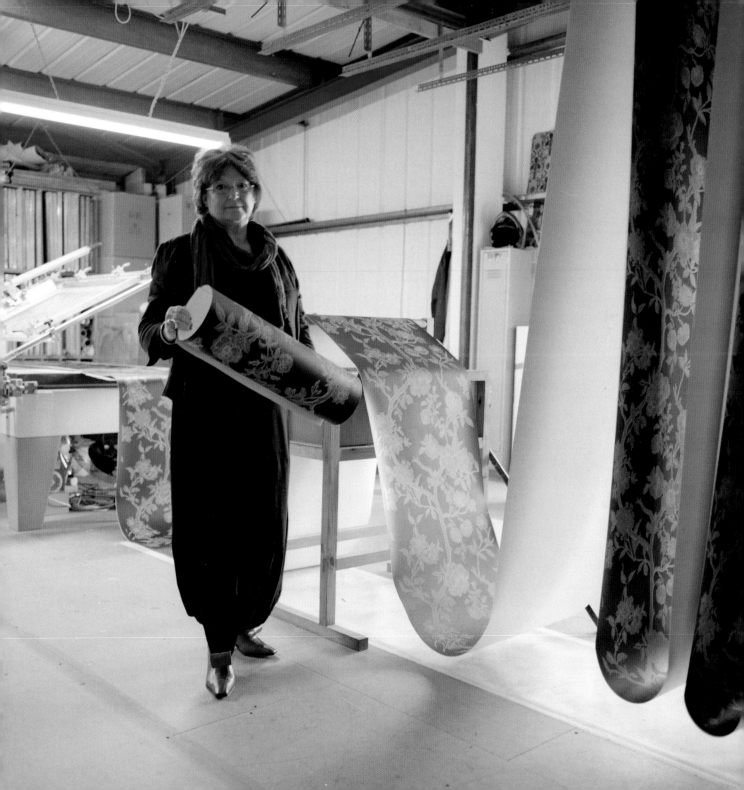

# Julian Bicknell
## Architect

AT HIS DRAWING BOARD AT ST JOHN'S STUDIOS IN RICHMOND, where the tall windows give ample light until late afternoon, Julian Bicknell is adding one more to his catalogue of over one hundred and fifty projects.

Julian began his studies at Cambridge as an engineer, but his architect uncle Peter Bicknell encouraged him to change to architecture. During his early career he was fortunate to work with Ted Cullinan, Sir Hugh Casson and Sir Philip Dowson. His first classical essays were at Castle Howard, where he designed new interiors for the fire-damaged Garden Hall and Library in collaboration with George Howard and the painter Felix Kelly. Further collaboration with Felix Kelly led to the design, for Sebastian de Ferranti, of Henbury Rotonda, a perfect but miniature Palladian Villa in Cheshire. 'Generally speaking,' he says, 'designing a house is like writing a piece of prose. Henbury was like writing poetry.'

Since then Julian has designed many buildings in the UK, as well as a series of 'English' leisure constructions in Japan. A founding trustee of the Prince of Wales's Institute of Architecture, he has also taught at schools of architecture all over the UK, and in Japan, Russia and the USA.

Over the years the practice has made a speciality of presentation drawings in the manner of 18th-century printed engravings. Married to an artist for over forty years, Julian has used their frequent painting trips together to study interesting buildings and hone his own drawing and design skills. His work has been widely exhibited.

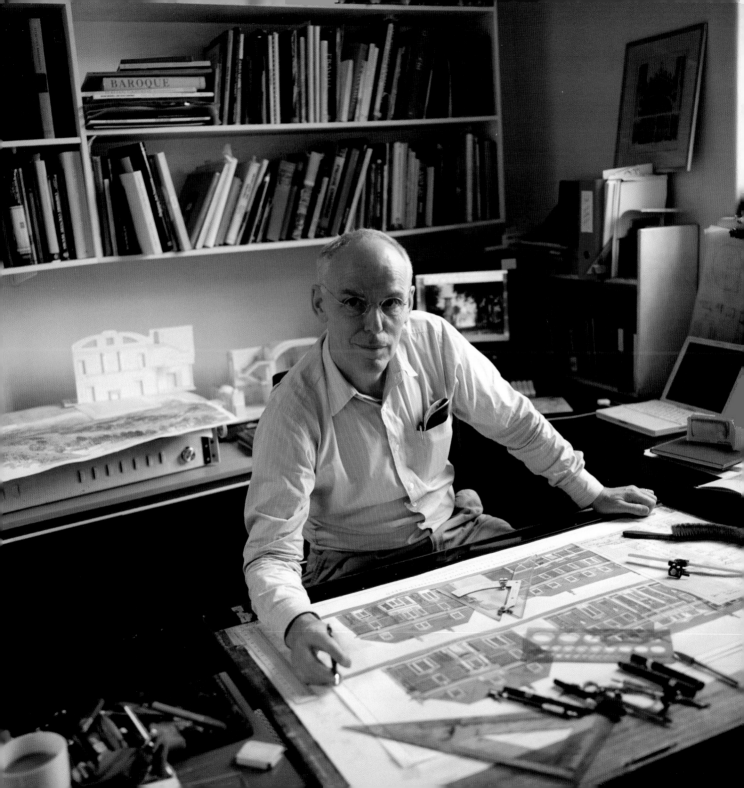

# Rosalind Bliss
## Mural Painter and Wood Engraver

In a village near Belper, Derbyshire, enjoying the mature gardens and well used artist studio, Rosalind lives in what was formerly her parents' holiday home.

Her father was Douglas Percy Bliss, Director of the Glasgow School of Art for 18 years, and she grew up surrounded by art, often visiting her mother, the painter Phyllis Dodd, in the Director's studio at the top of Charles Rennie Mackintosh's famous school building on Renfrew Street. After graduating from Edinburgh College of Art, she spent her earlier adult life in Notting Hill, living above a shop and watching the world change around her. She taught part-time at the North London Collegiate School, which enabled her to carry on with her painting.

After Rosalind retired, she moved back to Derbyshire, to this extraordinary place with its many plants, where she adores working. It was a huge change from being above a shop in the heart of the swinging city, and at first she was quite neurotic about the noise of tractors and aeroplanes. Now she can't imagine how she ever lived in Notting Hill.

As a mural painter, Rosalind paints folding screens, which are an alternative to walls, and she is also a wood engraver.

When I leave, Rosalind hands me a bundle of sweet peas, mint, and a dash of curry plant for me to go on my way with. I drive up through Windley past a 1950s bus stop, in what I consider to be one of the most beautiful parts of the country. It's a far cry from Notting Hill, but I can imagine a young lady growing up with 'Biba' beside her front door in the swinging Sixties.

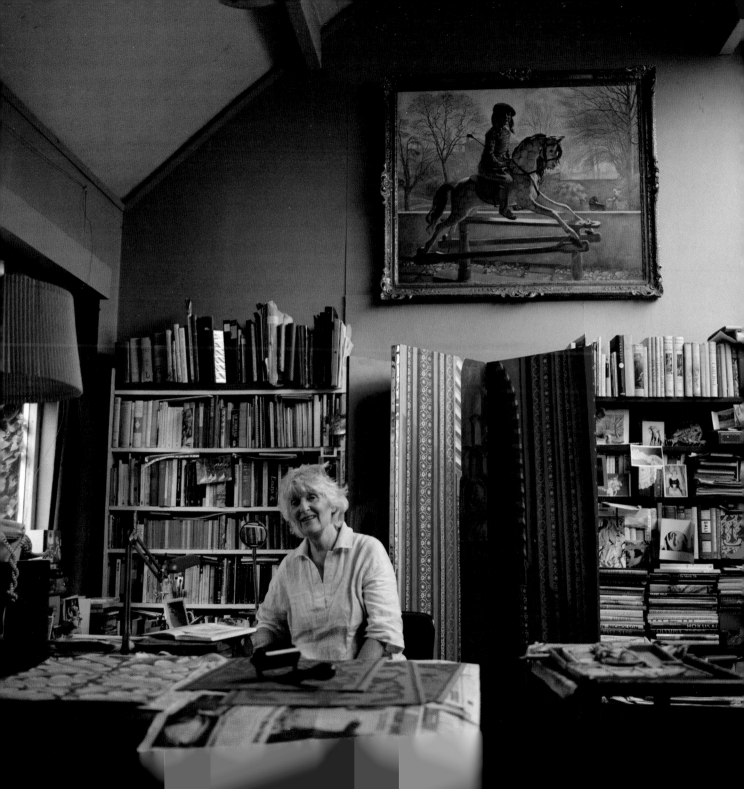

# Judith Bluck

## Sculptor

On a hillside in a hamlet in Yorkshire, Judith Bluck works steadily on Harriet the hare. The bronze has recently come back from the foundry and requires gentle aftercare. She is currently filing off the 'flashes' left by the casting process. Her cottage is built into the side of a hill, so although the studio is on the top floor it can also be accessed from the driveway, a vital consideration for a sculptor handling heavy objects.

As a child Judith was often made to chop wood. It had to be cut straight, and this discipline, combined with the influence of her father (he was a clock- and watch-maker, and they would often go bicycling together) guided her towards her first career as an engraver. She became a sculptor when she had seen a fair few 'bad' sculptures and realised she could do better.

Judith employed an assistant for about 20 years and now has people to move and fix the sculptures for her. She enjoys going to the foundry and ensuring that all is completed correctly. She thinks it is important for a sculptor to understand the capabilities of a foundry, and find the one best suited to their work.

As Judith and I talk about the procedures of bronze casting I realise how much she enjoys this part of the process: not simply the modelling but also the effects that can be achieved through casting and patination.

The natural landscape surrounds her in her daily life, and powerfully influences her work.

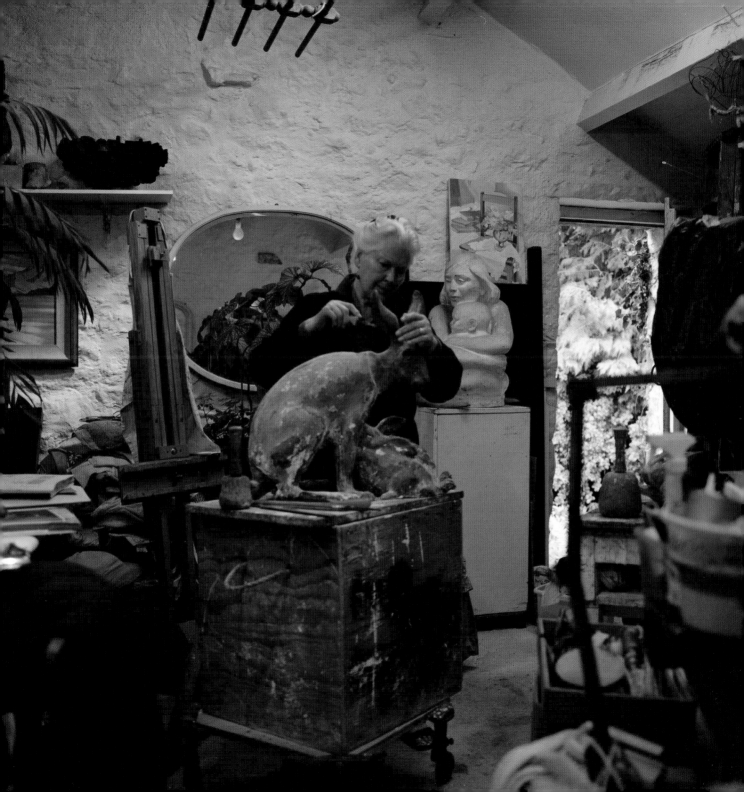

# Lynda Brockbank
## Designer

'CRESCENT LODGE', LYNDA BROCKBANK'S DESIGN AGENCY, is named after her home, where she started the business from her kitchen table.

In the photograph she can be seen with a book by Alan Fletcher, one of the founding partners of Pentagram. Fletcher was a major influence on her, as on a whole generation of designers. Most graphic designers know how to make things look good, but Fletcher brought a turn of mind to the job that was much more than this.

Lynda tries to bring Fletcher's philosophy into Crescent Lodge, where, like him, she allows her staff to read and to set aside time for research. Her designers can work in depth, knowing that a commission is theirs until they let go of it. The process is a journey that has to be followed to the end. The designers support one another's efforts in a way that Lynda describes as 'almost monastic'. 'You can abandon yourself to your work here,' she says, 'because there will always be someone who will help you.'

Coming from an artistic and musical family, Lynda has worked in design for over 22 years. Young people are a constant inspiration. One project involved a group of youngsters who had been excluded from school. 'We influenced them,' she says. 'We spoke as designers not as social workers, and they were enchanted by us.'

Lynda also sponsors students from disadvantaged backgrounds and ethnic minorities, channelling a fresh stream of talent into the industry. 'It's like leaving money in a telephone box. I always try to ask people to sponsor just one student. It keeps the industry high.'

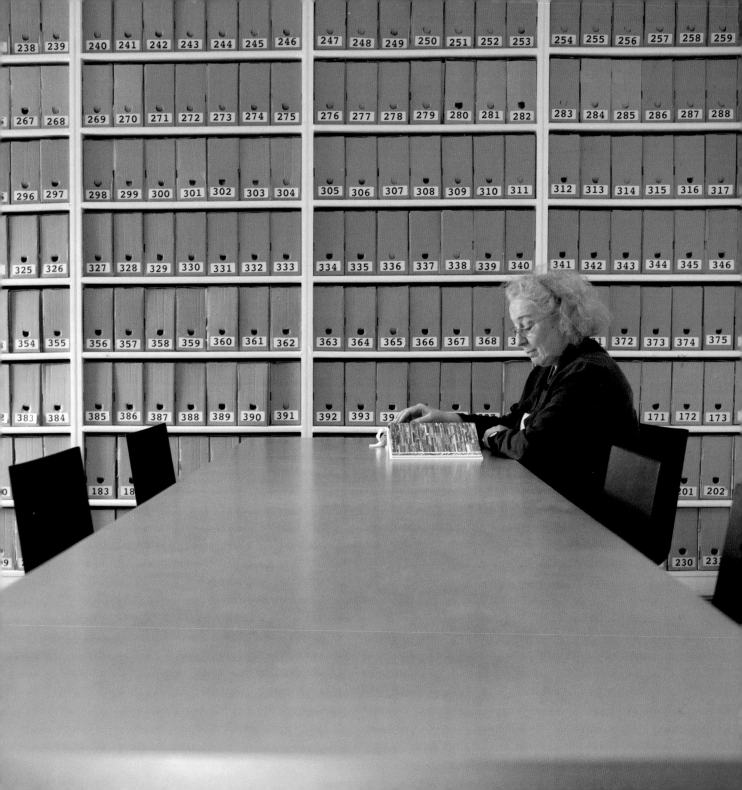

# Caroline Bullock
**Painter**

CAROLINE BULLOCK SITS AT HER KITCHEN TABLE, WITH
sunshine beaming in from a window, and paints in
the tradition of naive art. Her technique, she says, is
straightforward: 'Nothing complicated or inessential:
it is a visual thing and a feeling thing. I see things really
clearly and want to paint just as I see.'

Caroline has a degree in History, but no formal Art
School training. 'I didn't have A level Art – only O
level,' she says, 'so I didn't go to Art School. I was rather
pleased about this, as it would have frightened me. They
might have drummed out what I wanted to do.'

Her earlier paintings originated from travels with her
husband, Glynn Boyd Harte, a member of the Art
Workers Guild and a memorable Master. Her portrait
of them together features in Lister and Williams'
book *Twentieth Century British Naive and Primitive Artists*.
Although their styles were different (he made his name
with crayon drawings, watercolours and lithographs)
they would always provide constructive criticism
of each other's work. Since his death in 2003, and
the onset of Parkinson's disease, she has taken her
inspiration from early morning walks through the
streets of her Bloomsbury neighbourhood. She feels,
she says, 'extremely lucky to be able to pop into the
British Museum whenever I want to'.

Caroline works chiefly in oil on primed board's in
manageable sizes, and has had several successful
exhibitions. She's full of plans for future work. 'I would
like to illustrate children's books,' she says. 'In particular
Aesop's Fables, as I love painting animals.'

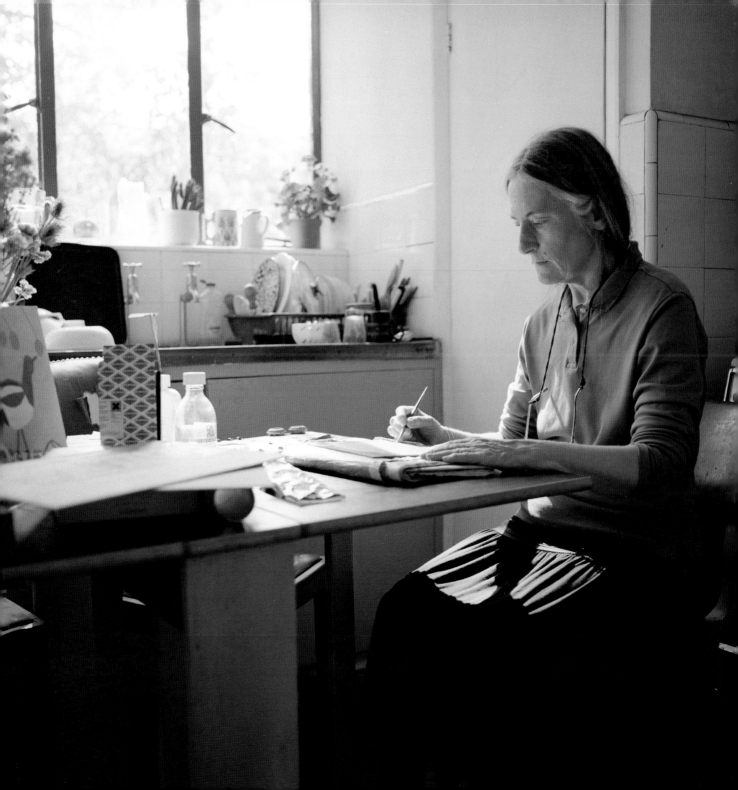

# James Butler
## Sculptor

IN THE WORKSHOP OF HIS FARM AT RADWAY, JAMES BUTLER IS working on a sculpture of Isambard Kingdom Brunel, a commission that he wants to make as impressive as the subject himself.

James's work ranges from commemorative coins and small figurines of ballet dancers to monuments and memorials. His monument in Normandy for the Green Howards Infantry Regiment was unveiled on D-Day in 1996, and every year he returns to meet the families of the regiment. While such commissions gather 'terrific feedback', small compromises are often necessary. The soldier featured in the memorial was originally meant to be smoking, but in the end his cigarette had to be replaced with a tin helmet. Similarly James's design for The Fleet Air Arm Memorial on the London Embankment originally had the winged figure of Daedalus launching himself from an aircraft carrier, but this last detail too had to be sacrificed.

On a table in his workshop rests a bust of Jomo Kenyatta. It was his commission for a twice life-size statue of the Kenyan President that enabled James to launch his independent career as a sculptor.

For James the hardest part comes when the clay has to be removed and discarded. 'If the mould breaks, then everything is lost.'

His final summing up is characteristically sunny. 'At 77, it's a nice way to earn a living – recreating the presence of the human being, just by mucking about with clay.'

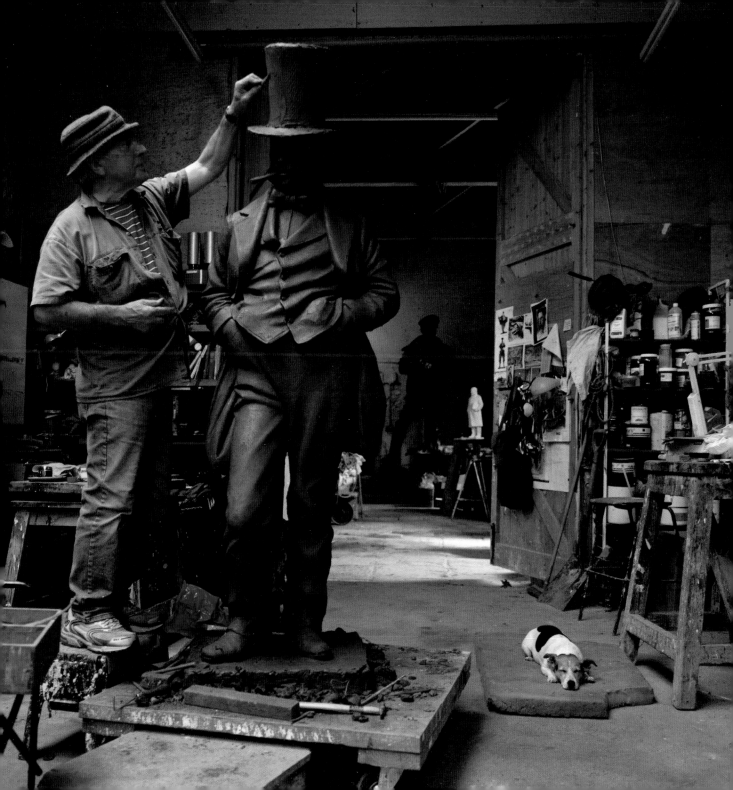

# Donald Buttress
## Architect

WHILE PROUD OF HIS MANCHESTER ORIGINS, DONALD Buttress now works from home in St Albans. He came south when he was appointed Surveyor of Westminster Abbey in 1988, in succession to Peter Foster, but his work has taken him further afield to Canada, China and South America.

Donald set up his practice in 1965, and has taught the history of architecture at Manchester and in the USA. He has a special place in the world of historic building conservation, being opposed to the excessive restraint advocated by the Society for the Protection of Ancient Buildings. He believes in replacing damaged stonework with new stone, and the introduction of new design elements and new sculptures. At Tonbridge School Chapel he weathered controversy about changing the design of the interior after a fire. In this, he resembles the more vigorous Victorian church architects. One of his heroes is Guild member George Pace (1915-75), who introduced modern design into mediaeval buildings as part of a 'living tradition'.

Donald has been surveyor to Llandaff Cathedral (where Pace did some of his most memorable work) and to Chichester Cathedral, which has a tradition of commissioning modern art. He has also worked on the cathedrals of Sheffield, Bangor and Leeds. He has designed a complete town in Ontario, with a cathedral in a baroque style, appropriate to his exuberant personality. His most recent work was the design of the architectural setting for the memorial to King George VI and the Queen Mother on the Mall.

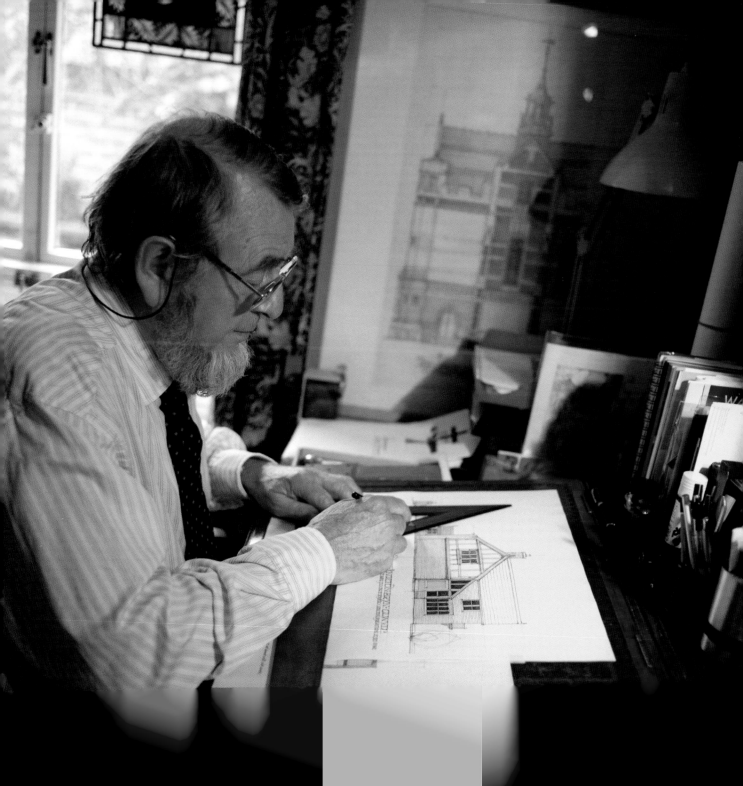

# Oliver Caroe

## Architect

OLIVER CAROE IS THE FOURTH GENERATION OF CAROE architects. He describes his great-grandfather W. D. Caröe, as 'an antiquarian but not one of those who was determined to make the history and every part of a building stand still in time'. Oliver believes that 'the passionate debates of the 19th century about conservation, preservation and new life for historic buildings are no less relevant in the 21st century', particularly when the principles of sustainable heritage must now also embrace sustainability and climate change.

Having worked for large and small practices, honing his design, conservation and business skills, Oliver has now founded his own practice. He is AABC accredited, which is recognition for specialist conservation skills, and he combines these with a passion for design excellence which was drummed into him at Cambridge. He feels that you cannot be a conservation architect without also being a designer and craftsman.

Oliver has been the lead designer for the major refurbishment of No 1 Millbank for the House of Lords, the baroque headquarters W. D. Caröe originally built in 1906. His scheme at Millbank, he says, was not about preservation so much as making the Grade II* listed building 'breathe and sing again for a 21st-century use'.

Although major projects like Millbank and Kirkstall Abbey are exciting, he finds it equally rewarding to return to a simple repair project, a modest set of drawings for a house or reordering a church. 'Even at a small scale, minor works must marry conservation and understanding of history and materials with an aesthetic sensibility and pride in the completed work.'

# Jill Carr
## Painter

JILL CARR'S STUDIO IS TUCKED AWAY BEHIND A COTTAGE AT
Shingle Street in Suffolk. In front of the cottage is a
vast array of seascape, but it is the wonderful marshes
behind, with their pump house and dykes, that Jill finds
more 'get-at-able' as a subject for her painting.

Jill was fortunate to attend Langford Grove, a boarding
school where paintings by Vanessa Bell and Duncan
Grant hung on the walls and the artists themselves
often came to visit. A seminal influence was Helen
Lessore, one of her teachers, who later ran the Beaux
Arts Gallery. Herbert Read refers to Langford Grove in
*Education through Art*. Following a foundation course at
Thanet School of Art, Jill won a scholarship to the Royal
Academy Schools. A series of teaching jobs followed
before she was able to make time to concentrate on her
painting.

Jill's work, including some sculpture, is represented in
collections in the UK and overseas. 'I usually work on
the spot,' she says. 'The character and atmosphere of a
place have a subliminal influence. Spatial relationships
fascinate me, while trying to keep the forms as simple
as possible. Colour is important but not paramount.
I have always used mixed media, often combining
chalk, charcoal and water-based paint. I also love doing
lithography on stone. It can have the spontaneity of
drawing.

'I think you know when you are getting somewhere
when the relationships seem to be very simple. It seems
to be obvious: there is an urgency when you see how
things relate on the surface on which you are working.'

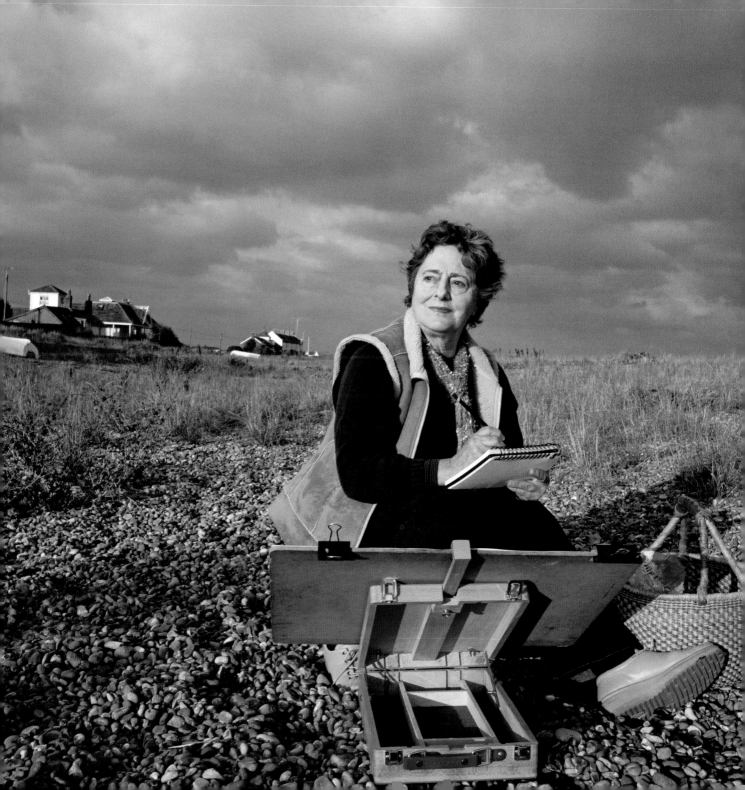

# Donal Channer
## Woodworker and Furniture Maker

DONAL CHANNER MAKES FURNITURE AT WESTBURY, Wiltshire. He set up on his own after leaving the London College of Furniture and relied on restoration jobs to make a living while he became established. This was also part of his education, he explains. 'You have to know how things are put together and how they are made to repair them. Knowing this at first hand is vital and underlies all my work.'

He moved workshop five times before arriving at Westbury in 2000. His workshop here is purpose-built with ample light, two large benches, a wall of tools, and a number of woodworking machines, some of which date back to 1928.

He is inspired by the Baroque as well as the Arts and Crafts Movement, and works with traditional designs of many kinds. With clients asking for anything from elliptical staircases to curved gazebo doors or individual inlaid cabinets, he often finds himself rubbing shoulders with contemporary design, while at other times working with heritage organisations to restore damaged items or recreate missing ones.

His is 'quiet work, not bombastic, and very practical'. He begins with the function of an object, using traditional elements with a modern edge to them. An individual chair requires the same engineering skill and precision as a whole staircase, however different they may look from the outside. He would like to make 'the kind of chairs you could sit in for hours and not want to get up from'.

'After working the wood you can see the colours and patterns – I love that.'

56

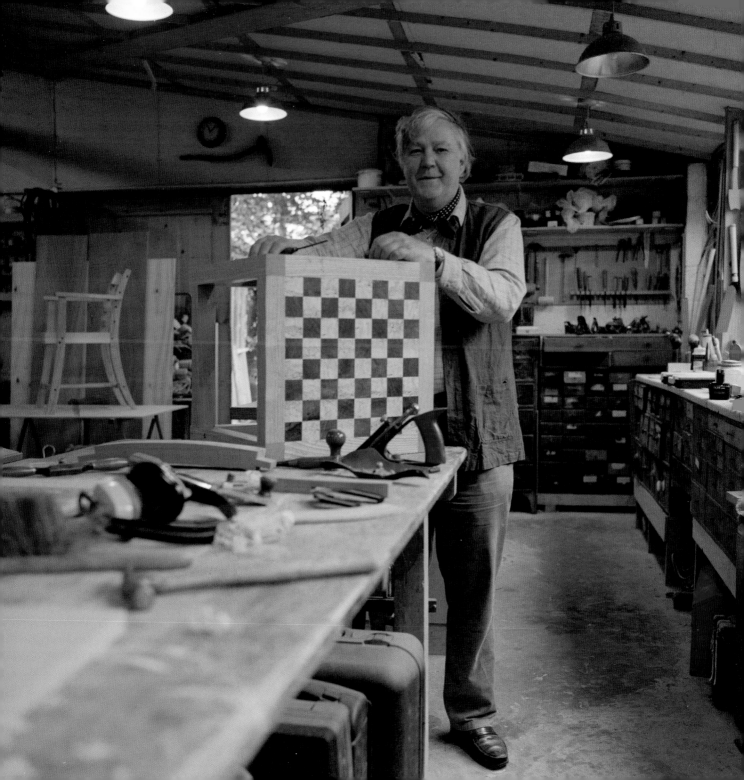

# Jerry Cinamon
## Typographer and Design Historian

WRITER AND BOOK DESIGNER JERRY CINAMON SPENDS A
lot of time at the British Library and the National Art
Library, enjoying research at leisure. His current project
concerns a German printer of the 1930s.

Jerry came to Britain from New York in 1960. Initially
he concentrated on book jacket design and some
advertising, but books are his passion, and he made his
reputation as a consultant designer for Penguin Books,
creating some of their first books in which pictures
and text were fully integrated, such as the 'Style and
Civilisation' series in the late 1960s, and the redesign
of the Pelican History of Art as paperbacks. We take
integration for granted now in art books, but Jerry's
work shows a genius for placing the pictures in a
spread and keeping everything in scale. He cares about
lettering, good typography and photography, which he
practises as well.

His home is typical of the 1960s: clean, abstract in
mood, with chairs by well-known designers of the
period. Design for him is not just about his own field
of printing, but about the whole ambiance of the
environment and the energy that this can generate.

'When you pick up a book you feel a little tingle, and
when it is properly designed it is a real experience and
often is something I have to own.'

# Katharine Coleman

## Glass Engraver

IN A SMALL WORKSHOP OFF LONDON'S CLERKENWELL ROAD, Katharine Coleman perches over her bench facing a small courtyard. There is no direct sunlight, as the light she works by has to be constant throughout the day. Her elbows rest on cushions, which help stabilise her hands as she holds the piece of blown glass beneath the copper blade. I am surprised to find that it is not the blade that cuts, but the gritty paste and water that the copper carries with it as it spins.

Katharine attended a boarding school, where the art department was supportive of her precision drawing despite the fashion for 'expressiveness' prevalent at the time. She studied Geography at Cambridge, then as an academic spent a very formative year in Peru, studying manuscripts in dusty forgotten archives.

She started glass engraving at the age of 37. Walking past an art gallery on Cork Street in 1984, her attention was caught by an exhibition of glass works by Peter Dreiser. Her husband took the day off work so that she could camp outside Morley College in Lambeth and be first to enrol onto a glass-engraving course.

Two years later she felt ready to learn copper engraving. With Peter's encouragement, she took a huge risk and bought a German lathe, 'called a SPATZIER costing £3,500,' she recalls. To support her engraving she took a part-time job and worked evenings and weekends for the next ten years.

Katharine produces around 30 pieces a year and collectors await new work before she has even made it. She has won countless awards throughout the world, recently being honoured with an MBE.

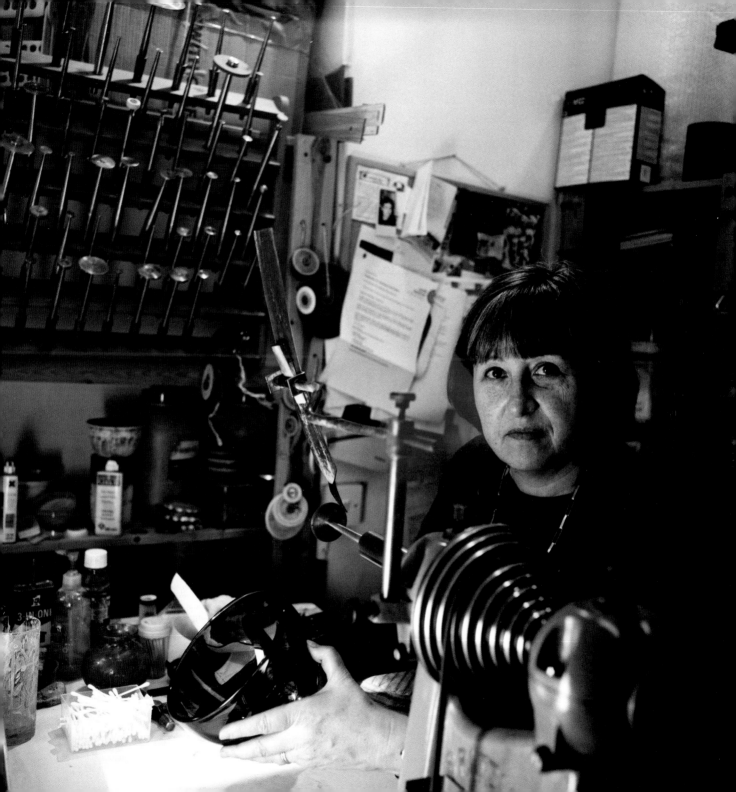

# Prue Cooper
## Potter

PRUE COOPER HAS HER POTTERY STUDIO IN SOUTH LONDON, in a large factory overlooking the river Wandle, with light and airy Crittall windows. Since 1996 she and Guild member Regina Heinz have worked side by side and shared the same large kiln in the corner.

A typical piece of Prue's work has a central image and an inscription around the edge. She makes dishes with images taken from life, such as two men staring into a hole, or someone attacking a 4x4 with a sledgehammer. They make something unexpected for guests to discover as they gradually clear their plates.

Prue trained as a painter and spent her early career as an art dealer. Having made things all her life, she turned to ceramics professionally when she found working with clay a very satisfying way of making things that are useful.

As a picture dealer, she was interested in artists who show the oddities of life. This approach is reflected within her own pottery, in which she constantly stretches her imagination. Almost every piece is to do with narrative, and conveys a message about community and 'sociableness'.

'A large dish for food implies sharing, and is an expression of sociableness. And people need stories – stories explain how we're all in this together.'

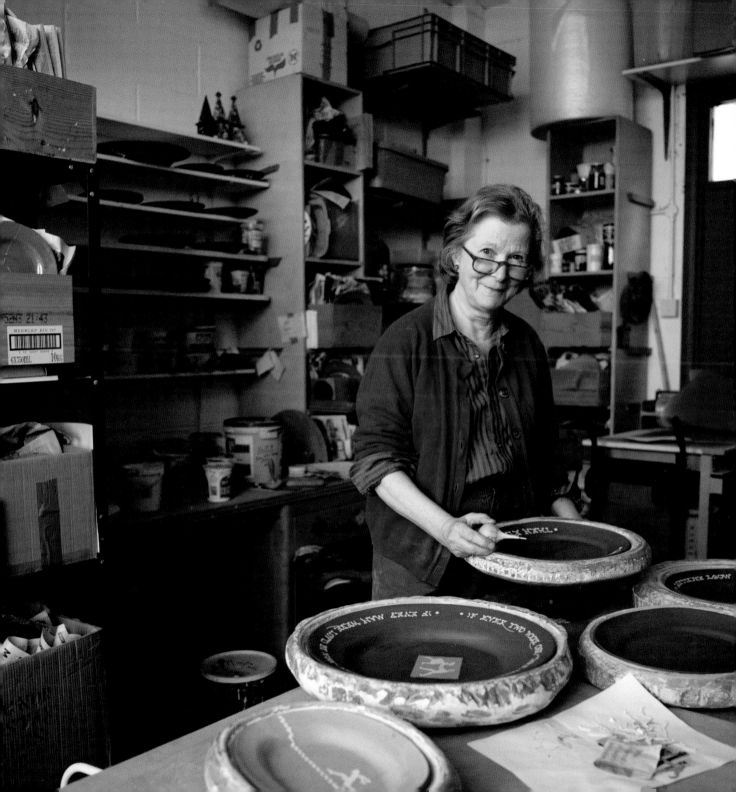

# Jane Cox
## Ceramicist

JANE COX WORKS FROM LEAFY BROCKLEY, SOUTH EAST
London, making functional and decorative ceramics
with free gestural brushwork expressing an exuberant
love of patterns found in nature. The design is applied
spontaneously using brushes, coloured slip and scraffito
enhanced with transparent coloured earthenware glazes.

Among childhood memories of museums, the sight of
a Picasso sculpture in the South of France of a boy on
a horse stands out as a formative event: white marble
framed by a beautiful blue sky. She was so excited by the
contrast of those colours. She felt she could eat it!

Jane is generous about sharing secrets, often giving
demonstrations of decoration at exhibitions and fairs
and in her lecturing role at Central Saint Martin's
College of Art. 'People do not own techniques,' she
insists. 'They are for all to share.'

Employing assistants allows Jane to develop her work
while giving others the opportunity to gain grass
roots experience. Such informal apprenticeships are a
response to her concern that key skills may be in danger,
and she recommends anyone who can afford it to take
someone on for the health of their craft.

Colour and pattern are the driving forces in Jane's work
and clay is a wonderful, versatile medium for creative
expression. Making functional work, she feels, brings
beauty to our everyday lives and something sacred and
special to the mundane.

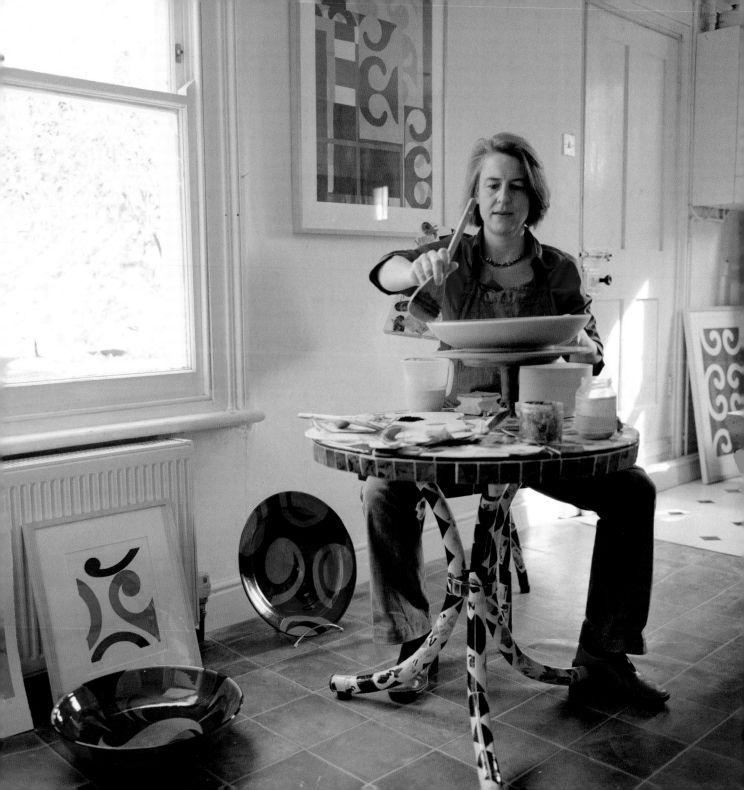

# Oriole Craven
## Silversmith

ORIOLE CRAVEN IS SEEN HERE POLISHING A PIECE OF HER silverware at her home in Cambridge.

In front of me is a fish serving set unlike any that I have ever seen. Little fish faces are embedded in the delicately hammered handles. Her husband shows me a sweetie-tin decorated with shells, slightly rugged, but still with the distinctive look that characterises her work. She tells me that she made this as a container for his broken chocolate: practical and yet fun at the same time.

Oriole's work was much admired by Peyton Skipwith, former Director of the Fine Art Society, who exhibited her work at a Society Christmas show, beginning an association that has continued ever since. More recently 'Primavera', the famous craft gallery in King's Parade, Cambridge, has taken nearly all her stock.

A recent stroke has prevented Oriole from making the delicate and beautiful pieces she envisions within her head, but she still hopes one day to go back to making things that are both beautiful and useful at the same time. 'One has to be able to use it,' she insists. 'Some beautiful things are just for show and I am not sure I make things beautiful enough for that.'

Her pieces are in fact completely beautiful – lovely, practical and really quite cheeky.

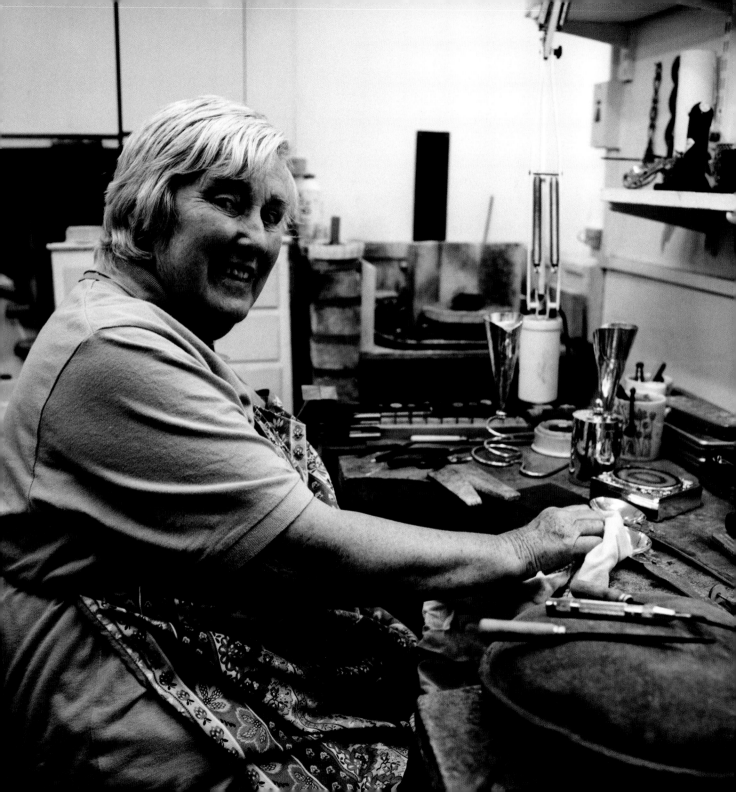

# Tim Crawley
## Architectural Sculptor and Stone Carver

TIM CRAWLEY, DESIGNER AND CARVER FOR FAIRHAVEN AND Woods outside Cambridge, is currently working on a marble fountain with Atlas figures and relief panels of mythical scenes. He directs a team of half a dozen craftsmen who are all busy chipping away.

Tim was the designer and carver of the controversial new figures of Modern Martyrs on the west front of Westminster Abbey, commissioned by Donald Buttress in 1998. His most famous work to date, however, is probably the restoration in 2006 of the four 12ft high sculptures of Lions and Unicorns on Hawksmoor's fantastical steeple of St. George's Bloomsbury, which had been removed by the Victorians. From design to completion the whole job took two and a half years to realise.

He has worked on many of the best-known stone buildings in the country, including Westminster Abbey, Ely Cathedral, King's College Chapel, and the Bank of England. A major part of his design work is modelling in clay, producing maquettes which the other carvers then work from.

As a stone carver, Tim very much feels part of a continuing tradition going back generations. He is still inspired by the work of the past as the materials and tools used have changed very little over the millennia. He thinks that this feeling of continuity is very much part of the Art Workers Guild, and that it is a wonderful feeling to see one's own name alongside some of the greats from the Victorian and Edwardian periods. He believes in William Morris's doctrine of the value of good work, giving you a 'fulfilling life and dignity of role'.

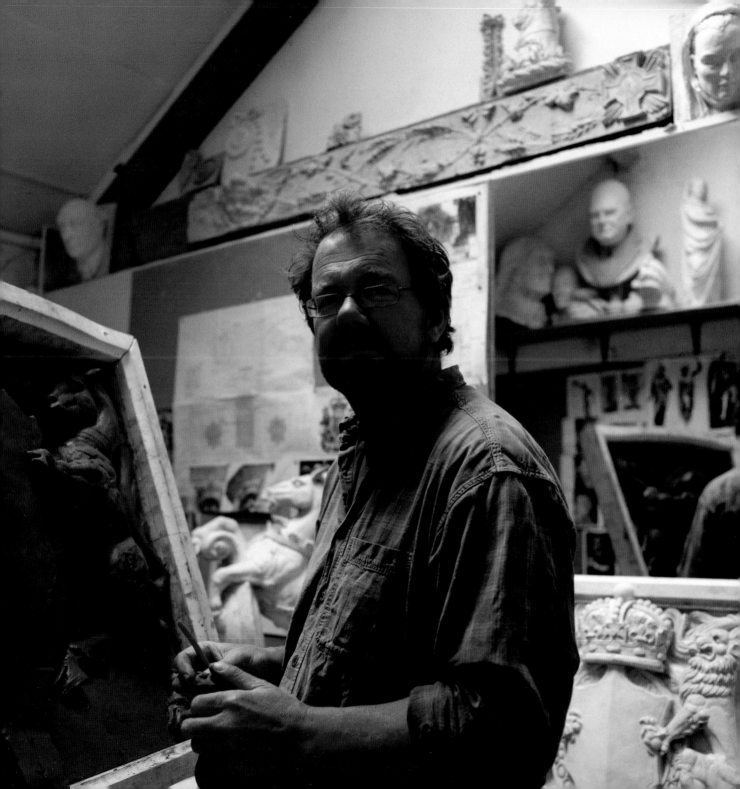

# Alexander Creswell
## Watercolourist

YOU WILL FIND ALEXANDER CRESWELL LIVING IN 'COPSE Hill', the Edwardian family house completed for his grandfather in Surrey, the heartland of the Arts and Crafts movement.

'Copse Hill' was designed by Christopher Turnor, the architect of the Watts Gallery, who was associated with Sir Edwin Lutyens. Gertrude Jekyll was consulted over the garden design. Along the escarpment are houses by Norman Shaw, Philip Webb and Alfred Powell, with a 1930s house by Oliver Hill to complete the series. The view over three counties stretches to the South Downs, uninterrupted by any other building.

The house with its surroundings has been a primary influence on Alexander's sensibility. Another great influence is Venice, first seen at the age of four, and then again in his teens. The synthesis of architecture and water has been the leading theme of much of his work.

Alexander paints beautiful buildings, beautiful places and beautiful boats. He tells me that if you can't own beauty, you can at least paint it. He mourns the rejection of beauty in the twentieth century. His bravura finished paintings begin with a little rucksack, containing a small paint set, three or four brushes and a bundle of pencils. He uses three sketchbooks: one to draw the architectural 'bones', and the other two for colour notes and splashes as the light changes.

'When you leave a country they ask, "Are you taking anything with you?" and you can say, "Only my sketchbook full of all your beautiful buildings." It's wonderful, this sort of avaricious greed.'

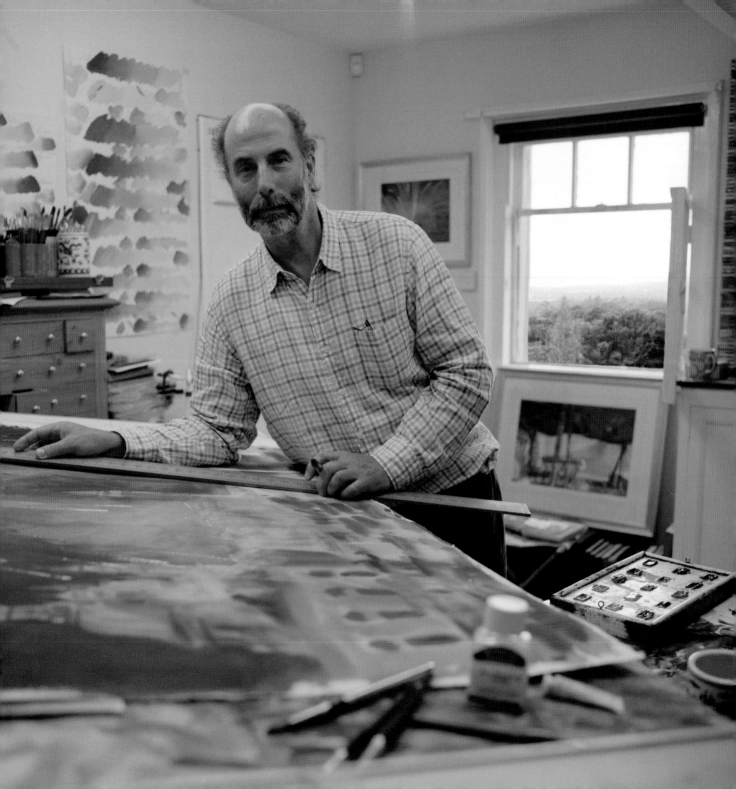

# James Stevens Curl
## Architect and Architectural Historian

PROFESSOR JAMES STEVENS CURL WORKS IN THREE MAIN
areas at his home at Holywood, County Down. Most of
his writing is done in his study at the writing-desk, his
reading-desk in the library, or at the piano in the sitting-
room. Drawing is always done at his eighteenth-century
architect's desk in the study. As he writes longhand
rather than on the computer (except for letters, etc.),
James is free to shape his texts instinctively and edit
them in the traditional way.

In a career spanning more than 50 years James has
held many highly prestigious positions in the worlds
of Architecture and Academia, and written numerous
books and articles. His massive *Oxford Dictionary
of Architecture and Landscape Architecture*, copiously
illustrated with his own drawings, has received wide
acclaim. A forthright traditionalist, he is now supposed
to be retired, but he still travels widely, working as a
consultant on numerous historical buildings, and the
stream of writing shows no sign of drying up.

'Caring for an old building requires a great deal of
knowledge: you have to know something about how
the bits are put together, about the traditional methods
of construction, and so on. If it is a building of quality
associated with a particular style it will have been
designed using a coherent vocabulary and a sophisticated
language. If one is unfamiliar with this vocabulary
and language one can ruin the building. I am afraid
that happens rather too often because of widespread
ignorance and the fact that Schools of Architecture are
not interested in the subject.'

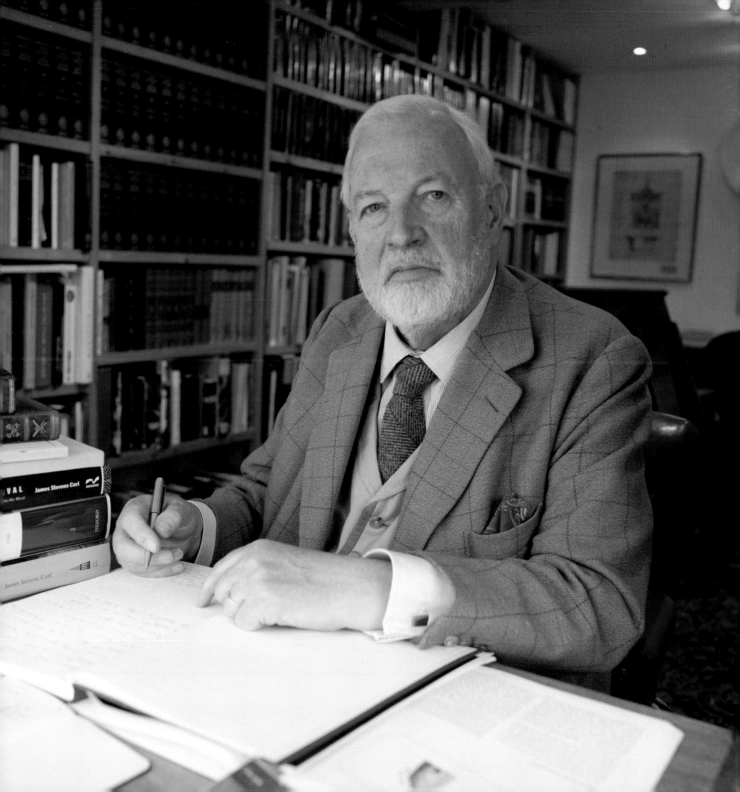

# Claire Dalby
## Painter, Wood Engraver and Botanical Illustrator

IN A SMALL TOWN IN PERTHSHIRE SET BETWEEN THE DRAMATIC
landscapes of the Ochil Hills and the Grampians, Claire
Dalby works in minute detail. Her drawing room is
furnished at one end with an Albion press and print-
making equipment. Beside the window is her painting
desk, complete with microscope, where I find her
sitting patiently, observing a bromeliad.

Her father, the late Brother Charles Longbotham, was
a fine watercolourist. She met her husband, a botanist,
at Flatford Mill Field Centre, learning from him the
importance of the smallest botanical detail. Her most
notable works include the Natural History Museum
wall-charts, for which she drew and painted about 100
species of lichen.

She was first introduced to wood engraving by the work
of Joan Hassall, who was the first woman member and
the first woman Master of the AWG. They met on the
day that Claire bought her first tiny wood block. Her
own wood engravings are small and extremely detailed,
which she partly explains as the result of short-
sightedness – 'great for detail, but rotten for catching
the right bus'.

Claire brings a broader approach to her Shetland
landscapes, using a size 0 brush to find the precise
colour and feel of the land, before exploding to a size 6
for the washes. Recently she has found a subject in the
landscape around her, beginning with Stanley Mill, an
enormous edifice from the Industrial Revolution.

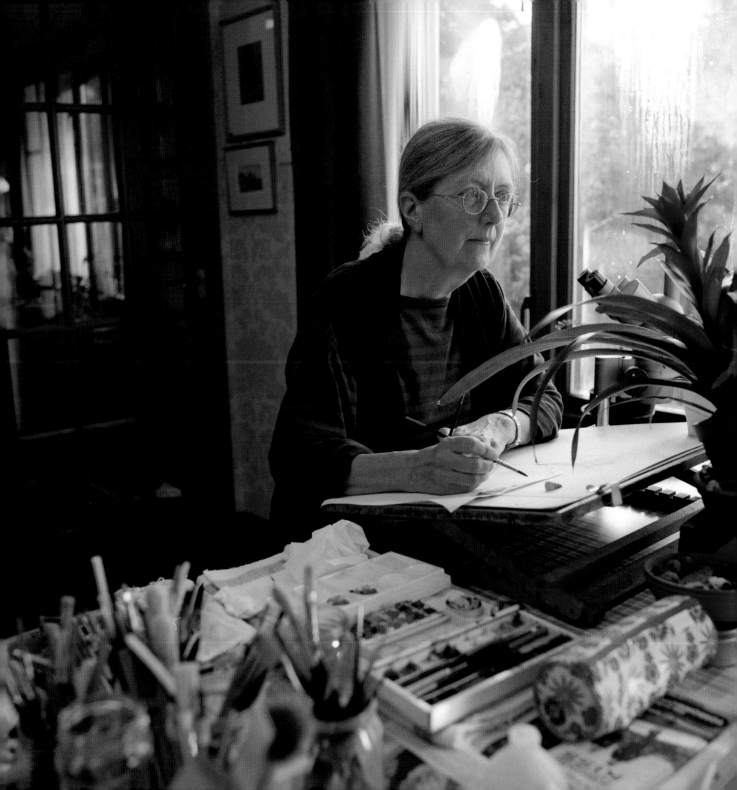

# Helen Draper
**Paintings Conservator**

HELEN DRAPER PAINTED AND DREW FROM AN EARLY AGE.
At the age of 12 she watched a television programme
about an oil painting restorer. Her immediate response
was, 'That is what I want to do.'

After completing an art history degree, Helen served
an internship in conservation at New Zealand's
principal art gallery, in Auckland. An MA in Paintings
Conservation at Northumbria University followed
this grounding. The Masters course was intellectually
absorbing, and it was good to be immersed in
something practical which also brought together the
study of art, physics, chemistry and the history of
artists' materials.

After developing her skills by working with senior
conservators, Helen set up on her own in 1992.
Cleaning paintings intrigues her more than any other
aspect of her work because it brings her into close
contact with the 'hand of the artist'. 'There is a special
excitement when you are cleaning a painting, and
you see original paint that has been concealed by
discoloured varnish and layers of dirt. It's magical.'

Helen has a special interest in seventeenth-century
British portraiture and in particular the artist Mary
Beale. She is completing a PhD on Beale's life and work
in London, and is raising awareness about the plight of
Beale's home at Allbrook, Hampshire. The house is the
earliest known surviving artist's studio in England and is
still surrounded by views which Beale would have seen
from the windows.

Helen's top tip: 'Nearly all conservators are addicted to
Radio Four…'

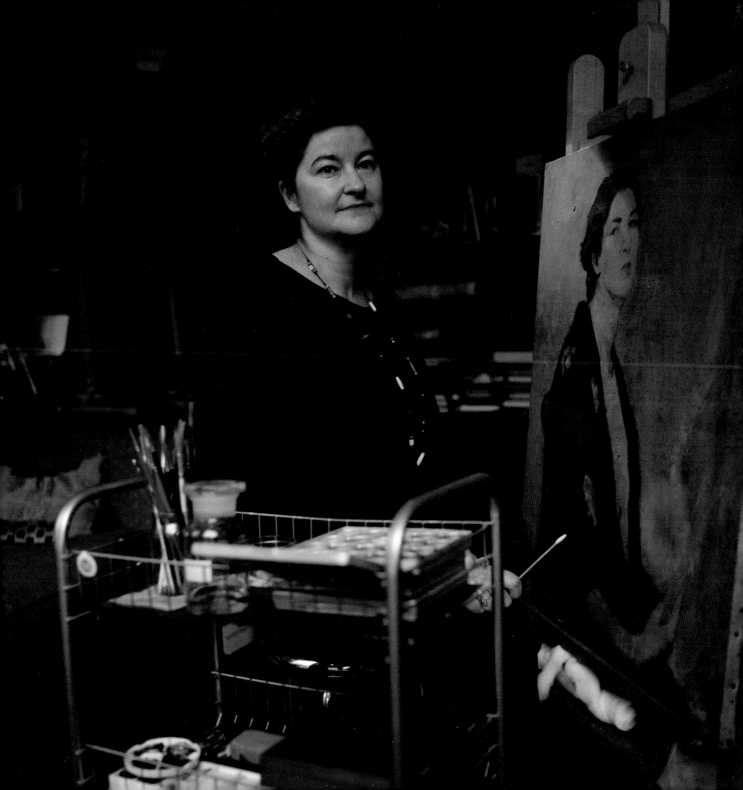

# Sarianne Durie
## Stained Glass Artist

SARIANNE DURIE HAS RECENTLY MOVED INTO HER NEW STUDIO purpose-built in a field next to her home at Bampton. Surrounded by chickens and a brook, with light streaming in from three sides, she has picked an idyllic spot.

With wooden sliding doors over the glass panels, kilns for glazing and an area for storing glass and drawing, her studio is exactly how she wished it to be.

Sarianne mainly works to commission. Church windows predominate, but there are occasional jobs for restaurants and offices. Sometimes she works with mirror and sandblasting, but prefers painting and firing the glass above all other techniques.

It was a class taught at the City Lit by Amal Ghosh in the 1960s that set her on this path. The fantastic colours and effects that could be achieved with handmade glass were a revelation – completely different to anything she had done before.

With stained glass the work can only be properly appreciated when it is installed. Once natural light is behind the window, hue and density are radically altered, while at the same time a secondary vision is thrown across the room, changing with the weather.

Sarianne has been influenced by Cézanne's drawings and by the Irish glass artist Harry Clarke. As a teenager she loved Art Nouveau, then operated 'a curved-line embargo' for a while. Only when she felt she truly understood line and formation did she reintroduce organic elements into her designs.

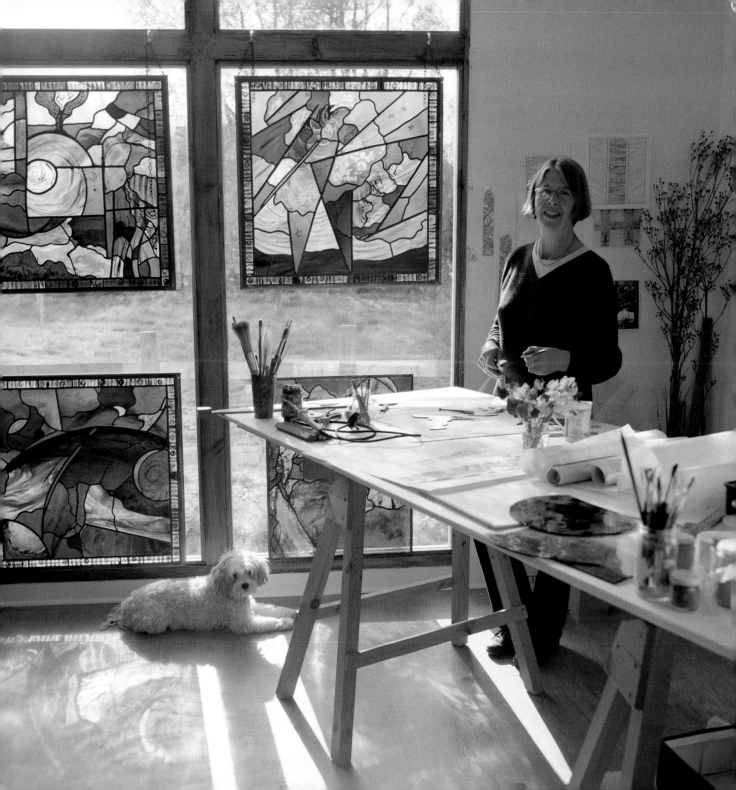

# Mary Fogg
## Quilt Maker

SITTING IN SURPRISING MARCH SUNSHINE IN MARY FOGG'S back garden, we discuss her career in textiles as she works on repairing a corner of the first quilt she ever made.

Although trained as a painter, Mary was never really satisfied with this direction. Her family had a tradition of 'make do and mend', and she fell in love with American quilts. She was used to making clothes for her children and realised the potential of textile art. Later Mary became a member of a small group of textile artists who often met in her house for discussion of work and to plan exhibitions.

Most of her work is designed to hang on walls not beds. Though her early inspiration came from old American traditional quilts, she has never actually made one in that style. She takes her inspiration from the world around her, from society, politics and nature, and from her materials, preferably those with a previous life, via an Oxfam shop, for example. Narrative ideas can be suggested by different kinds of cloth and she has often included 'hand-written' (with free machine needle) comments and the poetry or sayings of others.

'The use of sewing is exceeding old, as in the sacred text it is enrolled.' – John Taylor.

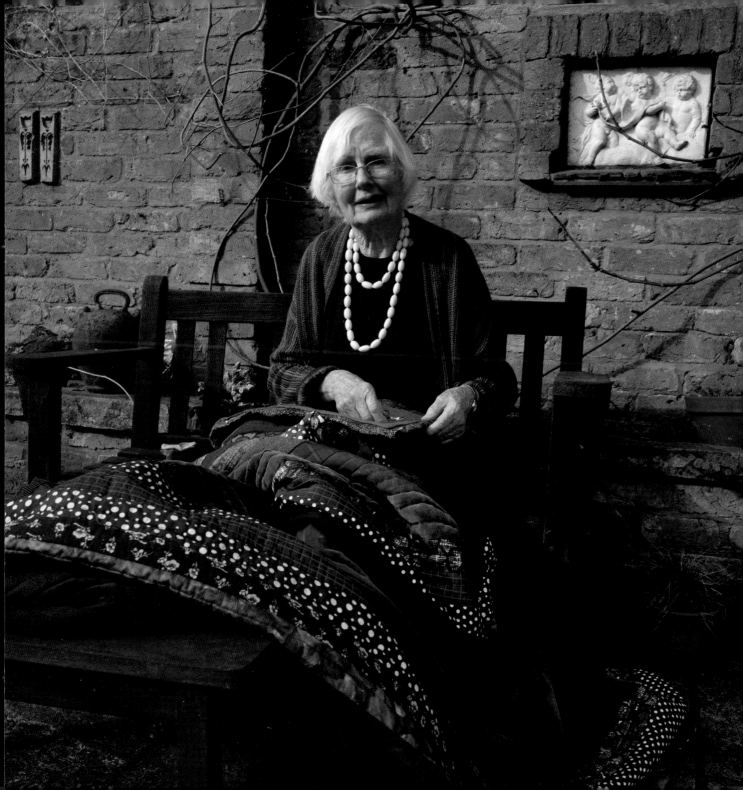

# Peter Foster

## Architect, Painter and Printer

PETER FOSTER IS SEEN HERE WORKING ON A MODEL OF A FOLLY in his workshop at Harcourt, Hemingford Grey. Born in 1919, he was Surveyor of Westminster Cathedral from 1984 to 1996, a position sometimes considered the highest in the field of historic building conservation, which has been filled by a succession of AWG members since the 1880s.

Peter had a classical architectural education, and was as a student of Sir Albert Richardson. He is also a practical craftsman, having constructed the additions to his 18th-century home, its courtyard office building, and its garden follies. His activities outside architecture are equally notable. Harcourt, between the years 1957 and 1963, housed the Vine Press where Peter and his partner in printing, John Peters, operated a hand press producing books, some of which are in the Guild Library. His watercolours, the earliest dating from 1936, have been exhibited in London, Cambridge and Scotland.

After his war service, Peter joined the office of Marshall Sisson at Farm Hall, Godmanchester. Sisson was Treasurer of the Royal Academy, and by the time he had bought Farm Hall they were classicists and designing buildings in that manner, helped by, among others, Donald Insall.

After walking through the colonnades and the 'Roman Room' that Peter built in 1965, we visit his gallery. His watercolours from the 1930s are as vibrant and alive today as when they were first painted. A Georgian sense of balance, and a love of colour and beauty are apparent in everything he has created.

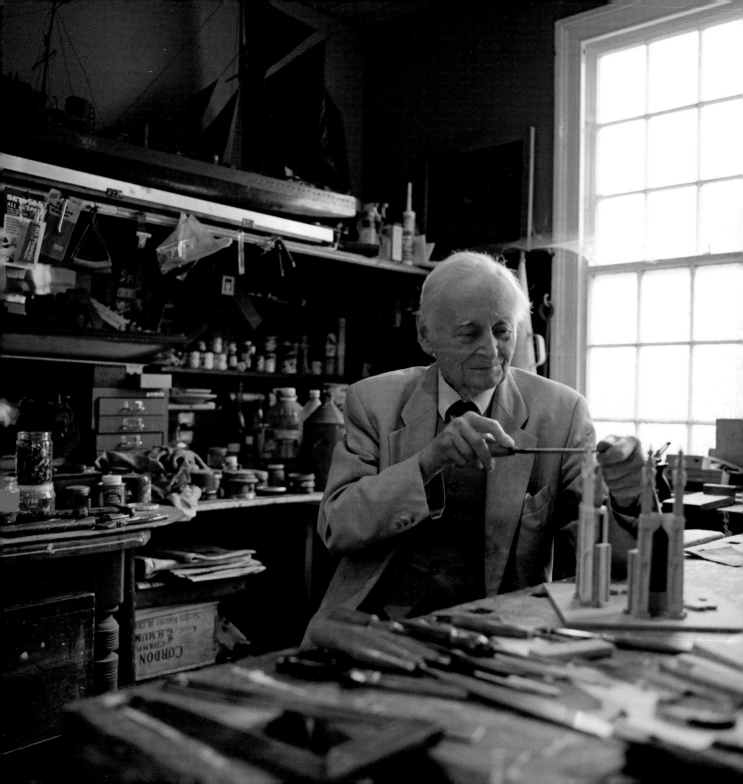

# Richard Foster
## Painter

IF YOU WERE TO IMAGINE A VICTORIAN GENTLEMAN'S SPACIOUS studio, it would look exactly like Richard Foster's in South Kensington.

His location provides him with many fine views of the Thames, but due to the ever-changing conditions of weather, wind and tide, capturing them is never easy. One particularly eye-catching river view was painted under Battersea Bridge, and could only be done on sunny days every other week at low tide, and during a rather short period in the winter. It took several years to complete.

Although he spends most of his time here, and in his house in Norfolk, a surprising amount of his work is painted on location. His single portraits and groups are mostly done in the sitters' houses, as this allows him to get a better feel for his subject. Commissions take him far and wide – he has just had an enquiry from Australia.

His recent catalogues are like small books, full of information and laconic comments. The reason he paints, he says, is for respect: 'You want people to say that you have not done too badly.' For him the main difficulty of the painter's life is being distracted. As Bernard Shaw, himself an honorary member of the AWG, once said: 'Painters should paint.'

Richard is a second cousin of Past Master Peter Foster. He became a member of the Royal Society of Portrait Painters in 1976, and his work is in many national collections.

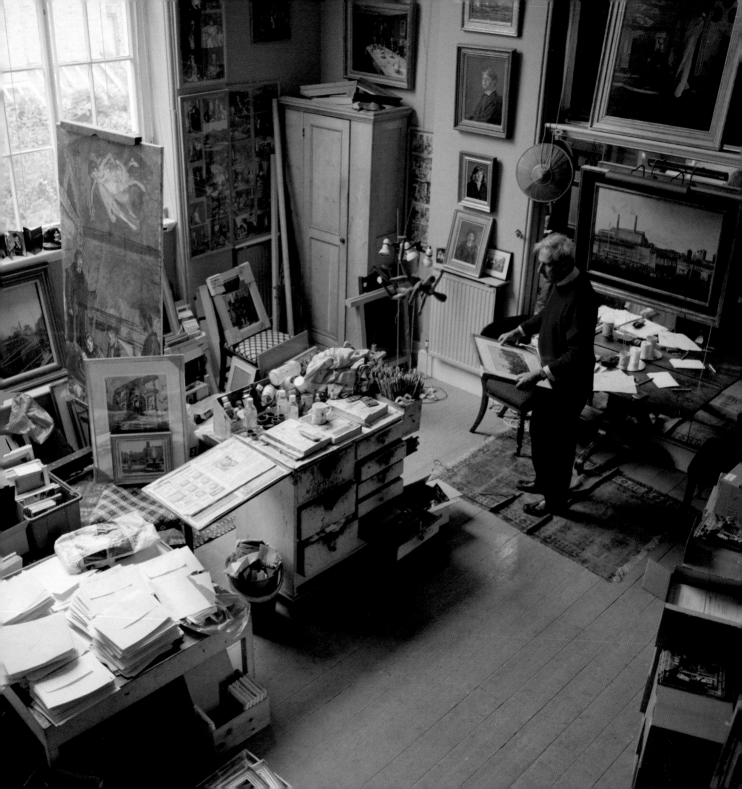

# Trevor Frankland
## Painter and Printmaker

TREVOR FRANKLAND HAS HIS PAINTING STUDIO AND printmaking workshop at his home in south-west London. He was President of the Royal Watercolour Society in 2006, and is a keen member of the London Group, The Royal Society of British Artists and the Royal Society of Painter Printmakers, as well as the Art Workers Guild. 'If you are an active member of a society, there are great dividends,' he says. The exhibitions organised by these groups enable Trevor to show around 40 paintings a year, and in the past ten years his work has been exhibited in about 120 venues.

He started as academic painter, then moved to abstract wooden reliefs and eventually 'Systems Art'. This work was exhibited in various Municipal Galleries assisted by grant aid from the Arts Council.

His work took a new direction when he was teaching at Hornsey School of Art and brought home a selection of mirrors. He put them in the kitchen and this motivated him to investigate the effects of illusion in his garden. Inspired by Japanese arts, Trevor began to excavate his garden and created a vision that has ever since guided his painting.

'As it develops, despite the change, there is always a constant. There is no beginning and no end.' He quotes a line by Matisse: 'You only ever have one idea, you are born with it and spend your whole life trying to find different ways in which to develop it.'

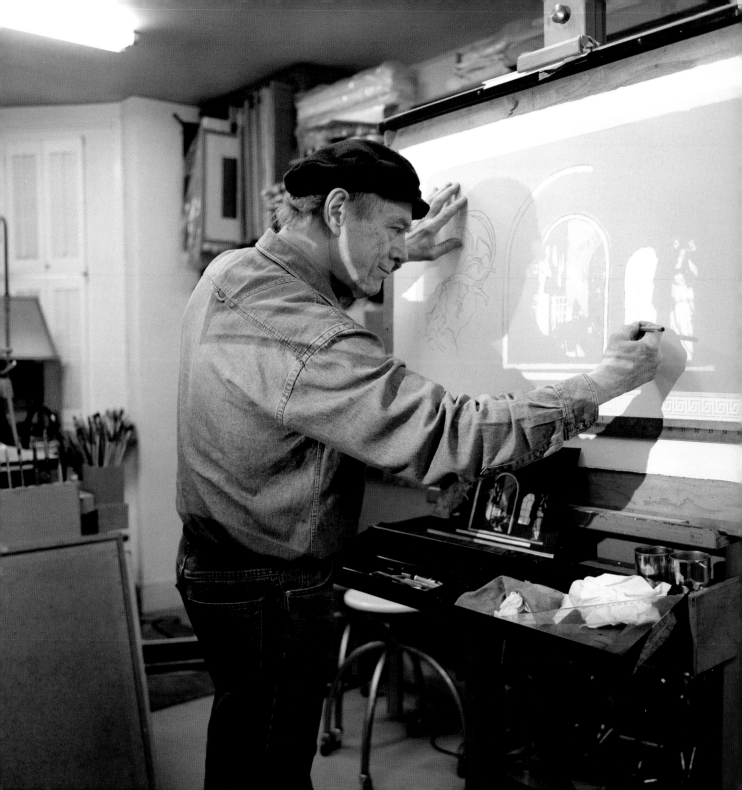

# Richard Gilbert Scott
## Architect

APPROACHING 'MEG'S COTTAGE' IN BURNHAM NORTON,
I found Richard Gilbert Scott and his wife Elaine
painting in their front studio. Richard designed the
cottage himself, and it fits perfectly into the picturesque
Norfolk seaside village, where artist neighbours include
Brother Polly Ionides.

Richard's father was Sir Giles Gilbert Scott, the
celebrated architect of Liverpool Cathedral and the
Bankside Power Station which now houses Tate Modern.
When Richard was eight Sir Giles set him the problem
of determining the position of a larder and a back
door, and from then on he knew that he wanted to be
an architect. During war service in the 1st Airborne
Division, he flew to Norway and gave a parachute to
the girl he later went back to marry. After the war he
joined his father's practice, before starting out on his
own in 1960. His best known buildings include the
Library and Art Gallery added to the Guildhall in the
City of London in the late 1990s, and a number of
churches. He also designed the Blue Circle Cement
HQ in Aldermaston.

Near 'Meg's Cottage' is a well preserved example of the
iconic red telephone box – possibly the most famous of
all Sir Giles's designs – which Richard has persuaded
British Telecom to keep in full working order. Richard
says that his father would be amused by the fact that
he is in some ways better known for designing the
telephone box than for Liverpool Cathedral, his great
masterpiece.

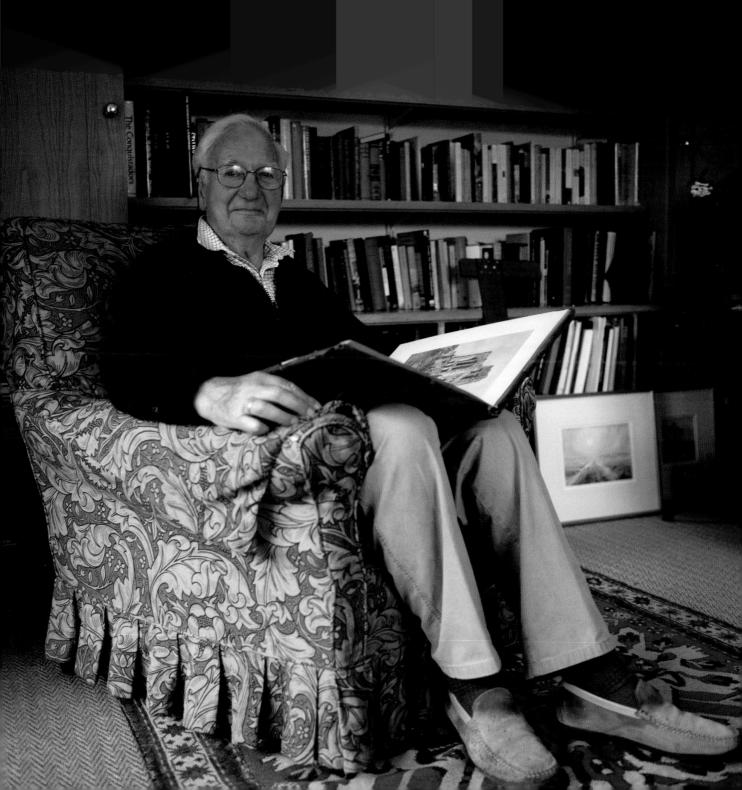

# Flora Ginn

## Bookbinder and Book Restorer

FLORA GINN HAS RUN HER BINDERY IN THE SEMI-BASEMENT
of her Victorian house in Clapham, south London,
since 1987. She started the previous year on the first
floor, but moved down because of the increasing items
of heavy equipment. At present she is improving
and extending the bindery, having gained planning
permission to excavate in the back garden.

Flora has been avidly collecting tools, equipment and
a wide range of materials for more than twenty years.
Her latest purchase is a board-cutter auctioned at
the British Museum Bindery in 2007, following the
establishment of a new Conservation Department at the
British Library in St. Pancras. Among other large pieces
of second-hand equipment are cast-iron nipping presses,
a lever press in which the pressure can be set by turning
gears at the top, a French percussion standing press,
and a guillotine. Many hand tools and hundreds of small
brass finishing tools, rolls and fillets adorn the walls.

After graduating with distinction from Roehampton
Institute in 1986, Flora spent the following twelve years
learning restoration at Brother Bernard Middleton's
bindery, near her own.

Book restoration and conservation is Flora's main
work, and today she is dry cleaning the pages of an
18th-century folio and furbishing its green full leather
binding. Antiquarian bindings often come with boards
detached, damaged head and tail bands, tears and
wormholes. When I asked which part of the craft she
loved most, she replied that it was gold tooling that gave
her the greatest satisfaction.

90

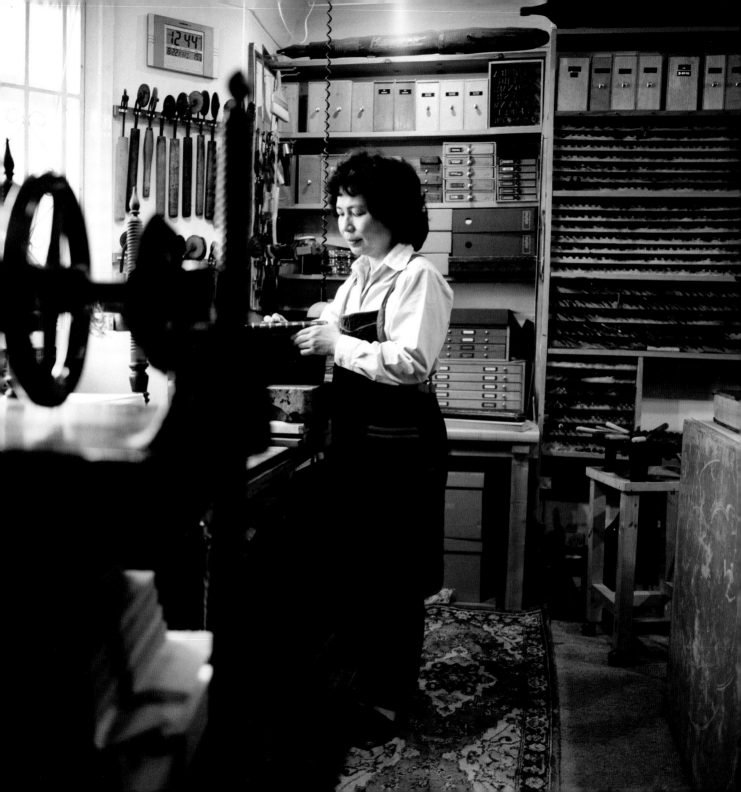

# James Gorst
## Architect

JAMES GORST IS SEEN HERE ON THE CONSTRUCTION SITE of a building his practice has designed in north-west London, a free-standing apartment block in black glazed brick tucked behind the Portobello Road. His work is generally private one-off houses, so he derives particular satisfaction from a project that provides good affordable housing for a wider clientele in an urban context.

James's early work was characterised by reference to earlier historic modes: a stripped centralised villa in Hertfordshire in the 1980s, a picturesque Voysey-esque town house in Chelsea in the 1990s. After learning from the past he felt ready to abandon explicit historical references and move towards a more personal contemporary expression that remained rooted in the craft and materiality of construction.

Today James is fortunate that clients come to him on the basis of his current work. His projects range from new country houses in Suffolk and Northamptonshire to new town houses in London. The practice, with eight employees, remains small and friendly.

His new flats make a striking contrast to the 1960s social housing that surrounds them. The site was originally a Victorian pub, 'The Malvern'. The new shiny black building with its bronze balconies makes a sculptural insertion and reinvigorates a previously fractured and neglected context.

# Assheton Gorton
## Film Production Designer

ARRIVING AT THE HILL-TOP HOME OF ASSHETON GORTON you could imagine that you had come to the land of mythical creatures that people his art.

Born in Sedbergh, Yorkshire, Assheton studied Architecture at Cambridge and Fine Art at the Slade. He was fortunate to work under Tim O'Brien at ABC Television from 1956 to 1963, where he learnt his craft working on over 50 plays for Armchair Theatre.

Turning to films, he first worked on *The Knack* and *Blow Up*. Many other productions followed, including *Get Carter*, *The French Lieutenant's Woman*, *Legend* and Disney's 'Dalmatian' movies.

The film business, Assheton tells me, uses every art form that has ever evolved, from traditional skills to digital. These skills, he believes, are the bed-rock of society and of our economy. He knows from direct experience how vital they are in every aspect of life, and how imperative it is for the individual to nurture them from an early age.

Assheton has built his workshops and studio in the Welsh hills in order to develop his own ideas, working on an etching press and using a computer to create books and other artefacts.

'My working language as a Production Designer,' he says, 'is imagery, which is a theatre of the mind – the stage of imagination and vision. In Proverbs it says, "Where there is no vision the people perish."'

'Imagination is the world of Eternity.' – William Blake.

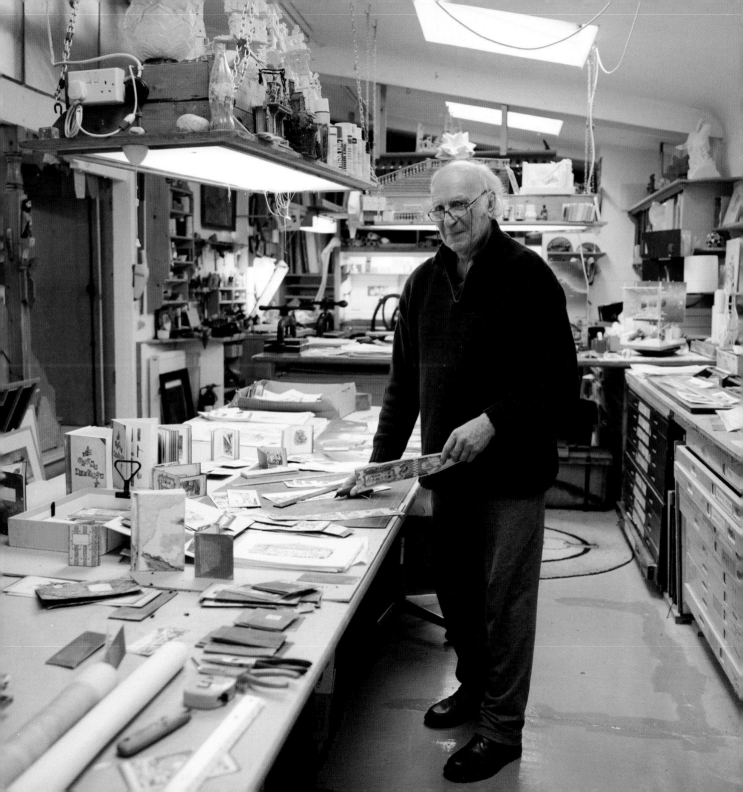

# Barnaby Gorton
**Painter**

BARNABY WAS BROUGHT UP IN A FAMILY OF ARTISTS. HIS father is the production designer Assheton Gorton, his mother a potter, his brother a photographer, and his sister a textile designer, and he was encouraged from an early age to learn as many skills as possible, drawing being fundamental to all.

Barnaby studied Fine Art at Cheltenham, and following that worked in the film industry for his father. After a couple of years he decided that he needed to have more direct contact with his work and for it to last a little longer, and left to form Treasure Gorton Designs in partnership with Paul Treasure, creating art for the private and commercial sector.

In 1992 he became a father and began working from home, concentrating on developing his own style and marketing that to an international clientele.

Recently Barnaby has been working again in films, creating wizard portraits for the Harry Potter series, as well as a set full of frescos with Rohan Harris. Alongside this he has created a number of large paintings for Gordon Ramsay, one of which you can glimpse in the background of the photograph. The culmination of his recent work is an 18-metre-wide painted sculpture at Heathrow Terminal 5 entitled 'Flight Time'.

At the moment he is painting a series of portraits of his family (as always the scale is large), while passing on the skills and ethos he learnt from his father to his three daughters.

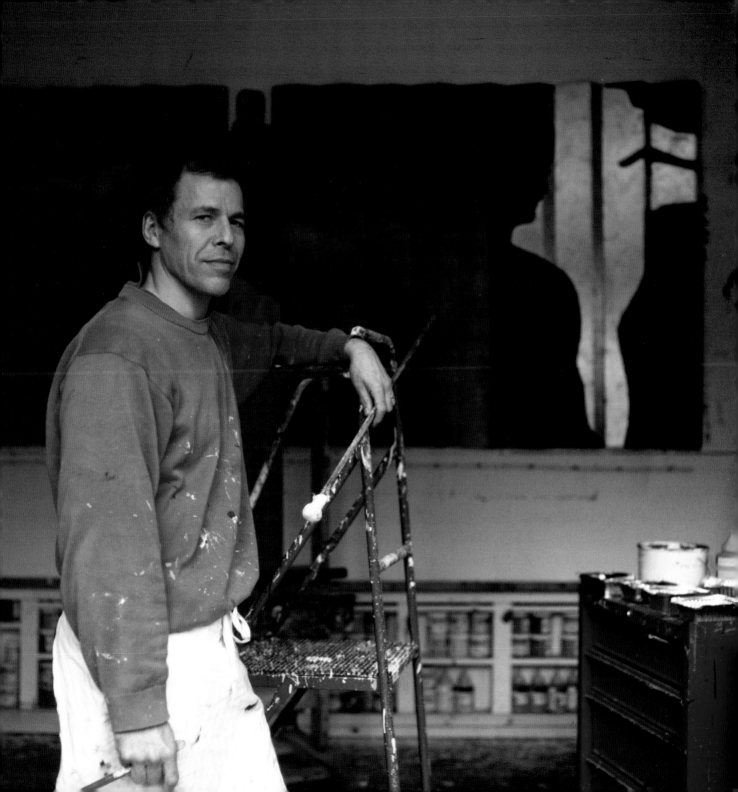

# Stephen Gottlieb
## Lute Maker

STEPHEN GOTTLIEB IS A LUTE MAKER, BUILDING ALL TYPES
of renaissance and baroque instruments from highly
decorated to classically simple. His workshop, in a
mews behind an optician's shop, is crowded with fine
woods, moulds, jars of natural pigment, resins, and
varnish samples. A CD of lute music from a recently
restored instrument plays in the background.

He trained at the Architectural Association at a time
when multi-disciplinary design was encouraged,
and decided to follow a growing interest in musical
instrument making. There were no courses at that time,
so he taught himself, spending one whole summer
travelling around Europe studying and measuring old
lutes in different museums. His first instrument was a
guitar, which he also played. Now he takes orders from
players all over the world.

Stephen's lutes, theorbois and chitarroni are lightly
constructed and are made typically with yew or
maple backs and well-seasoned spruce soundboards.
Decoration is in costly materials such as ebony,
snakewood, boxwood, bone and gold leaf.
All around his workshop I notice interesting pieces of
woodwork – lute pegs, chess pieces and other intricate
bits of turning; inlaid boxes; sculptures made of offcuts,
and a myriad of lute rose designs.

I wonder whether musical instrument makers have
jealously guarded secrets. Yes, he agrees, there is a lot of
mystique about varnishing. But his personal credo is in
sharing knowledge, confident that there is an indefinable
quality to a maker's own style: a personal handwriting
that makes their work unique.

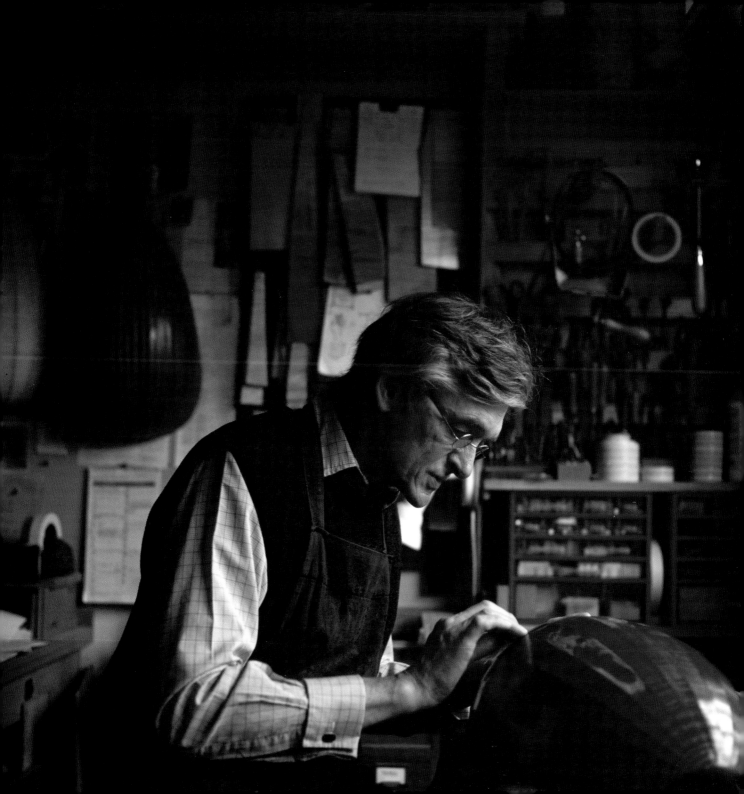

# Edward Greenfield
## Music Critic

EDWARD GREENFIELD SITS IN HIS GEORGIAN HOUSE IN Spitalfields surrounded by thousands of CDs and vinyl records. On his walls hang paintings of favourite composers by Jeffrey Spedding, among them William Walton, Beethoven, Brahms, and Sibelius.

Edward was music critic for the *Guardian* for half a century, and he is also celebrated for authoring the Penguin Guides to Records and hosting The Greenfield Collection for the BBC World Service. He still regularly contributes to *Gramophone* magazine and is currently writing his memoirs.

His listening technique, he tells me, is rather odd. Rather than hearing a piece right through, he prefers to sample passages in order to compare different interpretations. He owns up to 30 recordings of a single composition, any one of which he can identify within the first few minutes, purely from the quality of the playing.

During his year as Master he brought a starry range of performers to speak to the Guild, including Dame Joan Sutherland and Tasmin Little. Anecdotes of great musicians abound. In 1989 at a press conference held at the Savoy Hotel Leonard Bernstein complimented him on his *Guardian* review of Vladimir Ashkenazy conducting Tchaikovsky's Fourth Symphony in Moscow, which included the phrase, 'blinking back a tear as he began the coda'. Edward pointed out that if he had watched the concert live rather than on television he would have missed that detail. A press photographer captured their shared laughter, and a painted version of the moment now hangs in Edward's room.

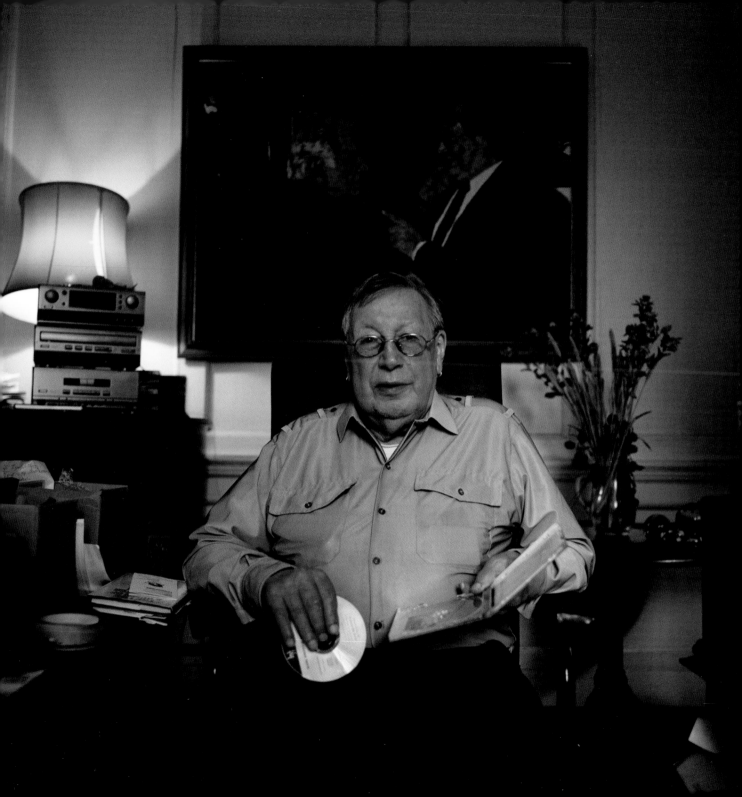

# Charlotte Grierson

## Weaver

CHARLOTTE GRIERSON IS ALMOST SWAMPED BY THE DOBBY loom in her small studio, but there is room enough for her to move around and so much light filtering through that it feels perfectly spacious. Stacked on shelves are folded scarves and bobbins of yarn, along with a warping mill and other wooden weaving tools.

Three years ago, after completing an MA in textiles at Goldsmiths, Charlotte moved into the Deptford workshop, bringing with her a dobby loom whose design goes back over 100 years. Her whole family are in the business of making. Her grandfather was a decorative arts designer and rug-weaver, her father an architect, and her mother a photographer, while her uncle, Martin Grierson, also a Guild member, designs and makes furniture.

Charlotte sells her work mainly through galleries, but also works to commission for clients who ask for specific colours or weaves for upholstery and furnishings.

She enjoys the whole process of weaving, from threading the yarns to the mechanical process of making the cloth. She enjoys the contrasting textures, and the transformation of raw materials into finished fabrics. She is fascinated by the way the qualities of the fabrics differ according to the tensions and yarns employed.

Charlotte is physically part of the weaving process, her slight figure engulfed within the loom, her whole body creating every movement that it makes. This extreme involvement epitomises her love of the craft.

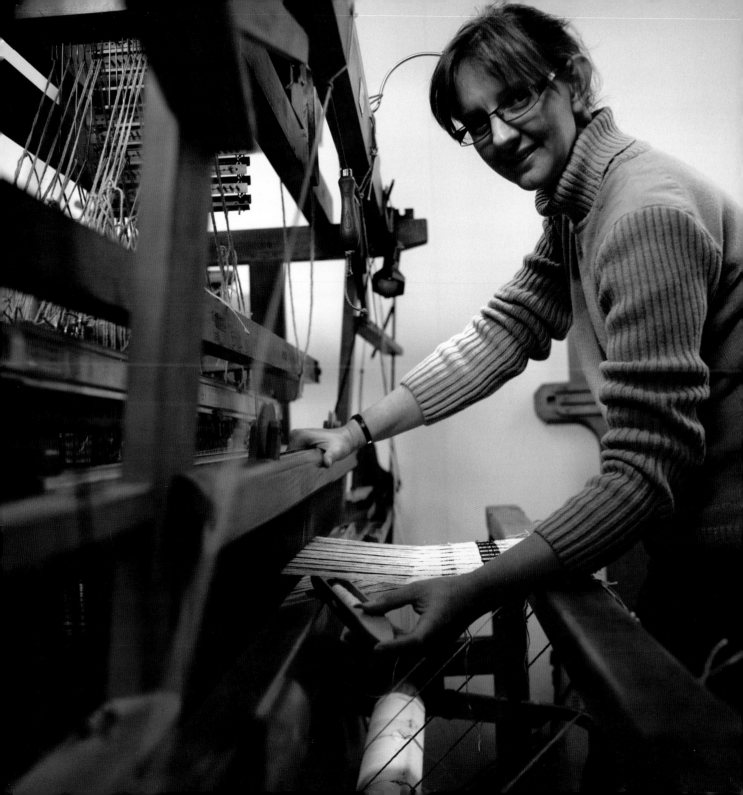

# Martin Grierson
## Furniture Designer and Maker

In an industrial side road in a regenerated area of
Acton is the well-equipped workshop where Martin
Grierson, assisted by a small team of fine furniture
craftsmen, has for 33 years designed and made furniture
for a variety of clients ranging from private individuals
to large corporate bodies and public institutions.

Each member of the team is encouraged to be
responsible for a piece to which he can add his name.
The spacious workshop allows every craftsman to have
his own workbench, while sharing the industrial and
craft machinery. The walls are lined with cupboards
holding their personal tools.

Martin started off in 1960 as a freelance designer for
industrial production of furniture, before setting up the
workshop for handmaking 15 years later. A significant
proportion of today's most successful furniture makers
have worked for him and gained a lot of experience for
their future careers.

His public commissions have come from the National
Gallery, various Cambridge Colleges and many others.
In 2000 he won the Worshipful Company of Furniture
Makers' Golden Jubilee Award for seating for the
Wallace Collection. He has taught design at Central
St Martins, Buckinghamshire, Rycotewood, Leicester
and Birmingham, and acted as External Assessor for
Buckinghamshire and Manchester. Joining the Art
Workers Guild in 2005, he has designed and made the
committee table and chairs in the Gradidge Room at
6 Queen Square.

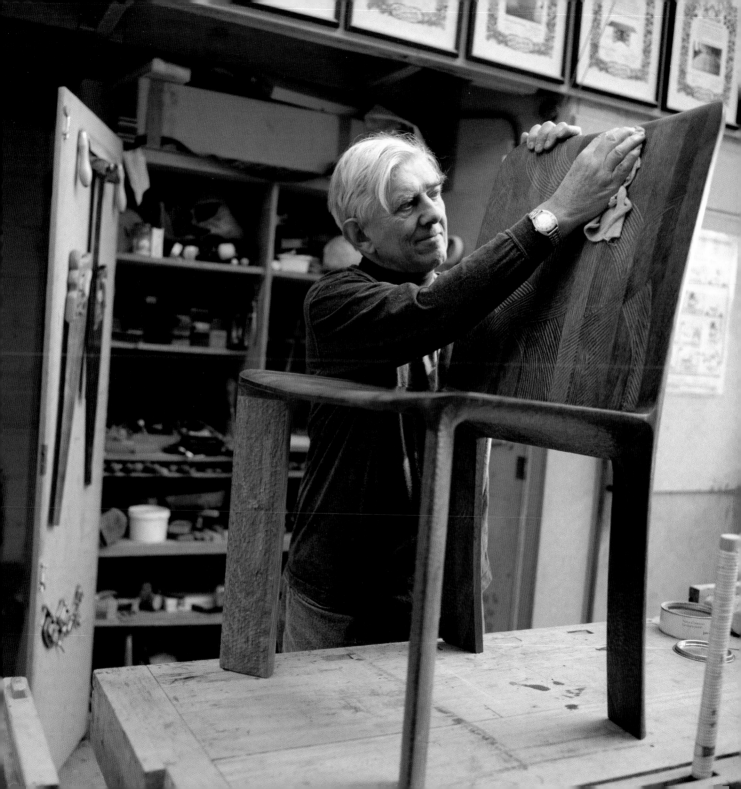

# Josephine Harris
## Glass Engraver

JOSEPHINE'S 'ONE OFF' COMMISSIONS IN ENGRAVED GLASS ARE about celebration and commemoration, and she loves the challenge and discipline of creating ideas relating to the demands of a brief.

Her career began with a four-year course at the Plymouth College of Art. Her mentor, William Mann ARCA, opened her eyes to observation and detail of character, which continue to inspire her. She was awarded the National Diploma in Art & Design.

Josephine worked at Plymouth City Art Gallery for three years, which gave her an insight into the art scene as revealed by Travelling Arts Council Exhibitions organised by Sir Kenneth Clark. She then moved to London, where she had a job at the Royal Academy of Arts working in the Schools. She was surrounded by established artists and very gifted students, which gave her tremendous encouragement to produce her own work. She exhibited and sold widely. At that time she was elected to the Royal Watercolour Society and the New English Art Club, also exhibiting regularly at the Royal Academy Summer Exhibitions.

Josephine discovered glass while at the Royal Academy and went to part-time classes under Peter Dreiser. She was elected a Fellow of the Guild of Glass Engravers. She then went freelance and set up her own studio, working mostly for private clients, public companies and the Church. The initial interaction with clients, the discipline, focus and deadlines, opened up a strong new structure which she continues to find intriguing. Josephine was elected to the Art Workers Guild and became Master for 1997.

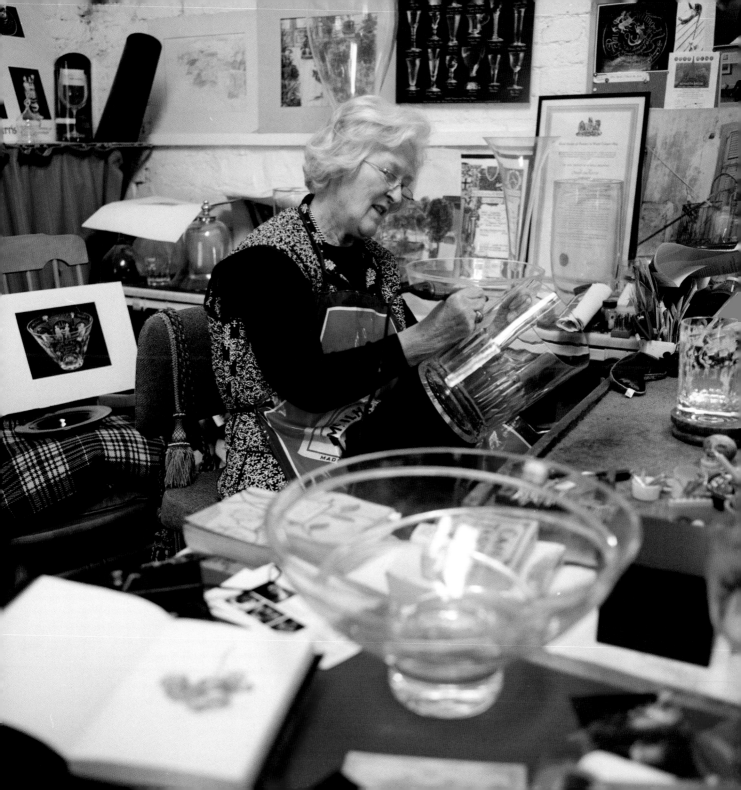

# James Hart-Dyke
**Artist**

OVERLOOKING A FRENETICALLY BUSY RAILWAY LINE NEAR
Tate Modern, James Hart-Dyke's studio window-ledge
houses a flourishing geranium fed on rabbit skin glue.
His studio is the base to which he returns from the far-
flung locations he visits in the course of his frequently
dangerous but exhilarating working life.

He is a landscape painter, mainly of mountains. His
other subjects include country houses in their landscape
settings and, as a contrast, dramatic scenes of war zones
such as Baghdad. He also paints portraits.

His training began on the architecture course at the
Royal College of Art. Alongside his talent for drawing,
he has always had a taste for physical adventure –
jumping out of aeroplanes, for example – and he tries
to marry the two in his work.

James packs his painting kit into a rucksack and departs
for what can easily become a month of travelling – 'a
week to get there, a week to find the subject, a week
to make the studies, and a week to get back'. The
studies he brings back consist mainly of sketches,
photographs and sound and video recordings.  Few
commissions are entirely straightforward. He might
be asked to paint the essence of a mountain – a blur of
shimmering light, for example – rather than a detailed
representation. Another client might want the image
for a logo or mascot, or to represent their historical or
geographical origins.  The subject lends itself to multiple
interpretations of this sort, for while all mountains
are obviously very different, there is no simple way of
defining them – they change dramatically whenever you
change the viewpoint.

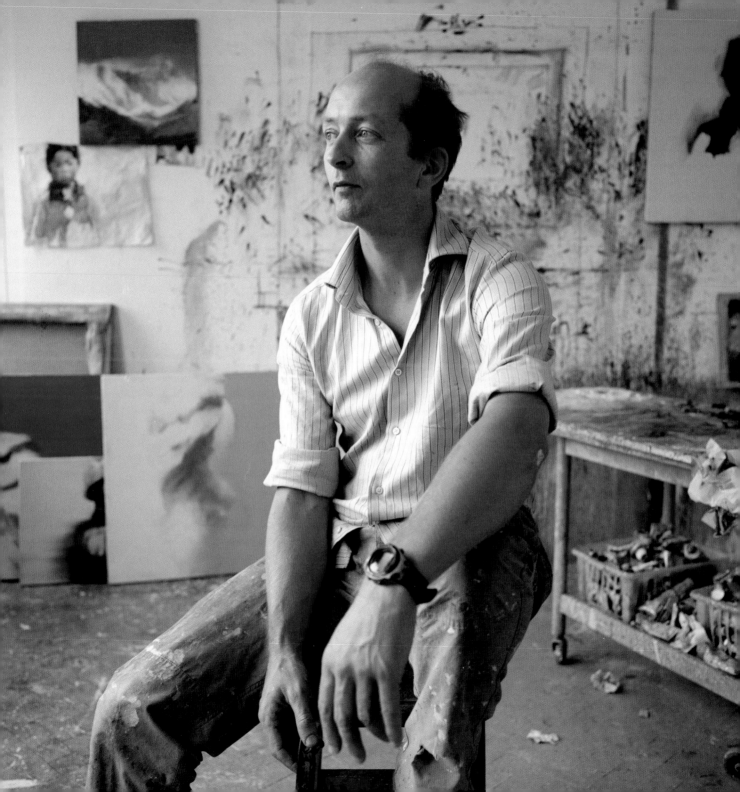

# Peter Hayes
**Ceramicist**

LOOKING OVER THE CLEVELAND BRIDGE IN THE CENTRE of Bath, you might spot Peter Hayes, working on his ceramic sculptures in the yard alongside his kiln and glazing studio.

Peter has worked on the banks of the Avon since 1982, when he found the old toll lodges deserted. One now houses his studio and showroom, while in a workshop on a farm his son Justin fires his larger pieces and runs the business side of things.

As a child Peter used to visit museums and find inspiration in wonderful ancient pots, marked by the indented fingerprints of their makers, and even today he keeps a clay chart of his own fingerprints among the curiosities that line the walls of his home. He has travelled widely, working with indigenous potters such as the Pueblo, Basotho, and Zulu, sharing their traditional techniques and finding that many of his own methods are derived from their ancient traditions.

The local clay – Peter's favourite material – holds an assortment of debris left by the Victorian canal-builders, as well as roots and pockets of glass, all of which can make firing excitingly unpredictable. Among his pieces is a group of standing stones made of canal clay mixed with glass, with a surface of black copper and magnesium.

Far from being restrictive, traditional techniques can be used to create works that are fresh and original. 'I make things,' says Peter, 'and hopefully occasionally I make nice things, and they are the ones that survive.'

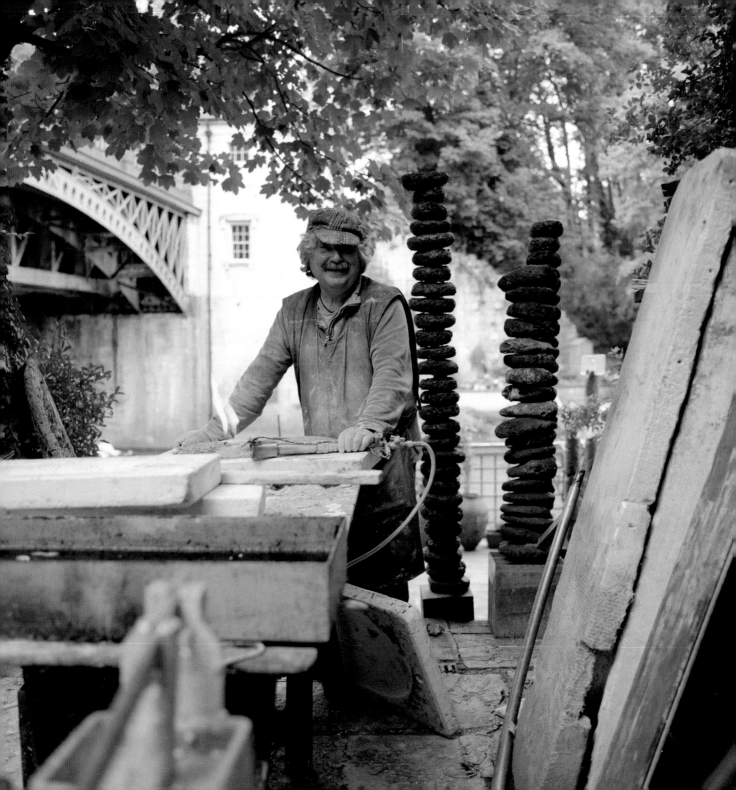

# Charles Hazzard
**Sculptor**

OFF THE BUSY A46 NEAR EVESHAM, I FIND CHARLES HAZZARD in five large bays of garages somewhere near a farm. We are surrounded by cast figures and a large wooden structure, lit by sunlight coming through the skylights. When the sliding doors are pulled back plastic screens keep out the cold.

Charles came home to Evesham after doing a stint in London and working for three years at Loughborough on a Henry Moore Fellowship. Despite the rush of passing cars, he is completely isolated: there is a petrol station down the road but it's quite a walk. He can concentrate on the job in hand and once he is focused the time goes quickly.

Charles is interested in the human condition, and the work is not created with a market in mind. Sometimes his figures are nude, or they deal with subject matter of no obvious commercial appeal, such as Down's Syndrome and Bi-polar disorder.

He works from observation with a life model, starting with clay then going on to cast in fibreglass resin. Although many other sculptors prefer to make their final casting in bronze, he is happy to use fibreglass for the finished work.

Along with figurative art, Charles is interested in architecture, which is reflected in his work. He often employs assistants, depending upon the particular requirements of the exhibitions and projects he has underway. What is essential is that whoever he works with knows what he is doing and has an interest in and understanding of the idea.

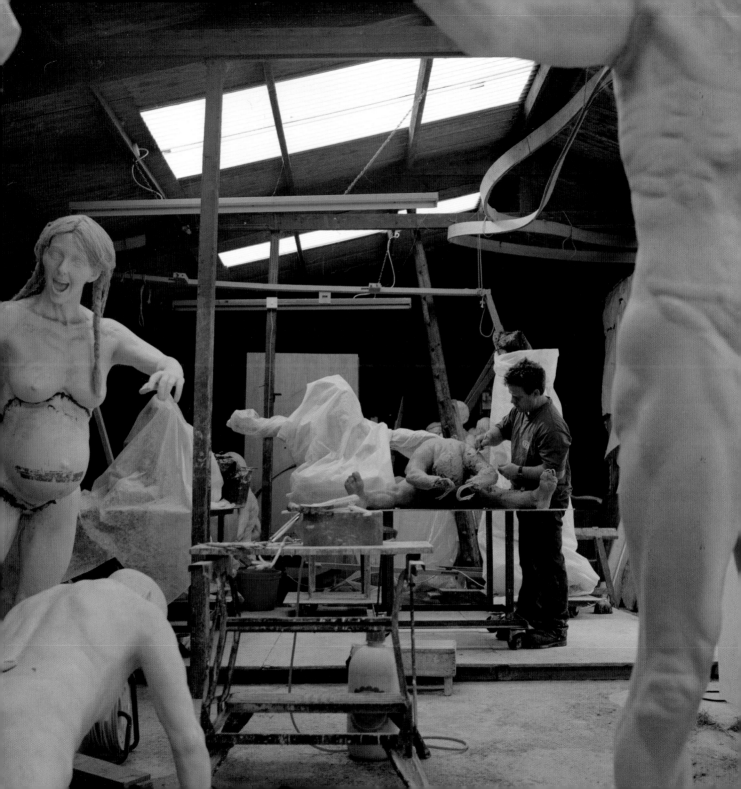

# Regina Heinz
## Ceramicist

REGINA'S STUDIO, WHICH SHE SHARES WITH PRUE COOPER, has large windows looking out onto trees and sky, a reminder in urban Wandsworth of her childhood in the Austrian countryside.

Her inspiration comes from the landscape, although her work has become more abstract over the years. She began as a painter, but on holiday one summer in Portugal she visited a ceramics biennale exhibition and realised what could be done with clay.

She sees her work as three-dimensional paintings. Clay slabs are pushed and coaxed into undulating forms and brushed and decorated with colour and geometric designs. Abstract and modernist painters like Piet Mondrian and Paul Klee and minimal artists like Eva Hesse inform her work rather than the ceramic tradition.

Regina works for exhibitions as well as to commission for domestic and public spaces. While her pieces are usually displayed indoors, an installation she made for a sculpture garden in Devon has inspired her to create more outdoor versions of her work. The experience of working with prefabricated components in a brick factory in China in 2008 prompted her most recent development. Multiples, cast from moulds and painted with vibrant colours, form the basis of modular wall panels and allow site-specific applications from small to large scale in both interior and exterior settings.

Regina's work never stagnates; her literal journey from rural Austria to metropolitan London, where she trained as a ceramicist, is reflected in the inner journey she has undertaken in her art.

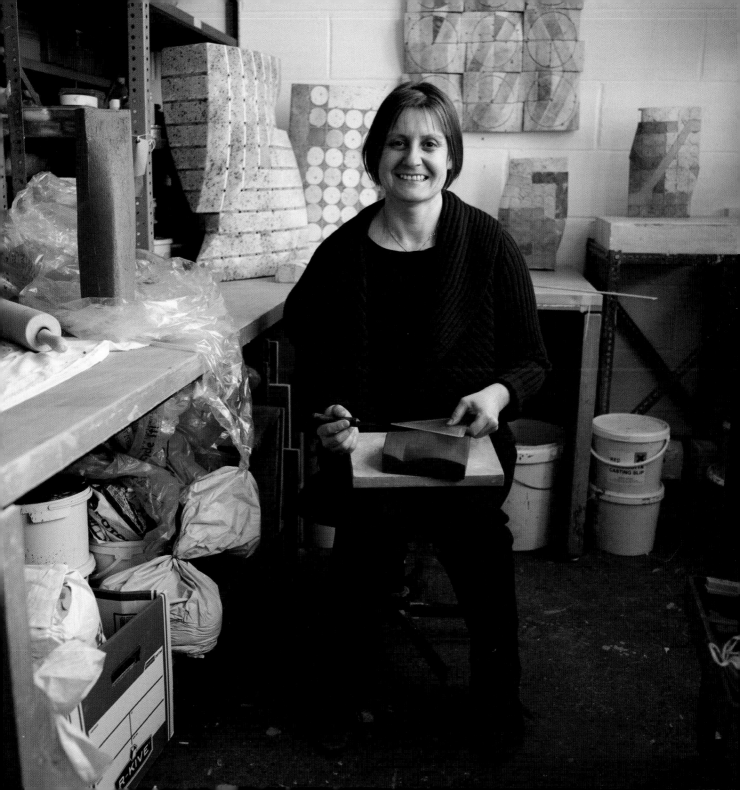

# Anne Hickmott

## Printmaker

ANNE HICKMOTT IS SEEN HERE PRINTING A LINOCUT ON THE Albion press at the William Morris Society, now housed in the domestic quarters of Morris's London home, Kelmscott House in Hammersmith. Anne is currently Artist in Residence in this inspiring atmosphere. The views around Kelmscott House are particularly stunning and she regularly draws upon them for her work.

Anne, who was Honorary Treasurer of the AWG for three years, first earned her living as a graphic designer and photographer and later as a full-time lecturer. She has always had a passion for flowers, which are a distinctive feature of her prints.

She works at Kelmscott House as often as possible, but also uses other workshops where she can print on a larger scale. Her printing tools are kept in a trolley so that she can bring everything with her to each location. 'I often use unorthodox things like electric drills or old kitchen skewers – nothing is sacred – and I use sandpaper to get a textured effect,' she tells me. 'You can use wax as the resist and to get all sorts of textures.'

Anne demonstrates printing to visitors at the William Morris Society, but does not often lecture these days. She simply wants to get on and print. Edward Bawden, her one-time tutor at the RCA, remains a source of inspiration. 'Perhaps,' she says, 'his words of encouragement are coming home to roost.'

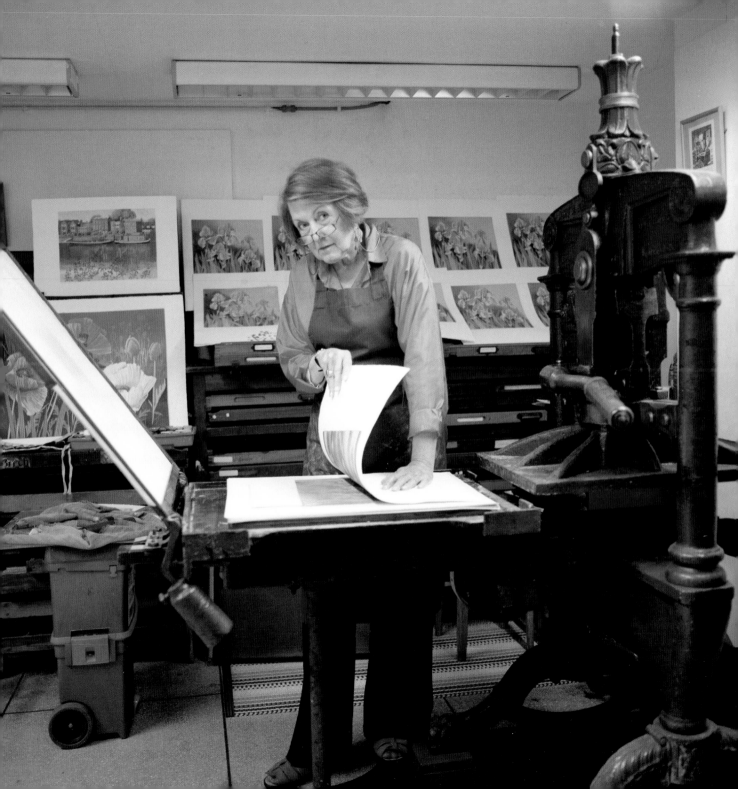

# Mark Hoare
## Architectural Designer and Painter

MARK HOARE'S HOUSE IN SUFFOLK HAS A LOT OF HIM IN it – he and his wife Kate spent three years camping in the handsome timber-framed shell as they worked with builders to strip away post-war layers, uncover lost windows, and reconstruct with a combination of traditional and new ecological materials.

At school Mark wanted to go into stage-set design. While studying Classics at university he also built theatre sets, but was always saddened when his work had to be dismantled after each show. A lecture from Patrick Nuttgens on Antoni Gaudí sparked off an interest in building with recycled materials, and the Prince of Wales's book *A Vision of Britain* further opened his eyes to the possibilities of architecture. He took a foundation course at the Prince of Wales's Institute in the 1990s, then worked for seven years for Charles Morris while studying part-time for an architecture degree and diploma at the University of Greenwich. In 2004 he was a SPAB Lethaby scholar, meeting and working with craft practitioners. Recently he joined other Guild members at the firm of Robert Adam Architects.

He draws by hand and with watercolour, but equally enjoys building and site supervision. He has always been interested in vernacular architecture– humble buildings like the cottage – and now that he has young children he thinks a lot more about how houses are used.

I leave him lovingly applying lime plaster (the SPAB's favourite material) to an area of cottage wall.

118

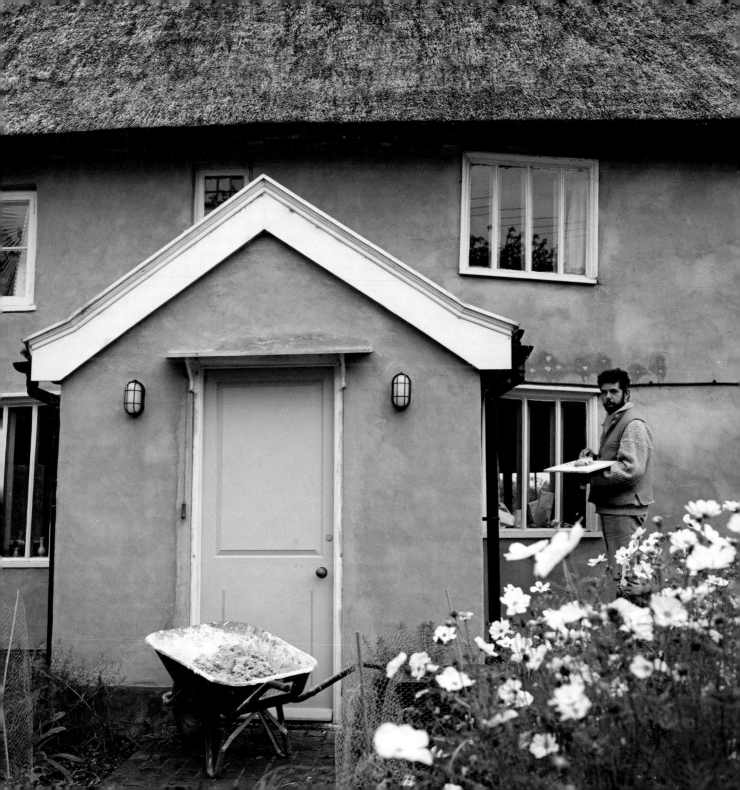

# Eileen Hogan
## Painter

WHILST STILL A SCHOOLGIRL, EILEEN HOGAN ATTENDED
Saturday classes at Camberwell School of Arts and
Crafts, and at the age of 15 was offered a place on the
Foundation Course.  Robert Medley, Head of Painting,
was himself an early influence, and also provided his
students with an eclectic mix of visiting lecturers,
including Frank Auerbach, Ronald Kitaj, Anthony Fry,
Patrick Procktor and Euan Uglow.

Eileen remembers the atmosphere vividly. 'Euan Uglow
would have a model in for several months.  The model
would keep the same pose, and we would all draw
intensely and slowly.  Auerbach would be different. He
would draw in the studio, charcoal flying everywhere,
and we'd work in a haze of dust.'

Eileen's fellow students were all male apart from two
other women, Maggi Hambling and Janet Dixon.
'Women were not exactly looked down upon, but
they were not taken very seriously.  It is considerably
different now to the way it was in the mid-60s.'

Throughout Eileen's career her paintings have related
to places which have significance for her, and she will
often develop specific subjects over a number of years.
Recent projects include a  series of paintings relating to
Ian Hamilton Finlay's garden Little Sparta in Scotland,
and her 'Four Squares' group, which is centred on the
London garden squares near to her current home.  The
human figure features in many of her paintings and in
particular her portrait triptychs, which include Ian
Hamilton Finlay, Peter Carrington and Betty Jackson.

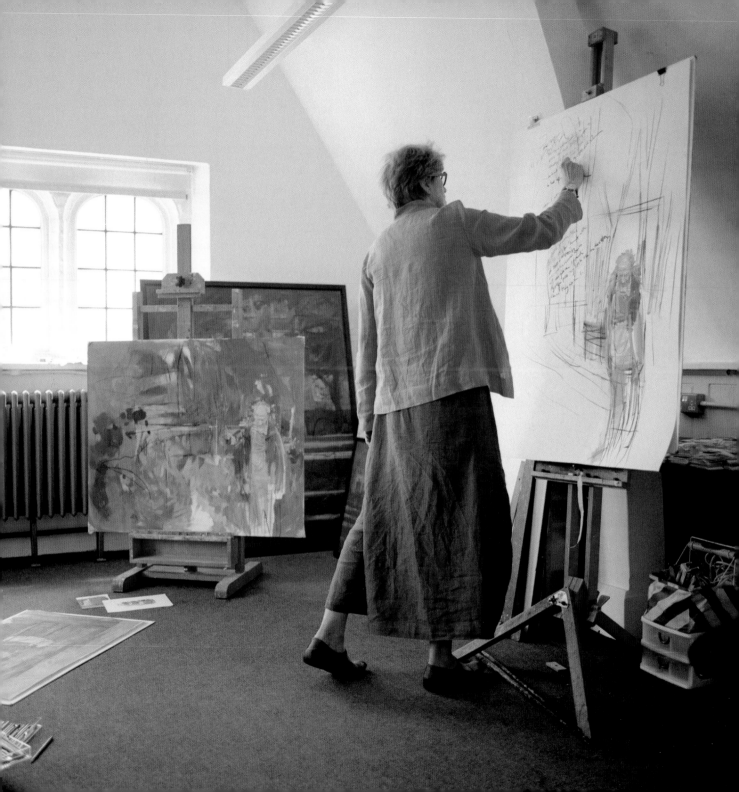

# Ashley Howard
**Ceramicist**

ASHLEY HOWARD IS SEEN HERE WORKING ON THE SERIES OF drawings for 'Ritual and Setting', an exhibition of work made for and inspired by Winchester Cathedral, which was held in Winchester Cathedral in 2009, moving later to the Crafts Study Centre. Ashley lectures at the University for the Creative Arts, Farnham.

Whether working for specific exhibitions or not, Ashley constantly draws out his ideas. Having done that, he says, 'I try to capture the same sort of freedom of line in the way that I treat the clay. You can see when you look at that free, soft clay … there is an energy and a sense of movement, and that is what I want to try to create – a dialogue between those drawings and the clay, so that it becomes a closer relationship than just sketching and then trying to replicate exactly what I have sketched. It is more about capturing the spirit.'

Ashley studied initially at the University for the Creative Arts, Rochester. In 2001 he returned to full-time study at the Royal College of Art. The ambitious 'Ritual and Setting' mentioned earlier is his most recent project. The supporting catalogue includes articles by Professor Simon Olding, Professor Magdalene Odundo OBE and Amanda Fielding.

Ashley produces porcelain and stoneware vessels in two distinct areas: a range of tableware informed by a dialogue between Far Eastern and homespun pottery traditions, and one-off pieces that draw on his interest in ritual vessels, the spaces they occupy and the ceremonies that surround them.

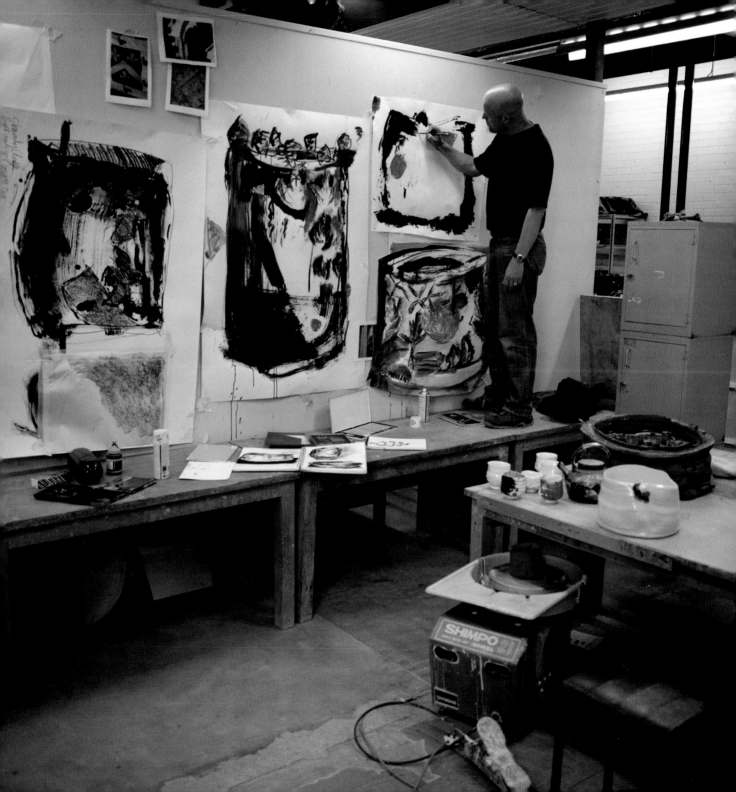

# Luke Hughes
**Furniture Designer and Furniture Maker**

LUKE HUGHES IS SEEN HERE IN THE LIBRARY OF HIS FAMILY home of Old Wardour House where he and his family moved in 1997. He commissioned an extension to the 17th-century house from the architect Eric Parry, and light floods in where previously it was dark.

Luke is a man of many talents. He went to sea in the Merchant Navy, studied art history at Cambridge and his hobby is mountaineering to the highest levels. In school and university vacations he worked with the Dorset harpsichord maker, Mike Johnson, and for three years on building sites as a carpenter. In 1981 he set up a small workshop in Covent Garden, where his studio is still based. It has grown from a craft workshop to a major business creating tailor-made interiors and furniture, mostly for public buildings and corporate clients, including 50 Oxford and Cambridge colleges, 40 parish churches, eight cathedrals, five Royal Palaces, two synagogues and more than 700 boardrooms for major city companies. In any building of quality the connection between architecture and furniture should be seamless, functionally and aesthetically. Inappropriate furniture destroys the effect of great architecture. The skill lies in matching the two.

As Chairman of Trustees of the Art Workers Guild Luke has helped the Guild to raise its ambitions from the mid-1990s onwards through his understanding of business planning and management. During this period the upper levels of the Queen Square building have been refurbished to yield higher rents, so that the first floor could be taken into Guild use for the first time.

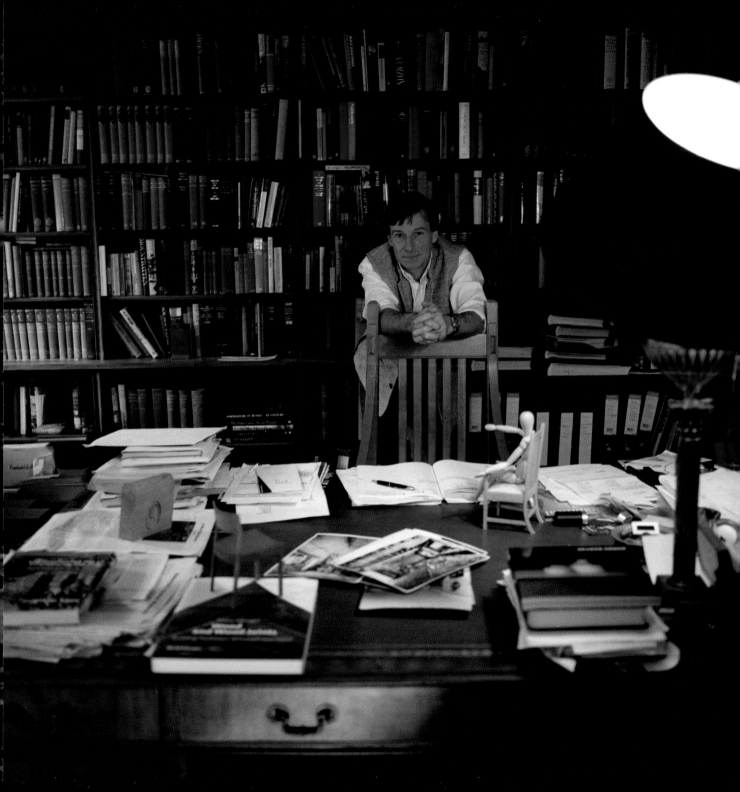

# Simon Hurst
## Architect

SIMON HURST began his architectural studies at the University of Bath, which gave him a sound technical knowledge, but not the historically informed hands-on approach he wanted. Thinking of abandoning architecture, he discovered the Prince of Wales's Institute of Architecture, enrolled for the diploma, and everything changed.

At the Institute he was encouraged to explore painting, sculpture and life-drawing while studying a variety of traditional building crafts such as thatching. During a year out working for the classical architect John Simpson he became involved in the reinstatement of a John Soane interior, which aroused a passion for Soane's work. In 1998 he won the SPAB Lethaby scholarship, which gave him the opportunity to study traditional buildings and their conservation with architects and craftsmen, and practise using traditional skills on site. Together the scholarship and the Institute prepared him to discuss and supervise construction detail without having to rely on abstract knowledge derived from drawings alone.

Over the last seven years Simon has worked on projects ranging from a classical garden shed to the multi-million-pound refurbishment of a 17th-century townhouse. Working with old buildings allows him to draw from tradition to develop a fresh and original architectural language that at the same time responds to and connects with the past. 'I can't imagine ever retiring,' he says. He plans to divide his time now between architecture and crafts – painting, sculpting, woodworking and stained glass making – much like the first generation of Guild members.

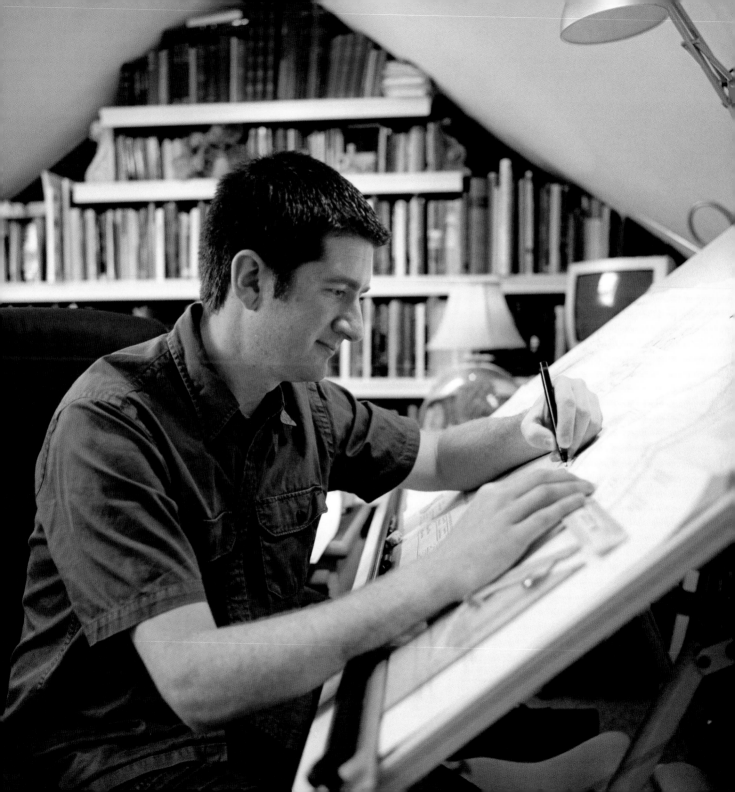

# Polly Ionides
## Sculptor

POLLY IONIDES, DIRECT STONE CARVER AND SCULPTOR IN
bronze, has had her eye on a piece of Swaledale fossil
stone for quite some time. Today she has finally lifted
it into her workshop – a renovated coal shed from
days when ships came right into the Norfolk village
of Burnham Norton – to decide what form is lurking
inside.

Since leaving the Slade in the mid-1960s, Polly has never
lost the thrill of working with stone. Her sculptures
explore the origins of growth and the emergence of
positive form. The work has always had an element of
simplicity and becomes ever simpler over time.

Much of her work involves designing pieces for the
homes and gardens of private individuals. She prepares
for a commission by getting to know the client, their
house and garden and the significant things in their life,
and the sculpture emerges naturally out of that process.
Recently she made a sculpture for a scientist as a subtle
memorial for his mother, who was a classical scholar,
arriving at an image of Terpsichore, the classical muse of
dance, in the form of a Fibonacci spiral.

Polly admires primitive art, Epstein, Brancusi and
Eric Gill. She finds inspiration in natural objects –
broken shells and pebbles on the beach. She has run
workshops, both in New Mexico and in her studio. She
is, she says, 'a great believer in showing people how to
handle the tools and materials, and then letting them
get on with it'.

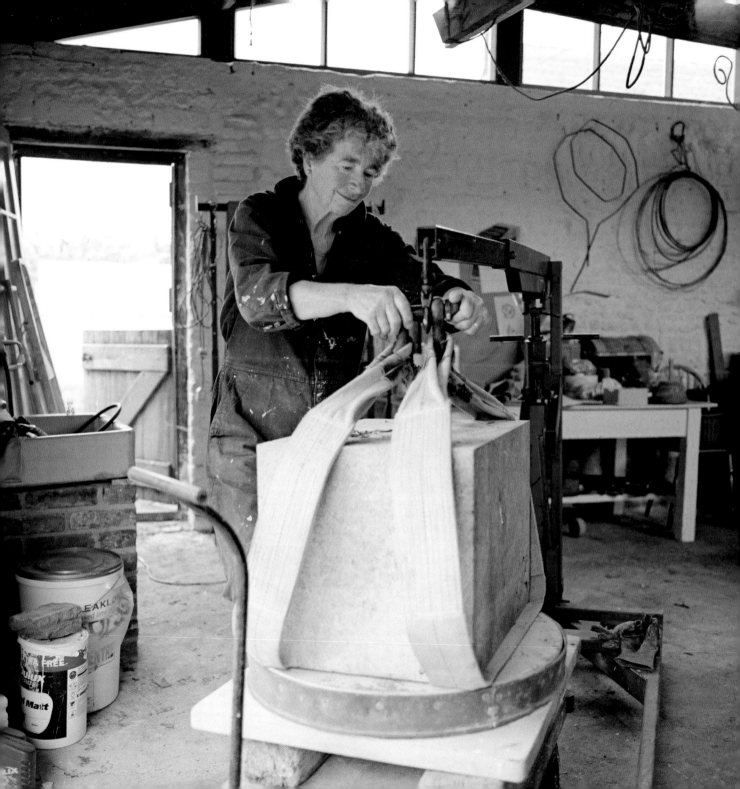

# Paul Jakeman
**Stone Carver**

PAUL JAKEMAN HAD A PREMONITION OF HIS FUTURE CAREER
when, at the age of ten, he carved a piece of chalk. After
school, working as a bricklayer, he would often look up
at the gargoyles on churches and think, 'I would love to
do something like that.'

He went on to do courses in masonry and carving.
While at the City & Guilds of London Art School, Paul
met fellow Guild members Simon Smith and Phil Surey,
with whom he now shares a workspace in New Cross.

Paul's most recent job was carving the Atlas Fountain
seen in this photograph. The fountain is in the
Elizabethan garden at Kenilworth Castle and was
modelled by another Guild member Tim Crawley.
A few years ago Paul and Tim worked together on
the restoration of the Beasts of Bloomsbury: the lions
and unicorns adorning the spire of Hawksmoor's St
George's Church in Bloomsbury Way. Paul carved the
south-east-facing unicorn visible from New Oxford
Street.

Commissions, exhibitions and visits to buildings all
provide ideas, which he translates into drawings and
clay models against the day when he will have time to
develop them. While valuing restorative work, Paul
would love to see architects use decorative carving
in modern buildings, making it fashionable again in a
contemporary way. He sometimes thinks he should
have been born a century ago, when carving was a
real industry. Nonetheless he gets plenty of work, and
regards his occupation as a vocation. He gets great
satisfaction from knowing that something he has carved
will still be there for others to appreciate long into
the future.

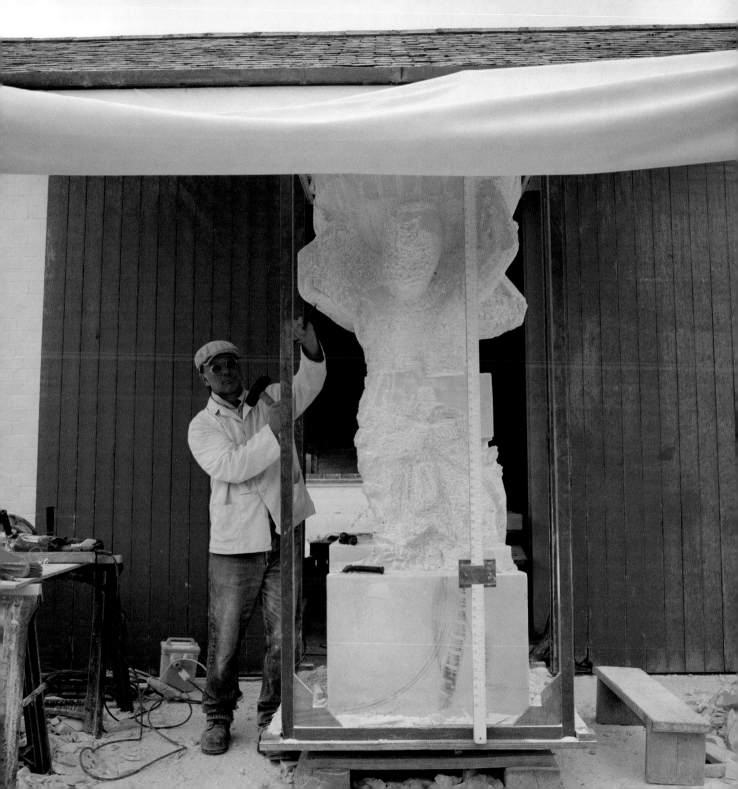

# Catriona Jardine Brown
**Artist**

CATRIONA JARDINE BROWN HAS WORKED ACROSS A RANGE of fine art media. She studied first at Winchester and then at Edinburgh College of Art, taking a degree in Tapestry, with plenty of life-drawing. After spending several years in London pursuing a career as an artist, she moved up to Northamptonshire to work in a college as a drawing specialist and Foundation Course Leader. It is through teaching that she has developed more art and design skills and become interested in book arts, digital media and printmaking, which she studied for a Masters Degree.

Catriona thrives on 'the land' as a subject. She takes inspiration from natural forms and textures to construct imaginary worlds in paint and print that explore our narrative links to the land, and her work with school and community groups has helped others to engage with their local environment and celebrate its particularity through drawing, painting and sound.

Over the years she has also undertaken many commissions, including an illustrated family tree as well as artwork for the advertising industry, and enjoys the different creative challenges these present.

Catriona has always made art – she tells me there was never a defining moment when she made a conscious decision to become an artist. 'Creativity,' she says, 'is always something I was and am.'

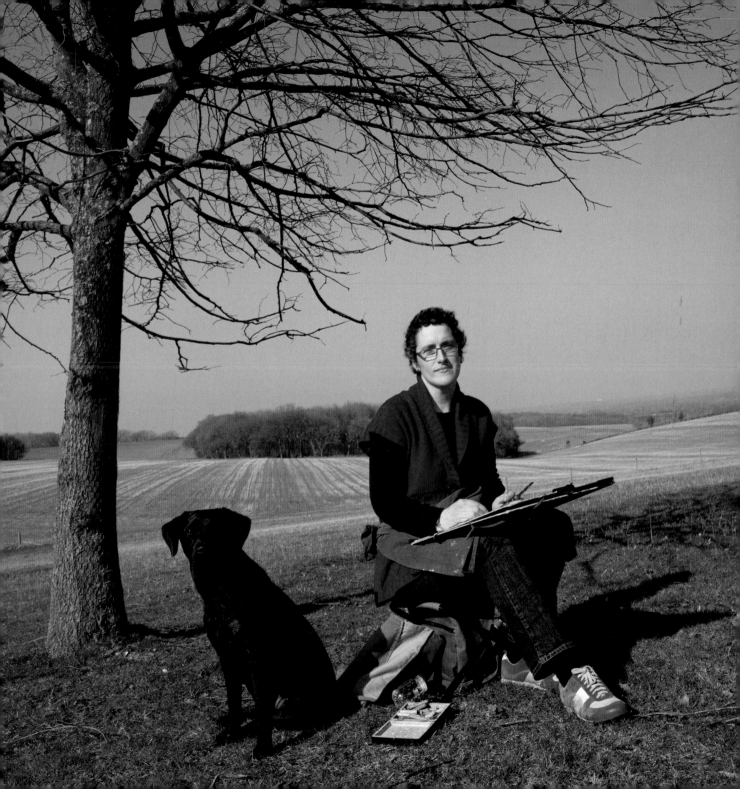

# Juliet Jeffery
## Calligrapher and Painter

Juliet Jeffery works in two areas of her home in Ludlow: the table in her dining room, where she paints her busy street and countryside scenes filled with gypsies, and the light and compact conservatory, where she produces her calligraphic work. The historic town in Shropshire attracted her chiefly because she loved its architecture.

She started out as a painter. Gypsies have always held a fascination for her, and together with buildings provide much of her subject matter. Her interest in calligraphy came out of a need to add narrative to her paintings. Combining hand-lettering with illustration seemed the natural solution. She studied the craft at Roehampton and in many workshops, and is now a Fellow of the Society of Scribes and Illuminators. Other current specialities include illustrated histories of buildings and illustrated animal-family trees.

Commissions are usually private. 'It's less frightening,' she says.

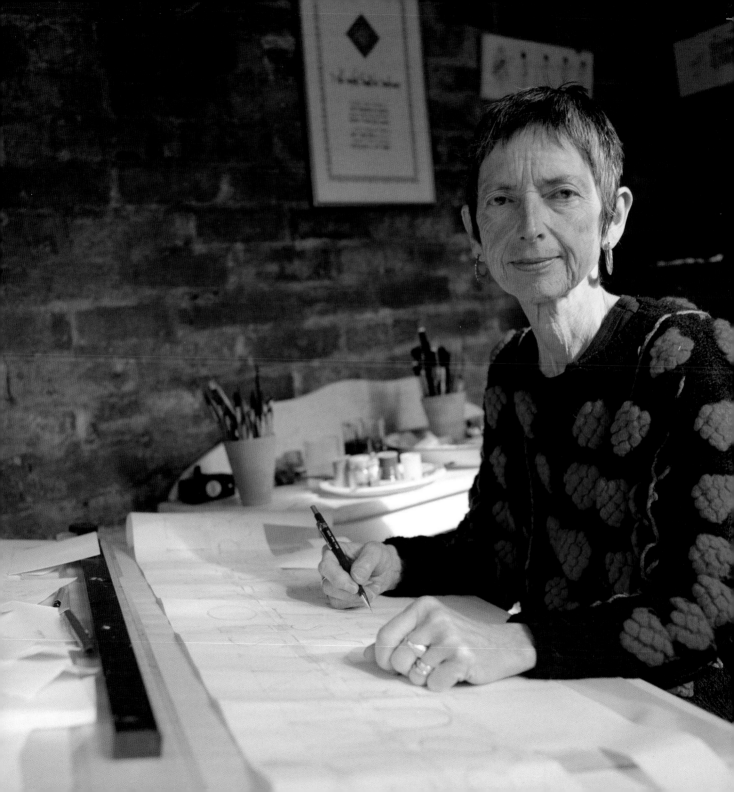

# Alison Jensen

## Painter

ALISON JENSEN IS SEEN HERE DRAWING THE CHORISTERS IN Salisbury Cathedral. She is captivated by the motivation of artist-performers, who have to practise again and again before they get it right. It is their dedication that attracts her to the subject.

Alison had a Danish father and for most of her life she has had a second home in Denmark, where much of her painting has been done. As a student both in Denmark and England, she learnt the importance of drawing the human figure. Her love of drawing was developed at the Byam Shaw School, under the tutelage of the late Brother Peter Greenham, and she went on to study at the Royal Academy Schools.

She uses oils for her commissioned portraits, whose subjects range from counts and countesses to bishops. In her drawings she likes to concentrate on capturing characters in motion, such as children, who, she says, 'make wonderful subjects but are rotten sitters'. For her it does not matter if a drawing is unfinished as long as it is legible. Rather than overwork a drawing she will sometimes work on three at the same time on the same sheet.

She first became fully aware of her passion for drawing performers of all kinds after attending a rehearsal by the violinist Yehudi Menuhin, and it is a theme that has occupied her ever since. Many of her days are spent at theatre rehearsals and productions, studying the figures on stage.

Alison Jensen has the honour of being Master of the Art Workers Guild in its 125th year 2009.

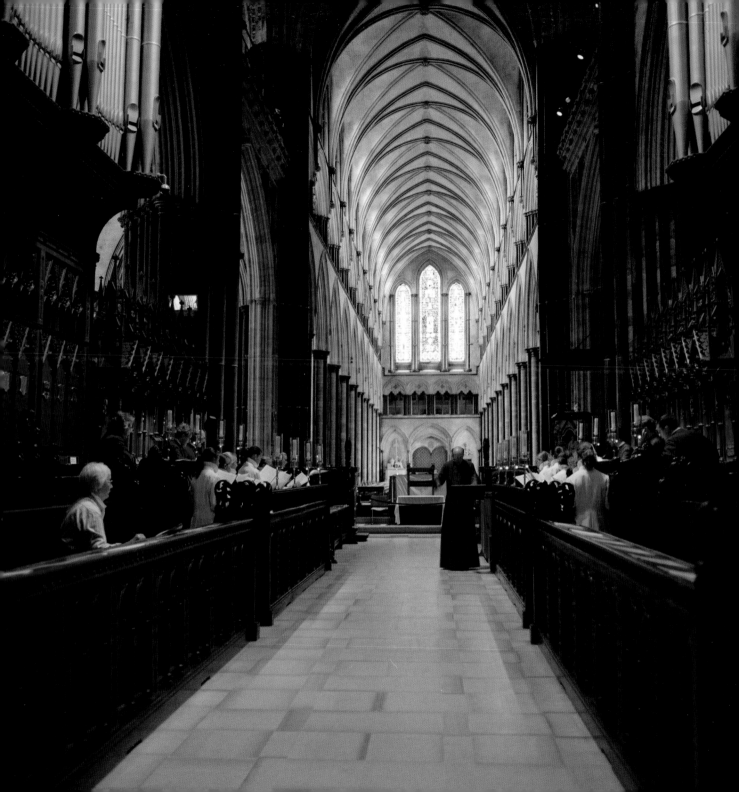

# Sarah Jones
## Silversmith

Sarah Jones works in a 1930s factory where Spitfire
parts were made during the war.

She is seen here working on a wooden log into which
she blocks the silver. Other work-benches include one
for wax modelling, one for silver jewellery and another
for bronze sculpture. There is a forge for annealing and
soldering, racking for tools and stakes, and a lathe. A
library of rubber moulds of her modelled designs is
shelved along one wall and a comprehensive assortment
of colours of powdered enamel line another.

The dogs in the photograph are Tilly and Billy.

For a decade Sarah sold her work from Camden Lock
market, then for twenty years she had two shops, one
in the City and one in the West End. She employed
numerous trainees and assistants, who were taught all
aspects of the trade and running a business. She always
loved selling direct to the public – seeing whether or
not a particular piece would sell, and getting feedback
from her customers.

Today, she is happy to work alone, selling through
her website. She prefers the balance her life has now
compared to the days when she worked seven days a
week making and selling at the market. 'Now I like it as
it is,' she says, 'still selling direct, making pieces to order
and for stock but not on the same scale as it was. There
is no stress, minimal overheads, and life is bliss.'

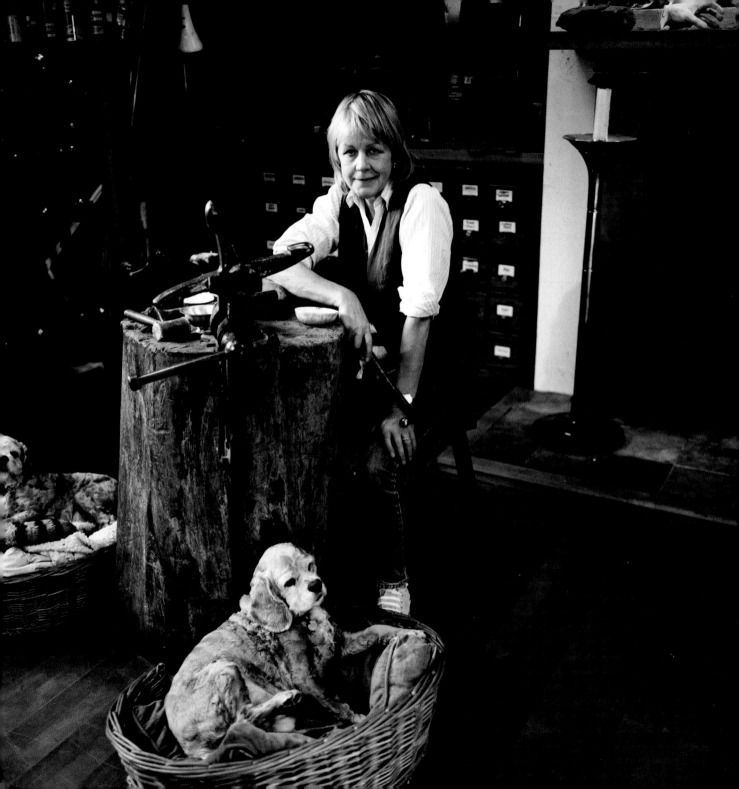

# Lida Lopes Cardozo Kindersley
## Letter Cutter

LIDA KINDERSLEY CAME FROM HOLLAND TO BE APPRENTICED in the workshop of David Kindersley, a Guild member who was taught by Eric Gill in the 1930s. Later Lida and David married and had three sons. Since David's death in 1995, Lida has maintained the reputation of the Cambridge workshop as a leader in its field.

She is strongly committed to training, taking an apprentice every year for a three-year period. In the first two months the ability of an apprentice to fit in and their commitment to the job are tested, as the sense of family cohesion in the workshop is very strong. For a letter cutter, this is your world. You work with stone the whole day long.

Lida feels privileged to be able to be allowed to cut through precious stone taken from the earth. She believes that there really must be a good reason to cut into the stone, and that the words must mean something substantial. Each job is carefully worked on together. Everyone is at a different stage and the team help each other to achieve the best.

Each member of the workshop taps gently away in a concentrated stillness, with a personal rhythm, in an environment of intense concentration.

'Beauty looks after herself.' – Eric Gill

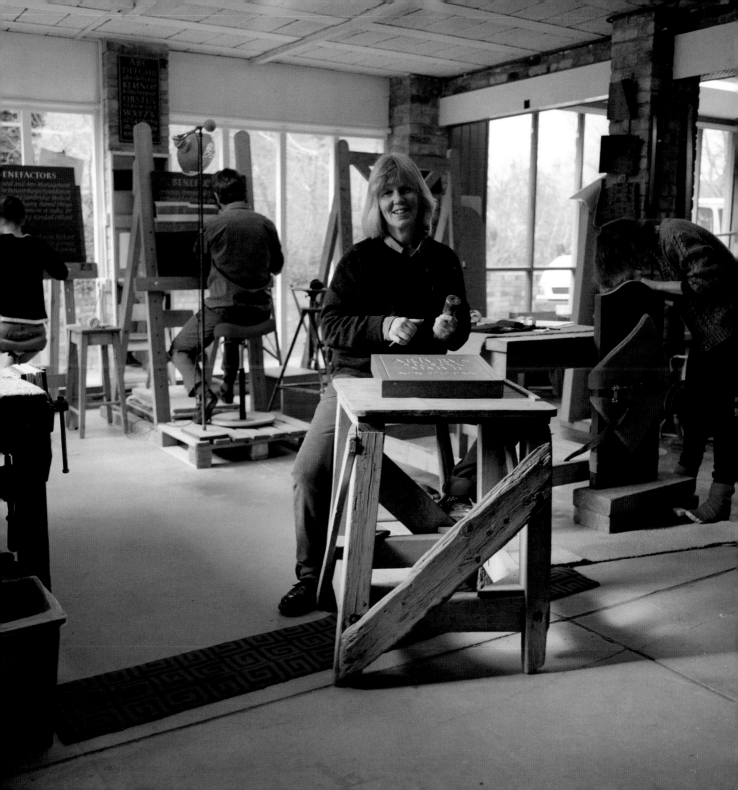

# Richard Kindersley
## Lettering Craftsman

RICHARD KINDERSLEY'S LETTERING STUDIO IN KENNINGTON
has two working environments, one for stone cutting
and the other for design. The building dates from the
1960s, and the generously proportioned space suits the
large-scale works, such as standing stones, which are a
special part of his output.

Richard was introduced to the craft by his father, David
Kindersley, one of the few letter cutters working in the
1950s in Britain. He studied lettering and sculpture at
Cambridge School of Art, before setting up his own
London studio in 1966.

His many commissions include sculpture works
for Lloyds Register of Shipping, Liverpool Crown
Court, lettering schemes for London Bridge, carved
lettering for the St John's College Cambridge Fisher
building and a relief sculpture for the John Radcliffe
Hospital, Oxford. He has won numerous brick carving
competitions and awards. His beautiful hand-carved
memorials can be found all over the British Isles.

Richard employs four assistants, usually taken straight
from college. In his informal apprenticeship system,
they learn everything they need to be able to start up on
their own.

Architectural lettering needs to respond to the
function of a building, its design and the materials of
construction. Clients often ask him to create a new font
specific to what they do. For Westminster's new Supreme
Court he designed letterforms that had a Bauhaus quality
but with a Renaissance feel. 'Calligraphy has a music
to it,' he says. 'The rhythm of good spacing has a lovely
evenness enlivened by the interplay of shape and form.'

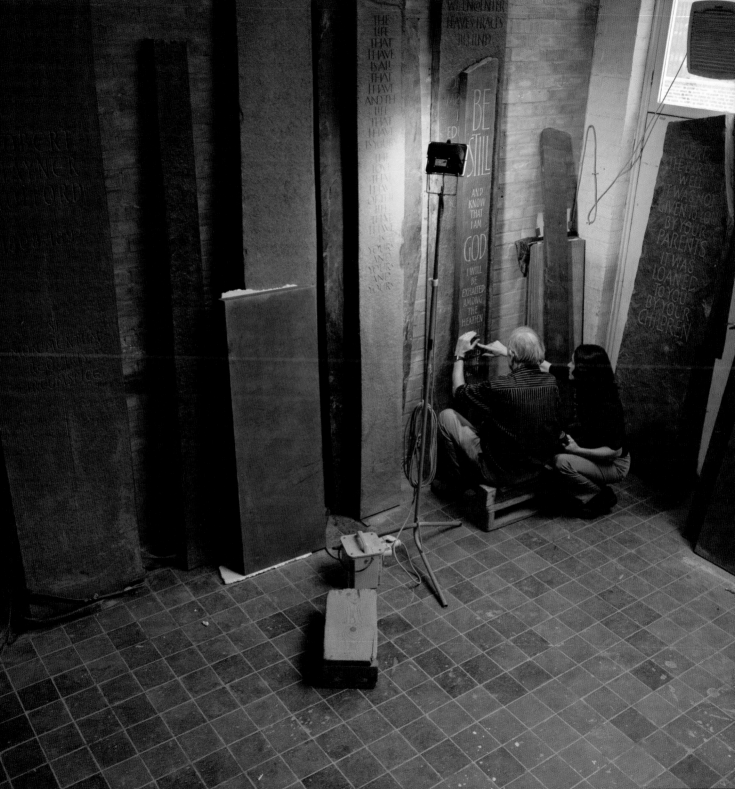

# Lucinda Lambton
## Photographer, Writer and Broadcaster

ON ARRIVAL AT LUCINDA LAMBTON'S RECTORY HOME, I am greeted by two dogs, Obadiah and Rastus. In the conservatory her husband, the distinguished journalist Peregrine Worsthorne, sits in the corner, reading the newspaper.

In 1961, with no formal training in photography, Lucinda invented a magazine, took a camera and went on a bus to Heathrow, following the Russian astronaut Yuri Gagarin around London, and making friends with him in the process. Her career in photography was off to a good start.

Working both behind and in front of the lens, nosing out historic and architectural flights of fancy, Lucinda has written and taken photographs for nine books including *Temples of Convenience*, the history of the lavatory in Britain, and *Beastly Buildings*, a book on architectural splendours for animals. She has researched, written and presented some 55 programmes for the BBC, including *On The Throne: The History of the Lavatory*, as well as a number of programmes for ITV.

Lucinda is not at all technical and may go through a ton of film, endlessly 'bracketing' her shots to have a range of light levels, just to get the one she wants. But for her that is a normal part of getting to know the subject.

Several projects are always in progress at any one time. Queen Mary's Dolls House, made in 1924 to designs by Past Master Sir Edwin Lutyens, is her current fancy, writing five little books to be sold in a cardboard model of the house.

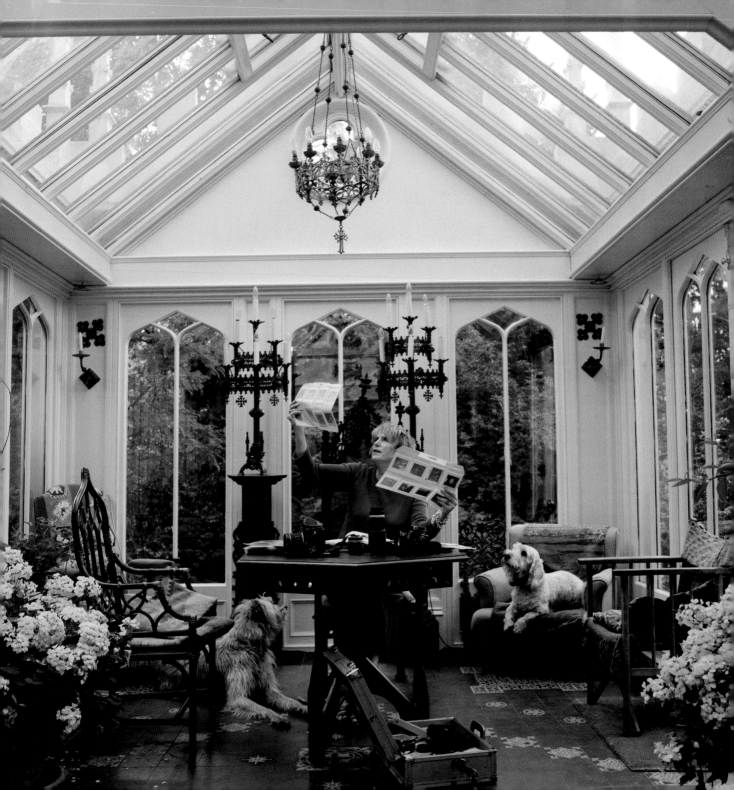

# Janice Lawrence
## Embroiderer

JANICE LAWRENCE SQUEEZES INTO HER TIGHTLY PACKED studio. The walls are lined with boxes of fabric thread; curiosities from travels abroad edge the shelves.

As a child she was always drawn to fabrics. Her mother and grandmother both embroidered. Watching her mother cut out a dress, she would covet her unwanted scraps and fragments of lace, and sometimes she rummaged through the waste of a party-dress-maker in search of the glittery bits so rare in the 1950s. The first time she seriously thought of becoming an embroiderer, however, was when she saw an exhibition of 'modern' embroideries at All Hallows, London Wall. At the time she was a student of geography at the LSE.

When she graduated she worked at the Victoria and Albert Museum, then joined a course run by Margaret Nicholson at the London College of Fashion. Involvement with a local branch of the Embroiders Guild led to the first commission for an altar frontal. Today she combines lecturing with commissioned church work and exhibiting embroideries, often inspired by her travels.

She loves using all kinds of materials and techniques, both traditional and experimental: hand and machine-stitch, metal threads, tights, sweet-wrappers, even CDs. Currently she is working on a series of landscapes based on journeys to the Arctic and Antarctic for an exhibition at the Barbican Library.

I peep inside some of her boxes, and she says that she will have difficulty remembering where I have moved everything. After that I keep my hands firmly by my side!

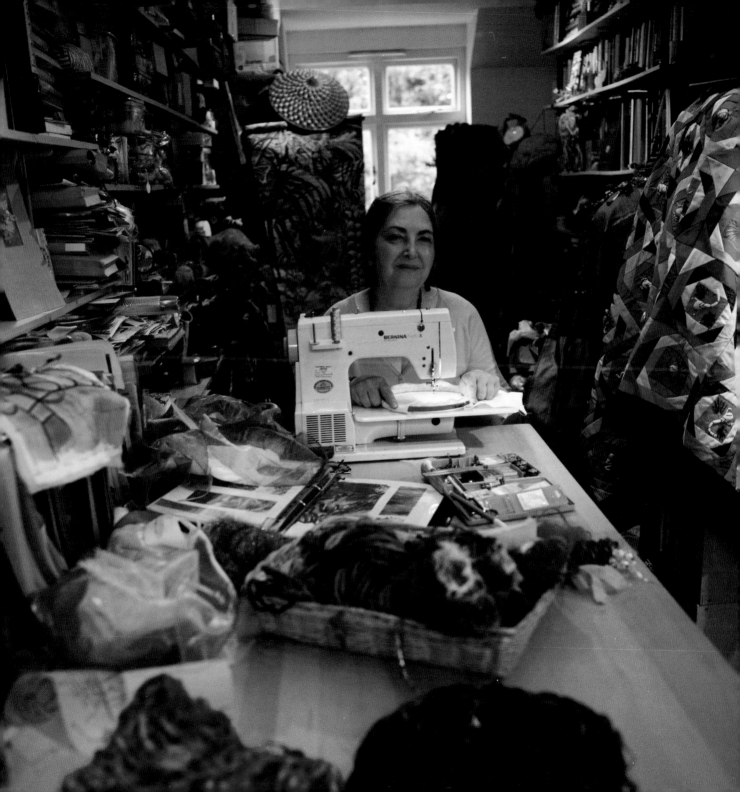

# John Lawrence
## Wood Engraver and Book Illustrator

JOHN LAWRENCE SITS AT HIS DESK WITH A LEATHER SANDBAG under a piece of vinyl, ready to make his next mark. He works on wood, vinyl and occasionally lino, displaying his engraving tools in a semicircle around the sandbag, along with a variety of mascots, paint brushes and reference drawings. An immense collection of drawings, engravings and books surround us. *The Little Chick, Tiny's Big Adventure, Seahorse* and Philip Pullman's *His Dark Materials* trilogy I recognise instantly.

Producing an engraved book is a lengthy business – two years in the case of a new edition of *Treasure Island*, which will be published in October 2009. When using vinyl he likes to work on several blocks at a time, which he then prints in colour and collages together, sometimes using wood textures. Everything starts out as a drawing, which is then reversed onto the wood, vinyl or lino. The blocks are type-high and fit comfortably onto the Albion press waiting in the corner.

Gertrude Hermes, who taught at the Central School of Art, inspired John to engrave freely and enjoy the organic quality of the material. John himself has always taught a day at college, currently Cambridge School of Art. His MA course in Children's Book Illustration includes an introduction to engraving, which to his regret is rarely taught now in Art Schools.

'There is nothing,' he says, 'as fresh as a child's drawing.' The wooden farm animals and soft birds that fill his studio indicate how closely he remains in touch with his own inner child.

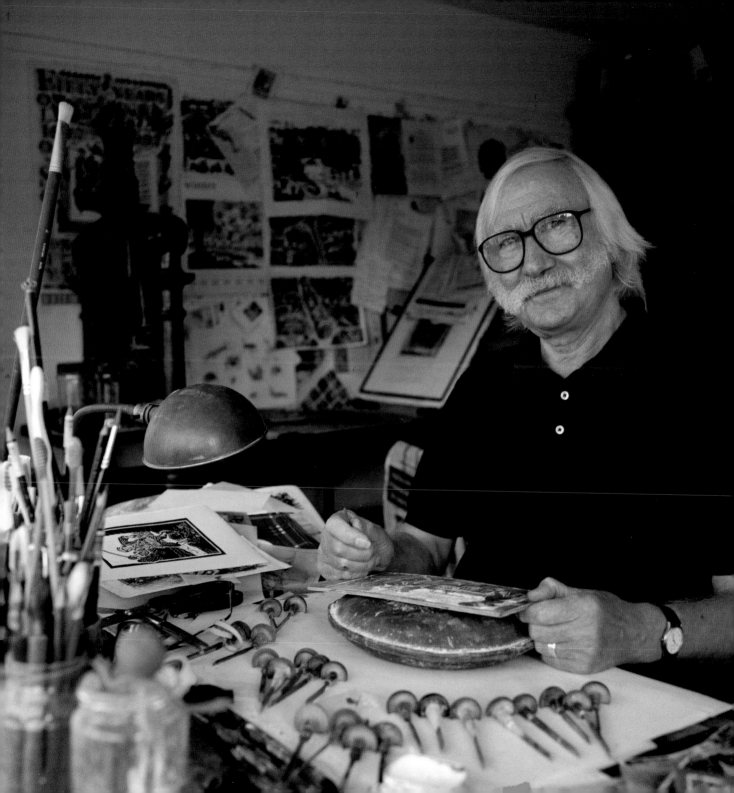

# Long and Kentish
## Architects

M. J. LONG AND ROLFE KENTISH ARE BASED IN A BOOK
bindery just off the Holloway Road in London, with
three floors and about 10-15 people working with
them.

They worked together as architects on the new British
Library with MJ's husband, the late Sir Colin St John
Wilson Forming Long and Kentish soon afterwards,
they have gone on to design the National Maritime
Museum at Falmouth. Among their smaller projects
is the scheme for alterations to the Art Workers Guild
building in Queen Square. This is designed to make
better connections between the Georgian house at the
front and the Hall behind by glazing over the courtyard,
and will also provide full disabled access to the Hall and
the first floor.

They admire architects of the past century such as Alvar
Aalto in Finland, Gunnar Asplund in Sweden, and those
of the English Arts and Crafts tradition.

Rather than having an individual house style, they work
with the specifics of each project, studying the location
of a building and its purpose, and working their scheme
up from feasibility studies through the stages of planning
approval to completed construction. All this can take
years, but they are used to that. The British Library
took 35 years on two different sites, and the Maritime
Museum took seven.

The atmosphere of their office is studious and busy,
but at the same time relaxed. I take a Polaroid of MJ
surrounded by reams of paper, which seems particularly
appropriate for a practice where the computer has not
taken over from the drawing-board.

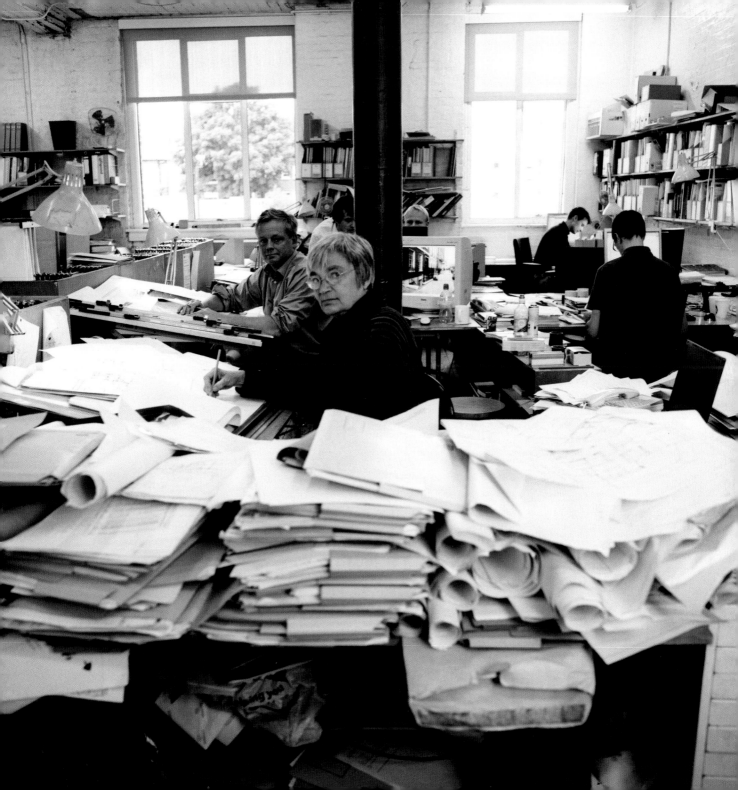

# Sue Lowday
## Leatherworker and Silversmith

SUE LOWDAY'S WORKSHOP LIES AT THE HEART OF SHEFFIELD
in a listed Victorian former comb factory. Trained as a
silversmith and jeweller, she currently works within two
disciplines, silversmithing and leatherwork.

Sue is fascinated by traditional tools and working
methods – her workshop boasts a host of hammers
hand-made for specific functions, and often she will
design a piece specially for a particular tool. Leather and
silver frequently cross over. 'If I find an interesting tool
from another discipline,' she explains, 'I will see what I
can do with it' – as for example when she uses the fly-
press for working both leather and metal.

Although Sue is an established silversmith (her work is
represented by medals, candelabra and other works in
many public collections such as Goldsmiths Hall and
Sheffield Town Hall) she has also been working with
leather for over 20 years. She loves making sculptural
one-off leather bags and mixing textures of hide and soft
leathers such as pigskin, moulding them into all kinds of
interesting and original forms.

On the workbench are strips of undyed leather and
an abundance of surgical gloves, each for a different
coloured dye, so that the pigments do not stray.
Bundles of leather lie ready to become bags. What the
photograph can't convey is the heady piquant aroma of
leather suffusing the air.

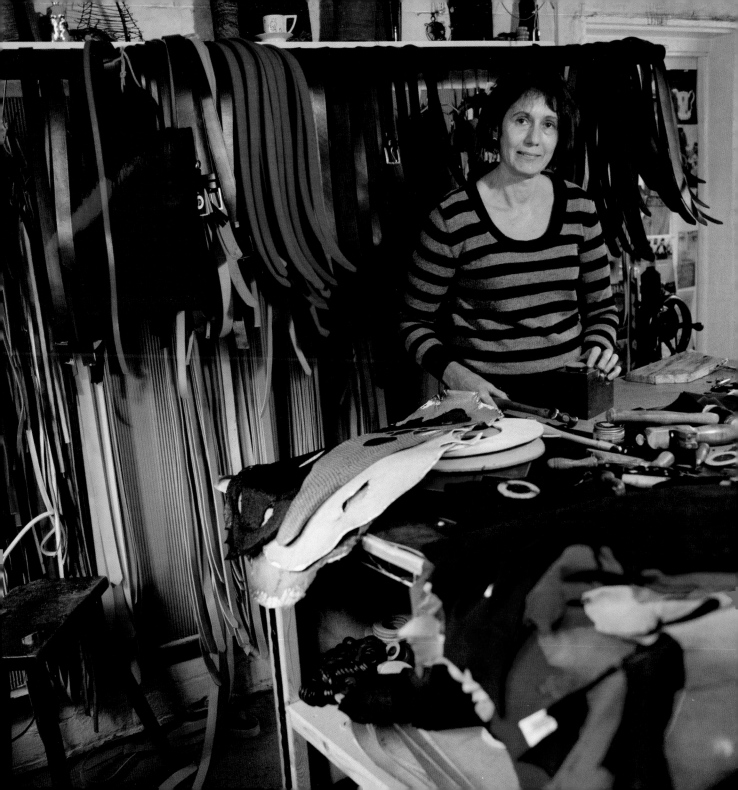

# Sophie MacCarthy
## Ceramicist

SOPHIE MACCARTHY CAME TO LONDON IN 1977 AFTER
a ceramics course in Buckinghamshire, and set up
production in an old coach house in Hackney owned by
Caroline Bousfield Gregory, where she sold directly to
the public with success. Seeking new inspiration, she
went to work for John Hinchcliffe in Dorset. He made
ceramics in a very decorative way, including big press-
moulded platters, an alternative to throwing the clay
that Sophie found stimulating.

In the 1980s there was a nostalgic taste for decoration
and Sophie's brightly coloured pieces, with depictions
of leaves and fruit, were well attuned to it. They make
you feel that the sun is shining, and have always been
priced at a level that encourages everyday use.

Sophie's grandfather was the literary critic Desmond
MacCarthy, a central figure in the Bloomsbury Group,
and Sophie became associated with Charleston
Farmhouse in Sussex when it opened to the public in
1986. She was a potter in residence, and made pieces
for their gift shop. She has avoided becoming stuck in
a Bloomsbury groove, however. She took a year off in
France to paint and draw, and took over an illustration
commission for a cookery book by Elizabeth David for
the Folio Society after the death of Glynn Boyd Harte.
Her watercolour still-life paintings of fruit, vegetables,
fish and fowl were a great success, and more volumes
have followed in the series.

'We are always developing in phases. Sometimes it is
not accepted, but I slowly make subtle changes and push
on with my own ideas.'

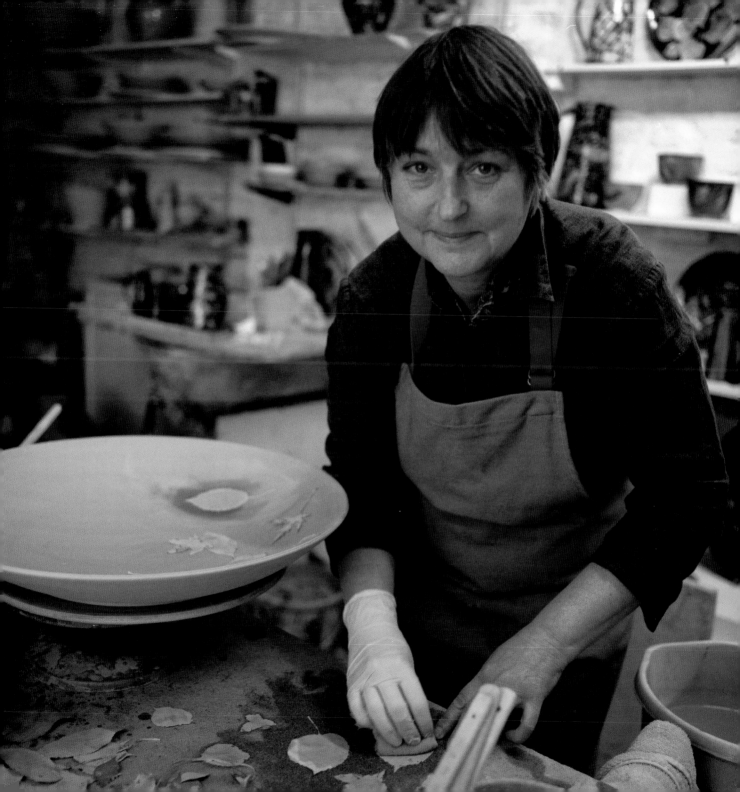

# Janet MacLeod
## Sculptor

JANET MACLEOD IS SEEN HERE IN HER GARDEN IN Cambridgeshire preparing 'Spirits of the Wood' before it goes off to Chelsea Flower Show. Her sculptures are conceived as an emotional response to a shape, line or sound from the natural world. They are mostly in bronze, but also marble and silver, and achieve a wide range of expression and textural effect. The concept of many pieces is of regeneration, new birth and the accompanying message of hope.

In the late 1970s, through the 'discovery' of clay, Janet moved from a commitment to painting to a compulsive dedication to sculpture. Her work in bronze started with dogs when, after she and her husband bought a pointer, she was asked by the breeder to sculpt her champion. It went well and was followed by other successful figurative pieces. Much of the later work has been inspired by the unique beauty of plant seeds and pods. The sculptures have a strong physical presence, but are imbued with a sense of calm and peace.

Janet's sculptures have been sold to private collectors worldwide, many of whom have returned again and again for more of her work.

About her compulsion to sculpt, Janet writes: 'From the minute a flash of inspiration enters a sculptor's psyche, from who knows where, a sculpture clamours to be born. It may take months or years to realise, but it is always there, patient but insistent. As with stone carving, the process of bronze casting is slow and meticulous, but the thrill of modelling the piece and working with the foundry to achieve the vision is incomparable.'

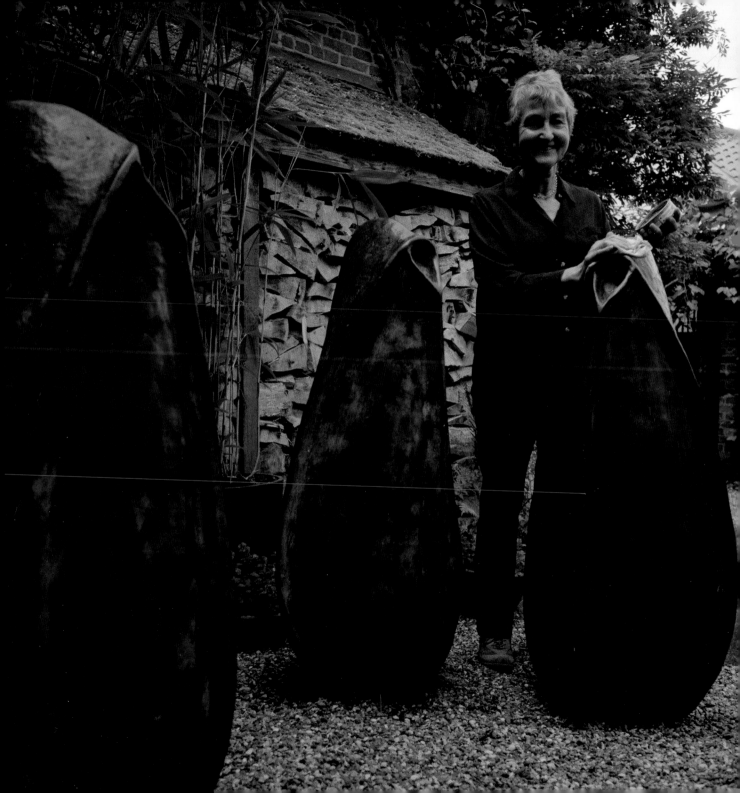

# Michael Madden

## Sculptor, Mural Painter and Wood Carver

MICHAEL MADDEN IS SEEN WORKING IN HIS STUDIO ON A high-relief mask for a wall.

He dropped out of art school to take up an apprenticeship with a specialist decorator for six-and-a-half years, working in such glamorous locations as the Ritz, the Clermont Club and the Sultan of Oman's palace on graining, marbling, gilding and mural work. Later on he enrolled at the City and Guilds Art School to extend his skills and enhance his understanding of restoration and historic art, then took a job working on exhibitions at the Natural History Museum and did a part-time MA.

He has undertaken some large and prestigious commissions. Woodcarving, which became his speciality, 'is a completely different way of looking at form from modelling – being reductive, it means one has to see in a very concise way.'

His personal, non-commissioned work displays a post-modern sense of humour. In the kitchen hangs 'Adam and Steve', a humorous take on Cranach's 'Adam and Eve' in the Courtauld Gallery. His carving 'The Almighty Cheeseburger', where God the Father holds a burger instead of an orb, is a comment on the all-pervading power of big business.

He quotes Picasso, 'Art is not truth. Art is a lie that makes us realise the truth,' and says of himself, 'I am trying to lead the viewer to a different truth by using visual paradoxes.'

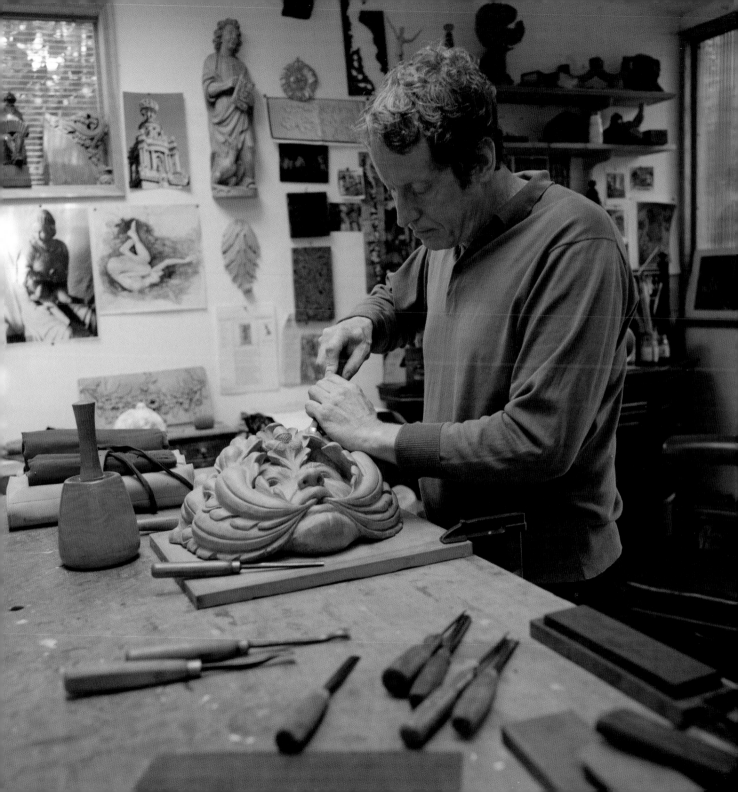

# Gareth Mason

## Ceramicist

GARETH MASON HAS HIS WORKSHOP SET UP AT HIS HOME in Alton. He is a sessional lecturer in ceramics at the University for the Creative Arts, Farnham (the same ceramics course from which he graduated in the mid-80s) and at other universities across the UK. He talks and demonstrates regularly at home and abroad.

Gareth discovered ceramics at art school, immediately relishing the extraordinary qualities of the material. Pots are now his painting surfaces, with the ceramic palette affording him a depth that paint cannot replicate. He will often fire and re-fire his work, repeatedly applying material and responding. This process imbues his work with the luminosity and volatility that only repeated exposure to flame can produce. 'It is like capturing moments,' he says.

Intense surface work and multiple firings are a convoluted process that he likens to a search, '…putting the pieces together – it is a journey.' This journey continues way beyond the ceramic fusion that is considered final in conventional pottery. 'Other qualities happen after the first glazing. Material contrasts are analogous to emotion.' We look at his pots and witness marks that he has planned and others undetermined, which are part of a process he calls 'not knowing'.

One level on which his work operates is the 'classic' form, derived from the ceramic forms that have existed throughout history, regardless of where they were made. He says these are archetypes: 'They just work. I pick up on that; the idea of a traceable ceramic lineage: echoes of it or hints of it. They represent the DNA of ceramics and the humanity of its forms.'

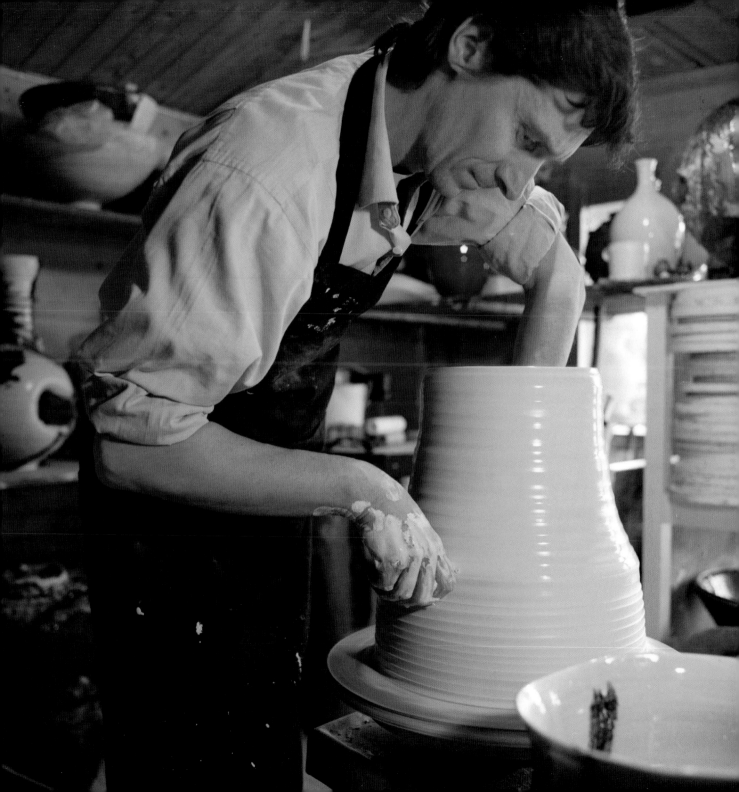

# James Mayhew
## Book Illustrator

RIMSKY-KORSAKOV PLAYS ON AN ANTIQUE GRAMOPHONE AS James Mayhew works in his studio, a small shed at the bottom of a long mature garden. Rambling shelves of books and CDs surround his desk, along with maps, inks and paints and a Pollock toy theatre.

James is working on an illustration for a new children's book, *Katie and the Water Lily Pond* – a little girl stepping inside a painting while her grandmother is asleep. Each of his 'Katie' books is illustrated in the style of a different genre in art history: Pointillism, Impressionism, the Italian Renaissance. His aim is to introduce children to the beauty of paintings that are very different from the fashionable children's illustrations of the past 20 years, in the hope that they will go on to investigate other works of art.

The idea of making high culture accessible to children runs through much of his work. His 'Ella Bella Ballerina' books, for example, tell the stories of different ballets as well as plays from Shakespeare. Often he draws for an audience of children during live concert performances. The drawings take shape as the orchestra plays, a direct visual equivalent to the music they are hearing. A recent programme by the local De Havilland Philharmonic Orchestra in nearby Hatfield included Mussorgsky's *Pictures at an Exhibition*. James shows me a collection of ten illustrations, all done in front of an eagerly watching audience while the orchestra played.

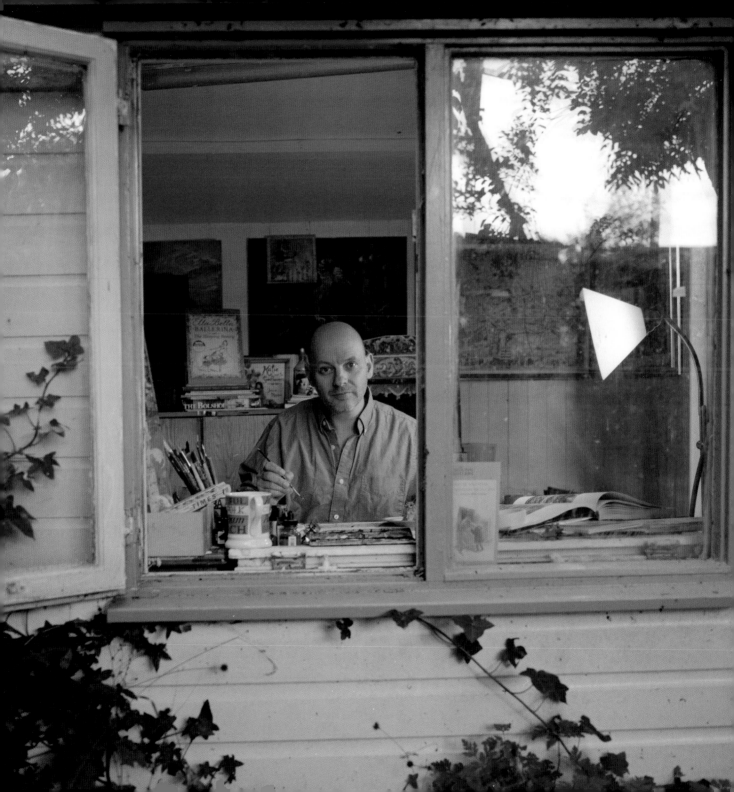

# Jane McAdam Freud
**Artist**

JANE MCADAM FREUD'S MULTI-DISCIPLINARY PRACTICE
covers drawing, printmaking, sculpture, medals and
digital media. She is the daughter of Lucian Freud and
Katherine McAdam, and her works are often inspired
by psychological concepts.

Jane exhibits both locally and internationally and her
shows are accompanied by papers and presentations.
Her film *Dead or Alive*, made in 2006, merges Jane's
sculpture with antiquities collected by her great-
grandfather Sigmund Freud.  It has been shown in
galleries and institutes in New York, Taipei and Florence,
and was also screened at her local museum in Harrow.

The project seen here shows a work resulting from
Jane's collaboration with the British Museum. Called
'Staff', this piece is inspired by the Egyptian Shabti – a
burial figure to ensure one has a servant in the afterlife,
which she paired with the figure of a neck tie. 'Staff'
symbolises the continuity of the idea of authority and
compliance.

Jane's sculpture has always been concerned with duality,
and she continues to work with pairing and the spaces
where art and psychology meet.

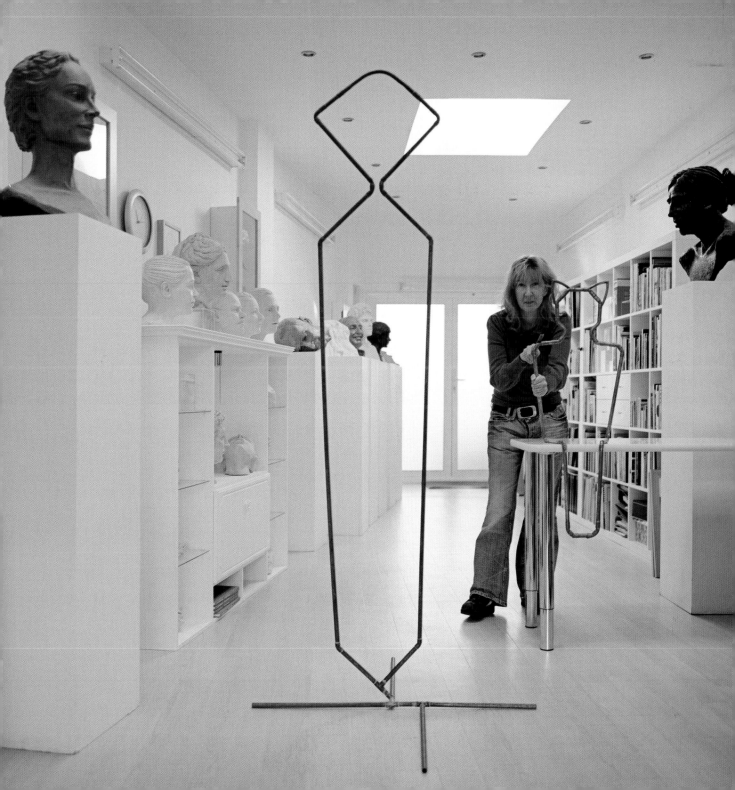

# Myra McDonnell
## Ceramicist and Potter

NEAR KINGSLEY COMMON, DOWN A SECLUDED LANE BESIDE A forest, Myra McDonnell lives in what was once an old charcoal burner's cottage. Her pottery studio, with its two kilns and glazing area, looks out unobtrusively over open countryside.

Myra originally trained for the industry in Stoke-on-Trent, then worked with tin-glaze decoration at Aldermaston Pottery before concentrating on making her own ware. For the last seven years she has taught at the University of the Creative Arts at Farnham, while decorating her own pieces in brush style. She uses traditional techniques and is keen to pass on these vanishing skills to the next generation.

A main client is Fired Earth, and she hopes that seeing her decorated tiles there will help bring them back into fashion. She also freelances for Dart Pottery, painting plants, animals and insects onto their ceramics. Another commercial outlet is Harvey Nichols – they sell her Carlton Ware tea sets. Her own range is blue and white fish, tin-glazed and low-fired – a kind of ware otherwise only made now in Italy.

Myra sees herself as more a craft potter than an art potter. She is equally at home working for industry and in her own studio. She can make a tea set; she can also complete an expert restoration.

What she most likes is decoration, which she finds totally absorbing: 'You can lose yourself in the brush work. The tonal layers: you build in layers – from the back up.'

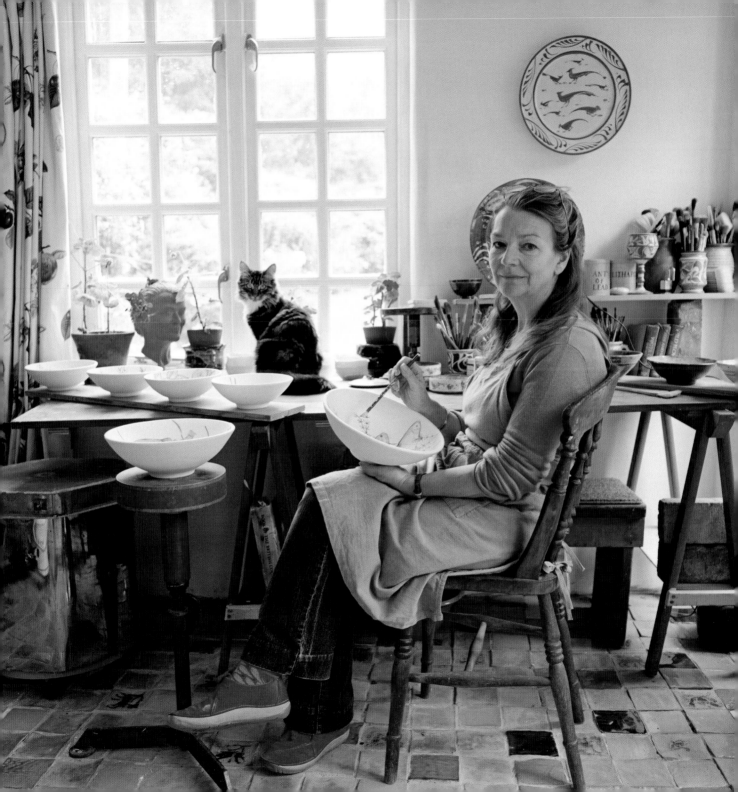

# Alan Micklethwaite
## Sculptor and Stone Carver

TUCKED WITHIN A NARROW STREET IN HULL'S HISTORIC centre is a many-tunnelled warehouse leading to Alan Micklethwaite's stone-carving workshop. There I find Alan working on a private commission for an inscription on limestone. Only about ten percent of his commissions are for lettercutting, the majority being for figurative stonecarving.

Inspired by Gothic and medieval architecture, Alan served an apprenticeship at Lincoln Cathedral after completing a fine arts degree. The late John Roberts, a member of the Guild, taught him carving before he set up on his own. His work is mainly with figurative sculpture on historic buildings, especially churches. He also makes a few pieces of independent free-standing work, but values commissioned work just as highly, believing that whatever the circumstances of its composition, a piece should always come genuinely from the artist.

He thought about becoming an architect, but preferred to become involved more directly in the building process, fitting his work into existing spaces. As most of his work is site-specific he likes to be in communion with every aspect of the site, in order to ensure that his work will fit harmoniously into its surroundings.

Alan works instinctively on the stone and finds it really exciting when the volumes and spaces become alive as they emerge. Clients like to see designs and plans, but free drawing, sometimes straight onto the stone, is what he loves best.

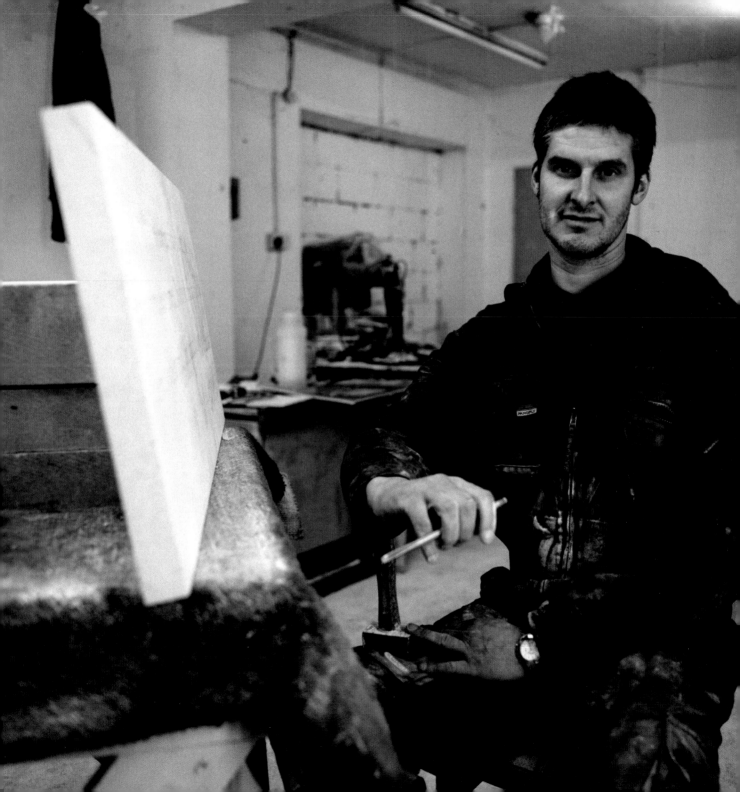

# Bernard Middleton
## Bookbinder

STEPPING INTO BERNARD MIDDLETON'S BOOK BINDERY, IN the semi-basement of his four-storey house in Clapham, is like entering a workshop of the past. The front room holds the Victorian paper guillotine and shelves containing his 3,000 binding tools; the back room his leather stock, endpapers and a sewing bench. The essence of tools, gold leaf, old paper, pungent leather and unknown chemicals captures my nose.

Bernard started when he was 13, and 2009 marks his 71st year in the craft. These days he works at a more leisurely pace, while still priding himself on upholding the craft of bookbinding. His clients range from English country houses to institutions which have been relying on him to preserve their valuable assets for decades.

Having served his apprenticeship at the British Museum, Bernard well understod the need for assistants and took on Eric Horne, who stayed with him for 25 years. His numerous flintlock firearms, watercolour boxes, Indian miniatures on ivory, and Wenceslaus Hollar etchings all came from Eric, who was an avid collector. Whenever Eric decided he had done with a particular obsession, Bernard would buy the lot.

Guild member Flora Ginn assisted Bernard for 12 years after Eric retired, and still has her own bindery nearby. They share binding tools – Bernard has one of the largest collections in London.

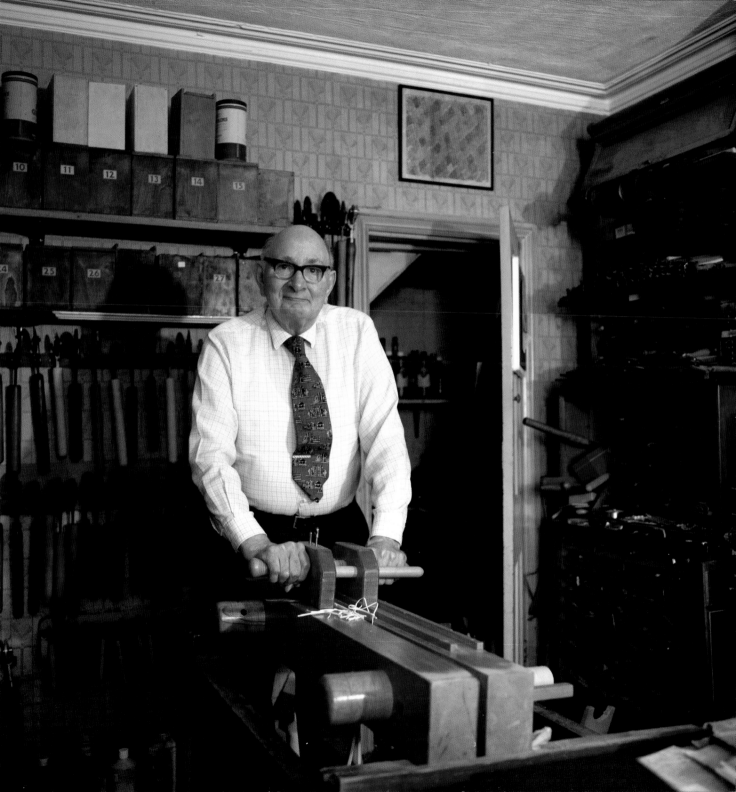

# Georgy Mkrtichian
## Wood Carver

GEORGY MKRTICHIAN IS SEEN HERE IN A WORKSHOP IN WEST
London.

Georgy was born in Tbilisi in Georgia to an Armenian
family. At art school, he specialised in wood technology
and in 1982 won a medal in Moscow for wood carving.
Subsequently he worked with several prestigious
restoration firms in Georgia before moving to London
in 1994, where he collaborated closely with private
collectors on a range of commissioned pieces.

The Georgian and Armenian wood-carving traditions
belong to two of the oldest continuous cultures in the
world. English traditions go back to the Middle Ages,
so there was a common background. Georgy has made
seamless repairs to late eighteenth-century furniture by
Robert Adam, from whom he takes inspiration, while at
the same time developing his own recognisable modern
style.

Recently he was sub-contracted by the National
Gallery to carve the frame for the painting by Matteo
di Giovanni that was displayed in the Siena exhibition in
2006-7. In collaborating recently with Martin Grierson,
he has developed a flair for contemporary carving with
great potential.

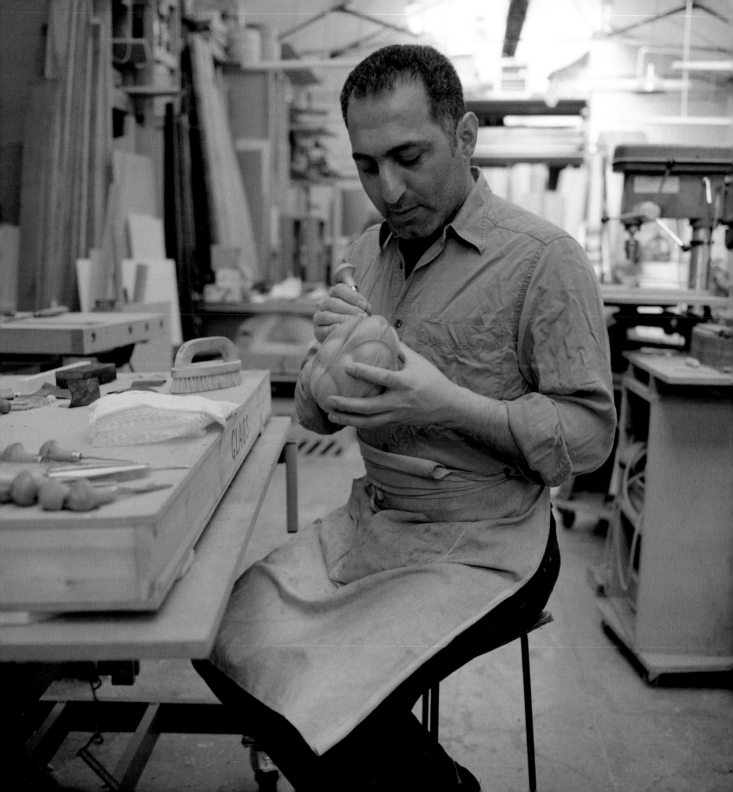

# Charles Morris
## Architect, Surveyor and Architectural Designer

ALTHOUGH CHARLES MORRIS ALWAYS KNEW HE WANTED
to work with buildings, he left school 'seriously un-
ambitious'. He studied at agricultural college and went
on to work in estate management.

Whilst studying at Cirencester, Morris found himself
living in Upper Dorval House, an Arts and Crafts
house in Sapperton designed by Ernest Barnsley, full of
Barnsley furniture and Gimson plasterwork and wall-
sconces. It made him realise that a building could have a
tremendous effect on one's spirit.

He has drawn buildings for the last 40 years, moving
over to building design in the 1980s, a time when the
supervision and administration of building projects was
beginning to pass from architects to quantity surveyors
and project managers. In his architectural practice he
devotes as much time to administration as he does to
design. This has left him with a lot of very happy clients,
most of whom have become great friends.

He analyses buildings and streets in terms of their
geometry, proportion and regulating lines, which are
applied equally to organic and to classically ordered
design. 'Slowly all these discoveries get stored up, and
hopefully it all comes back to you when you need it.'

Guild members Ben Pentreath and Mark Hoare have
both worked for Charles and owe him a great deal.
Since turning 65, he has begun to consider handing
over some of his commissions to these trusted younger
designers, but he enjoys his work too much, and
declares ,'I am not stopping now!'

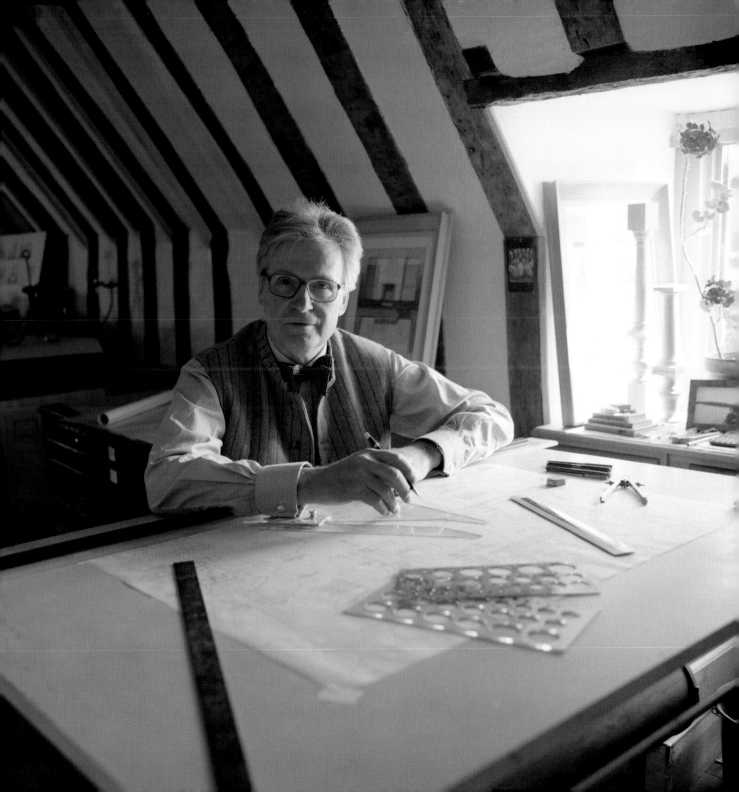

# Jane Muir
## Mosaicist

JANE MUIR IS SEEN HERE PEEPING OUT OF HER MOSAICS workshop, where she cuts glass *smalti*, the components for the Venetian style of mosaic. Next door she has an office where finished pieces are waiting to go off to clients. Her studio walls are covered with research materials. In the garden is a shed where she runs mosaics workshops.

Her studio in Weston Turville was once the local butcher's slaughter house. During the 30 years she has lived there Jane has utilised all the different spaces in the house, depending on the project in hand. Drawing and painting have always been crucial to her mosaic work, but recently she has turned her attention solely to painting.

Like Paul Klee, she draws on the imagination and music for her symbolic concepts. She learnt about line from Botticelli and Rembrandt's etchings. 'I do the etching as a kind of sideline when I am tired of working with architects.'

She enjoys the practical aspect of making mosaics: drawing an outline and manipulating handfuls of small stone pieces over the drawing-board. She gets into the studio at eight o'clock most mornings and motivates herself by going on long walks and practising her baroque recorder.

In 2009 Jane exhibited a series of paintings on the theme of 'The Green Man', an inquiry into the sources of creativity, combining her observation of trees and stone with her interest in folklore. 'And the poor old fool is still searching but it is a very exciting adventure.'

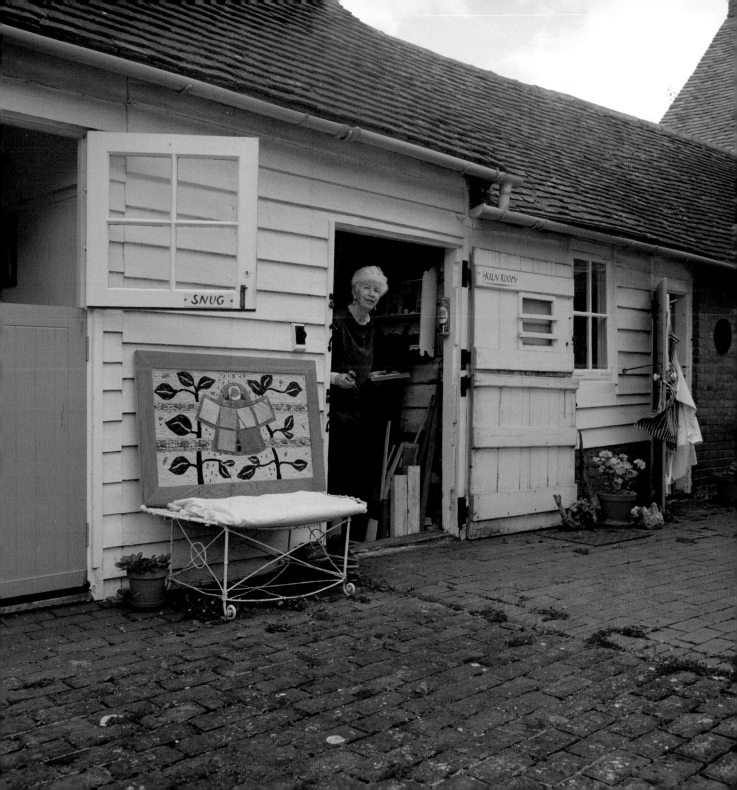

# John Nash
## Lettering Craftsman

JOHN NASH, THE AWG'S HONORARY LIBRARIAN, STANDS in the front garden of his home in Highbury, tapping patiently away with dummy and chisel at a memorial headstone to Honorary Brother David Curzon-Price.

John's typographer father, Ray Nash, was a friend of most of the principal figures in the printing renaissance of the early twentieth century – people such as Stanley Morison, John Dreyfus, Hans Schmoller and Beatrice Ward. In 1968 he became re-acquainted with Beatrice, and through her enthusiasm took up lettering as a practical profession. He studied calligraphy part-time with Anne Camp at Hampstead Garden Suburb Institute, and continued it for five years at her course in Digby Stewart College, Roehampton, gaining the Diploma in Advanced Calligraphy. At the same time he began to acquire experience in lettercarving, picking the brains of craftsmen like Tom Perkins and John Benson and working with the Flemish lettercarver Pieter Boudens. He also learned brush-lettering at City and Guilds of London Art School. Contrary to what one might think, lettercarving is easier than calligraphy – a mistake in a built-up carved letter can be sanded out and re-cut, whereas a mistake in a piece of calligraphy means you have to start again.

The disappearance of support for good public lettering has placed these disciplines under threat, but thanks to the influence of Edward Johnston and Eric Gill, and more recently Harriet Frazer, the craft of lettering in England remains sound. John thinks himself lucky to be able to work, largely on his own terms, at one of the last self-respecting trades which survive in the modern world.

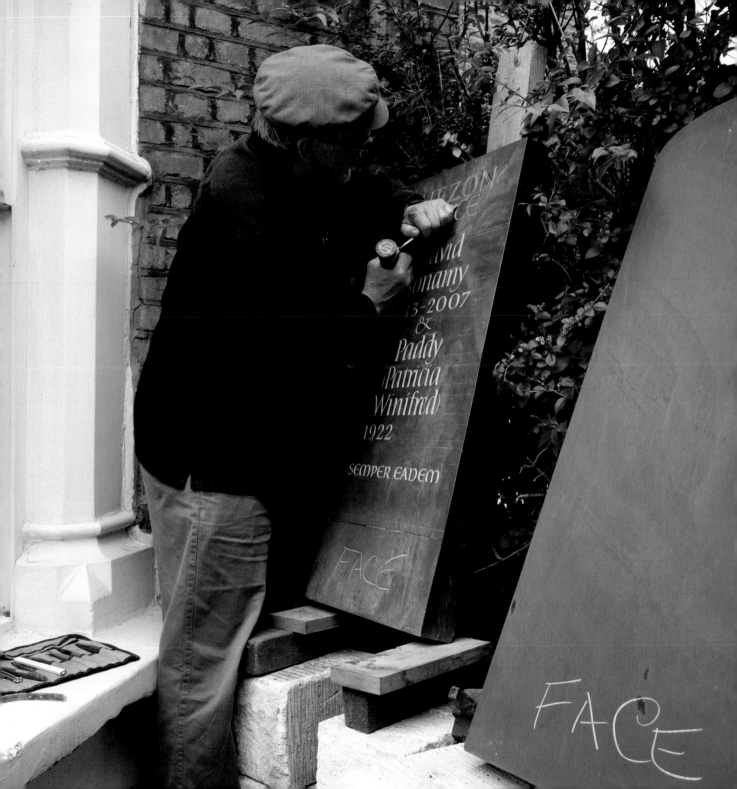

# Liam O'Connor
**Architect**

LIAM O'CONNOR IS SEEN HERE ON THE ROOF OF A HOUSE
on the north side of Hampstead Heath which he has
designed in the style of Sir Edwin Lutyens, a Past Master
of the Guild and the most famous British architect of his
time.

He recalls a visit to the British Museum at an early
age making a deep and lasting impression on his ideas
about architecture, the nature of public space and
monuments, some of the most prominent of which
in the UK he went on to design. The Commonwealth
Memorial Gates near Buckingham Palace and the
Armed Forces Memorial in Staffordshire are only two of
his achievements in this field.

He qualified as an architect at the University of
Westminster and worked for two years with Leon Krier,
contributing to projects like the master plan for the new
town of Poundbury for HRH the Prince of Wales. He
spent two years as Visiting Professor at the University of
Notre Dame in Indiana and in Rome.

One of Liam's key principles is to reconcile modernity
with tradition and break away from the tired
battleground of the dialectic between traditional
architecture and modernism. For him classicism is a
living style, not a resurrection of the past, and it must
work in the modern world.

In the Hampstead house he has integrated a Queen
Anne style cornice design similar to that designed by
Wren at Kensington Palace with guttering discharging
into concealed swan-neck cast metal piping, which
is co-ordinated with the modillion cornice, so the
functionality and the design are in harmony.

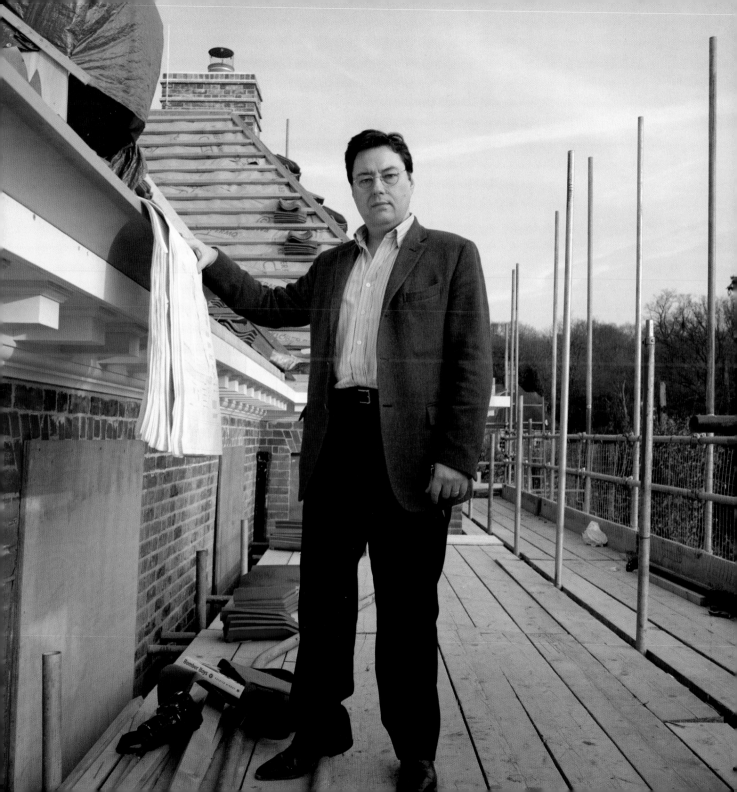

# Robert O'Rorke
## Painter and Restorer

ROBERT O'RORKE'S PAINTING STUDIO IS IN A ROW OF garages tucked behind a block of flats. Natural daylight streams into the long workspace.

Robert trained at the Royal College of Art, where, with Peter Blake as his tutor, he produced large pop and abstract paintings. Unable to support himself through painting alone, he apprenticed himself to a picture-restorer. Today he is known equally as a painter and a picture-restorer and divides his time between two studios.

As a painter Robert specialises in landscape and still-life. He feels that a picture has to work on an abstract as well as a figurative level, so foregrounds tend to be fairly loose with tighter areas elsewhere. Often he repeats a subject using different techniques, alternating gouache and oils, for example. At any one time he has several unfinished paintings on the go – some can take years to resolve.

As a restorer Robert works mainly with oils on panel or canvas. 'A bit like being a doctor' is how he describes it. 'People bring me paintings that can be in appalling condition and I have to put them back together. If you have done a really good job no-one should be able to detect what you have done.'

Maintaining two careers can be a tricky balancing act, but it seems to suit him. 'If it's cold and I'm not feeling very inspired I will do some restoration, but if the sun is out and I feel decisive I will go round to my painting studio and see what happens.'

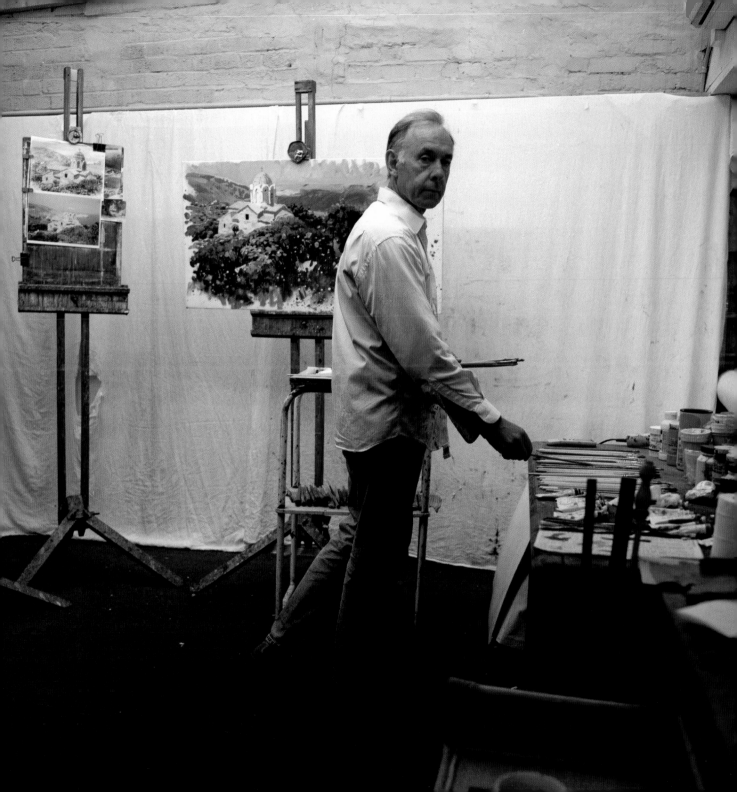

# Magdalene Odundo
**Ceramicist**

MAGDALENE IS SEEN HERE MOVING A WHEELBARROW OF CLAY towards her studio. Although she works on her own and enjoys working alone, Magdalene finds teaching invigorating and inspiring and says that she continues to learn and develop her own work through working with others in a university environment. She is happy to be with the students and considers being amongst them a most rewarding experience. That is a balance that has suited her perfectly.

Magdalene Odundo was born and grew up in Nairobi, Kenya, where she trained and worked in commercial art, advertising and neon sign design. She came to the United Kingdom to go to art school in 1971. She works and lives in Farnham, Surrey, where she is a Professor of Ceramics at the University of the Creative Arts. Magdalene enjoys developing projects that engage people in discussion and has curated exhibitions and organised international ceramics conferences and symposia. Magdalene helped organise the 2008 International Society of Ceramics Art Education Exchange symposium at Kenyatta University in Kenya.

She has often thought of taking on apprentices or assistants to work with her, to share her skills and knowledge. However, she feels that her years of teaching have allowed many more students to benefit from her practice.

# Stephen Oliver
## Architect

ASTON HALL, ON THE OUTSKIRTS OF BIRMINGHAM, HAS recently reopened following a major restoration project undertaken by Stephen Oliver on behalf of his firm, Rodney Melville & Partners, and he is shown in the photograph during the construction works on site.

Stephen is the Honorary Architect to the Guild, in charge of the building at Queen Square, and he looks after many other important historic buildings. Coming from a long line of builders, he studied architecture at Cambridge and then went on to work on the completion of Bury St. Edmunds Cathedral, a design by Warwick Pethers who continued the practice of Stephen Dykes Bower, a notable Guild member in the field of church architecture.

Stephen's kind of architecture involves research into and interpretation of the fabric and history of old buildings. No two projects are alike, and he often has to adjust proposals on site to accommodate discoveries made during the work. The detailed knowledge of materials and their long-term performance informs his design of new work. He has published his research into the work of his namesake, Basil Oliver, an architect Past Master of the Guild.

Stephen enjoys the opportunity to work with craftsmen and other Guildsmen. For the reordering of the Catholic church of St. Peter and St. Paul in Wolverhampton he collaborated with two Guild members, Rory Young, who created a polished aluminium crucifix, and Katie Worthington, who carved the new marble fittings. He is currently working with Ian Rank-Broadley and Tim Crawley on a new memorial to The Royal Anglian Regiment.

# Anthony Paine
## Architectural and Interior Designer

ANTHONY PAINE'S STUDIO IS IN A FINE REGENCY HOUSE
overlooking the valley of Bath.

A Fellow of both the Chartered Society of Designers
and the British Interior Design Association, Anthony
is best known for his use of classical architecture in
a contemporary context. Coming from a successful
building family, he was expected to take over the
family firm, but after training in building he switched
to surveying, and finally to interior design. He studied
under Past Master Anthony Ballantine at the then North
London Polytechnic, before setting up his own design
practice in London at the young age of 27.

Anthony's unusual background in construction and
design triggered a passion for classical and vernacular
architecture which has characterised his work for the
past 35 years. Notable projects, many of which involve
the design of entire environments, range from Georgian
shops in Spitalfields to a Kasbah outside Marrakech.
He is also known for his work for the bespoke tailors,
Gieves and Hawkes. He re-designed their flagship store
in Savile Row and went on to design more than 100
stores worldwide as well as a range of furniture and a
set of cards and cartoons.

Anthony was elected a Brother of the AWG in 1990
after winning  *The World of Interiors* award at the British
Interior Design Exhibition, and served as its Honorary
Secretary from 1993 to 2004.  'I love the Guild because
I share its core values and attitudes,' he tells me. 'PM
Anthony Ballantine taught me from the beginning to
value the interdependence of all types of aesthetic arts
and crafts in the creation of beautiful environments.'

# Csaba Pasztor
**Artist**

I MEET CSABA PASZTOR IN A PRIVATE MEMBERS' CLUB
room, one of the spaces he has recently designed and
refurbished. As I look around, everything I see has in
some way or another been touched by Csaba, from the
painting which acts as the air-conditioning cover, to the
wine cabinet, which gargoyles warn you to open at your
peril.

Originally from Hungary, Csaba received a classical art
training, then in 1989 came to the Royal College of Art
to study for an MA in Natural History Illustration. He
has always worked within the principles of the Arts and
Crafts Movement: quality and functionality without
excessive opulence. Over the years he has worked
at renovating weathered casts on buildings, taught
life-drawing and geometry, and renovated a Georgian
cottage using traditional and sympathetic materials, but
his greatest passion has always been painting. 'It is the
queen of all arts,' he explains.

Sitting in the 'Pasztor Emporium', we discuss how he
goes about giving a space like this an atmosphere of its
own. Everything fits in so well, he explains, because it
gets used repeatedly. Art has always been created to be
part of a space. Within a building everything in it has its
place, and is meant to be there, including statues and
carvings.

For him the classical principle is 'an attitude to living
as well as to education and training to be a craftsman.
I mean classical in the ancient sense; the education
transmitted from master to pupil within a tradition.
Craftsmanship still might be one of the last beacons
showing the way to the source of fulfilment and
happiness.'

# Leonard Pearce
## Marine Painter and Modeller

LEONARD PEARCE PAINTS IN A CONSERVATORY AT THE FRONT
of his house, overlooking the Argoed valley near
Blackwood in Wales. His nearest neighbour, who lives a
good distance away, makes violins – Leonard often hears
a violin being played when passing by.

Originally Leonard worked as a graphic designer, and
lived in Chiswick. Boats fascinated him, and he enjoyed
painting them. A colleague's wife displayed one of his
pictures in her shop window on the King's Road, where
it was seen by an American businessman who then
commissioned Leonard to paint the famous French liner
the *Normandie*. One commission led to another, and
now he has an extensive back-catalogue of paintings of
ships and liners, and will often travel abroad to paint a
vessel in the setting linked to its history.

Although these days he mainly paints to please himself,
he invariably chooses subjects that he knows are
saleable.  His specialism is the nineteenth century,
especially after 1851 when the Americas Cup Race
began. His attention to detail comes from his days as a
graphic designer. He likes to do paintings with a story
behind them, especially if the story is known to his
audience.

The view from his studio is exquisite, but Leonard has
never painted it. 'That would be a challenge,' he laughs.
'Painting is quite a commitment to yourself – it is like
being lost at sea. When painting a sea you are at sea.'

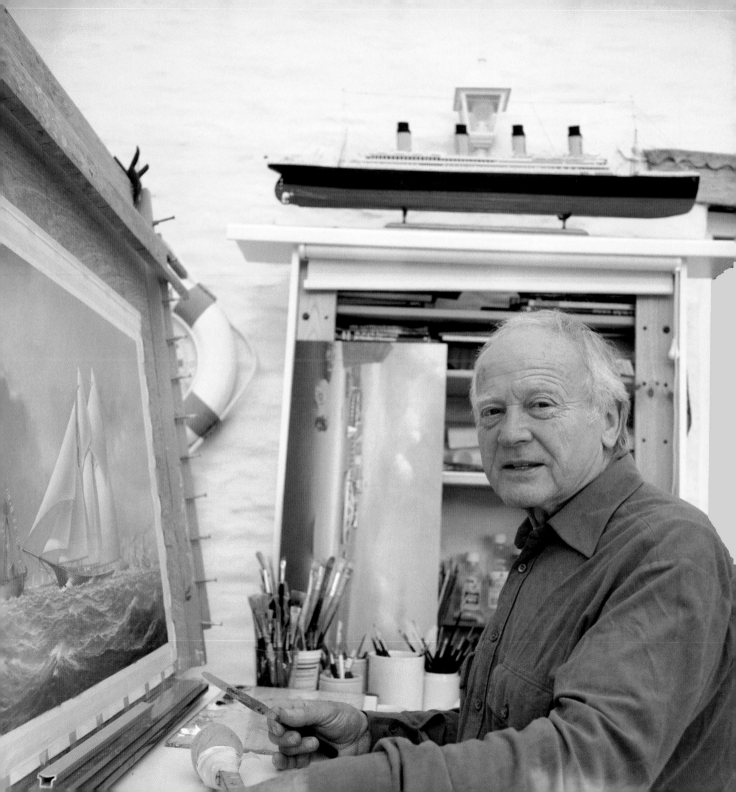

# Ben Pentreath
## Architectural Designer

BEN PENTREATH WORKS FROM A SET OF AIRY GEORGIAN rooms in Bloomsbury overlooking Lambs Conduit Street. This bustling London street lined with tall houses and interesting shops convinces him that it is still possible to create real towns as they did in the early 19th century, when simple terraced houses were repeated to create beautiful streetscapes.

'The twentieth century placed enormous emphasis on the creation of single objects or buildings, and was simultaneously very good at delivering vast numbers – of cars, fridges, houses – but much less successful at combining quantity and quality. That is the challenge of today,' he explains.

Ben argues that we must build beautifully and for the long-term if expensive low-energy technologies are to make any sense. In 2007 one of his developments, at Upton in Northampton, won the Building Research Establishment's highly valued 'Best EcoHomes' award.

Having drawn buildings since he was a young boy, Ben read History of Art and Architecture at Edinburgh, before training with Guildsman Charles Morris. During a year at the Prince of Wales's Institute he encountered the Art Workers Guild, and then went to New York, designing for film stars and living in Greenwich Village.

He returned to London in 2003 and set up his architectural practice a year later. When the office expanded he opened a small home store in Rugby Street – demonstrating how good design extends all the way from the structure of the city and street to the form of a simple mug, plate, book or candlestick.

194

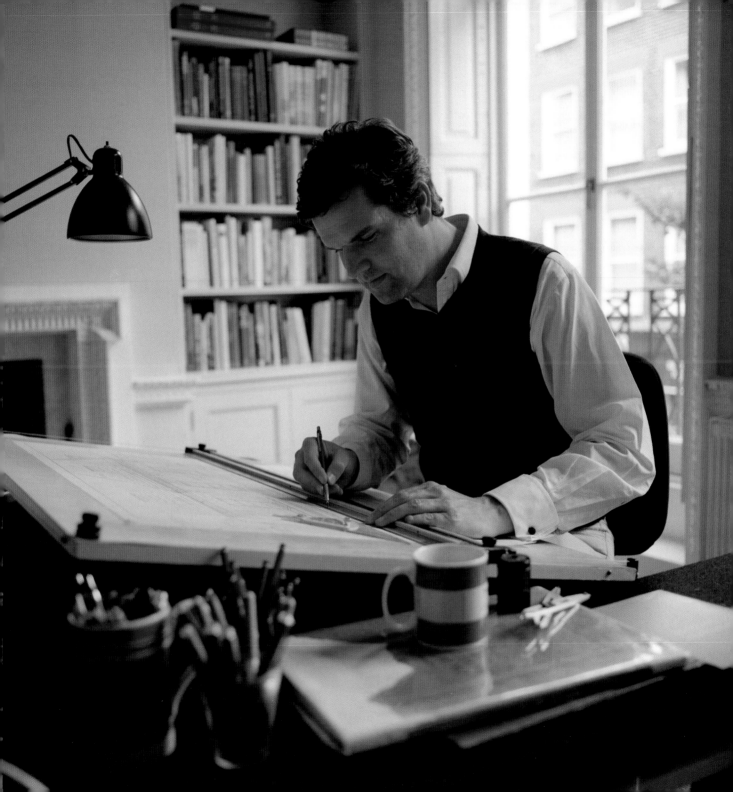

# Tom Perkins
## Letter Cutter

TOM PERKINS STUDIED CALLIGRAPHY AT REIGATE AND WAS
then apprenticed to Richard Kindersley for just over
a year, before setting up on his own in 1978. He has
continued the tradition of taking apprentices in his own
workshop near Cambridge.

He likes to design and work with modern letter-
forms, but will use traditional ones when the occasion
demands. He sees a symbiosis between the pen and
brush work of calligraphy, and the craft of stone cutting,
and sometimes uses calligraphic marks as the basis for
lettering design. He enjoys the slow and regimented
process of letter cutting, and also the freedom of
adapting the letterforms to the differing requirements
of each piece of work.

Tom spends most of his time on commissioned work,
such as memorials or stones for the landscape and for
gardens. These can range from small plaques to lettering
carved directly into a building, a challenging but
exhilarating prospect. Among his recent commissions
were cast metal letters of an Andrew Motion poem for
St Martin's in the Fields, and an opening plaque for the
refurbished Queen's Gallery at Buckingham Palace.

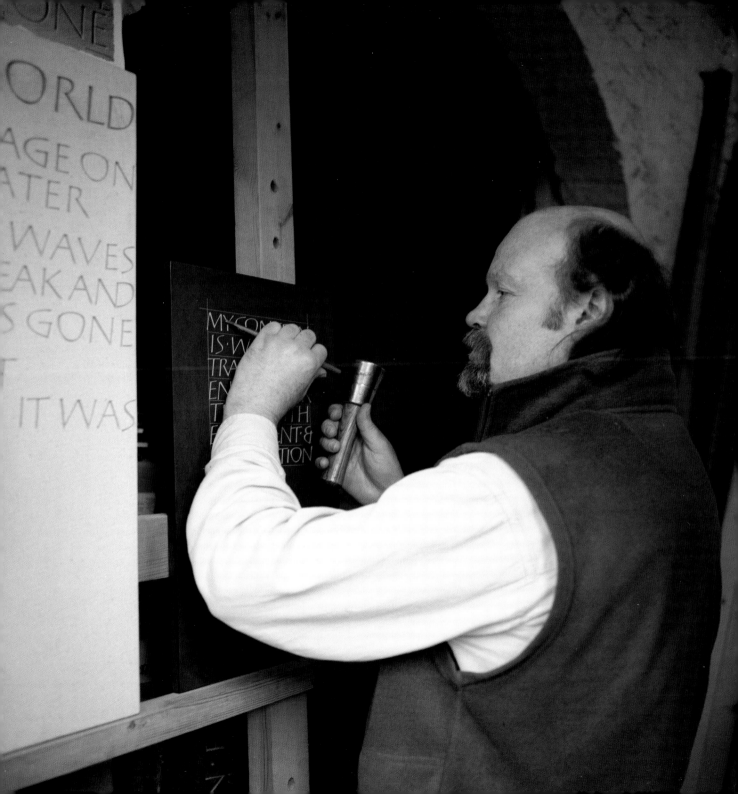

# Michael Petry
## Installation Artist

BEHIND LARGE OPAQUE WINDOWS ON A CORNER IN PECKHAM Rye, away from the busy traffic, Michael Petry is quietly planning and designing another installation piece.

He is the curator of the Royal Academy Schools Gallery and co-founder of the Museum of Installation. Recently he has written *Hidden Histories*, a comprehensive study of male same-sex lovers in 20th-century visual art, and also acted as guest curator for the New Art Gallery, Walsall and the Kunstakademi, Oslo.

In the photograph is his latest work, 'Party Number One', a length of wood with a number of ocular holes cut out. Viewers can insert their hands in the holes and fondle the piece, which is so highly sanded that it feels like velvety flesh. Petry's artistic language is challenging and subversive, but always articulate and to the point. His vast knowledge and experience in the world of conceptual art is widely respected.

His installation works are often large and, where he uses glass, fragile. Gallery curators need precise instructions on how to assemble them, particularly where sand and the threading of glass beads are involved.

'Perhaps the difference between me and other Brothers,' he says, 'is that sometimes I make the work myself and sometimes I don't. But the concept behind the making of it is what is relevant here. The greatest challenge for me as an artist is to take the site and almost make it internal. Then the work can be re-sited. And when it is re-sited it gets more exciting.'

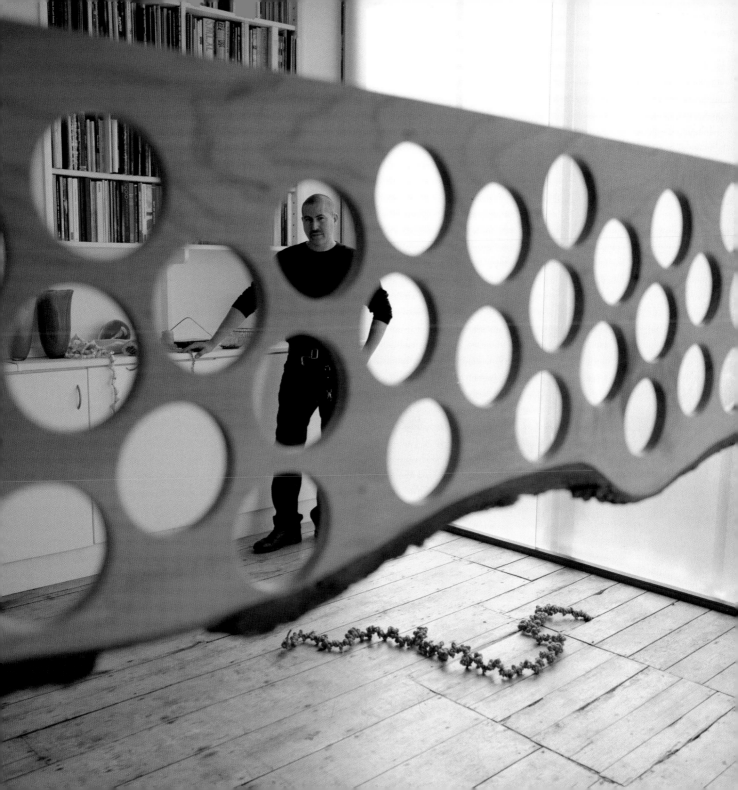

# Hugh Petter
## Architect

Encouraged from an early age by his parents' artistic enthusiasms, Hugh Petter was allowed to develop his interest in classical design at Portsmouth School of Architecture, before winning a scholarship to research the late 19th-century development of Rome at the British School. He won a place on the first Prince of Wales's Summer School in 1990, where he made contact with others who saw classicism as part of a wider project to develop individual creativity unrestricted by the narrow conventions imposed by most architecture schools.

He moved straight to running the Foundation Course at the Prince of Wales's Institute, a radical programme for school leavers and mid-career mature students that has had a wide if partly invisible influence over its ten-year existence. Teaching was absorbing, but Hugh also began to receive commissions, and joined Robert Adam Architects, where he soon became a director, sharing the practice's belief that classicism is a living and growing tradition.

Working for the Duchy of Cornwall on a large development at Newquay, Hugh has applied the principles of New Urbanism, aiming for sustainability in a plan that does not depend on car use, as well as in the buildings themselves.

Hugh's concern for filling the gaps in education led him to add a new service to the Art Workers Guild, using the internet to provide a portal for students seeking apprenticeship placements and for busy practitioners looking for the funding that will allow them to give extra time to training the next generation.

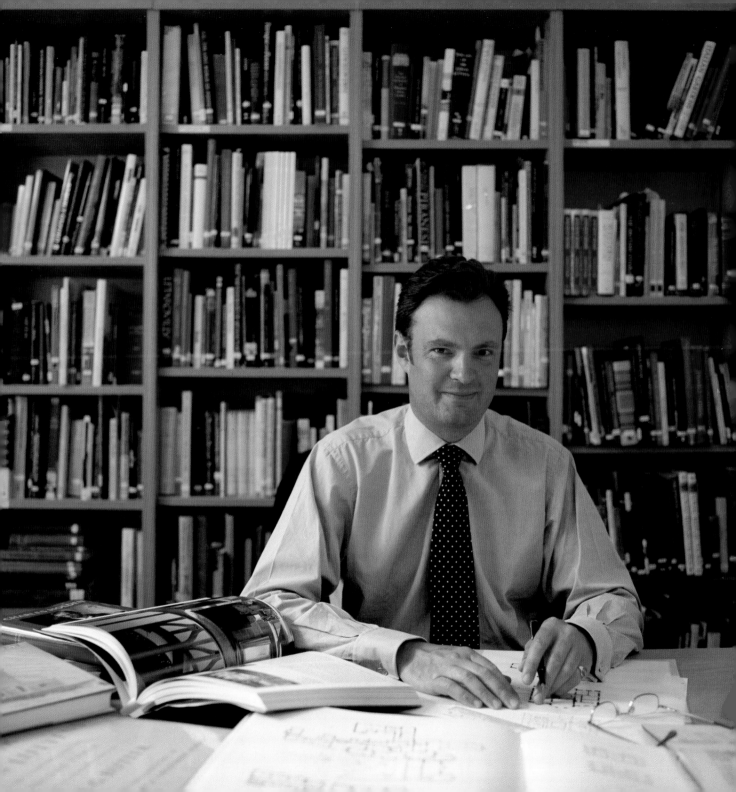

# William Phipps
## Silversmith

WILLIAM PHIPPS PRODUCES FINE SILVER CUTLERY IN THE
ground floor workshop to the side of his double-fronted
Victorian house, in what is now a fashionable part of
north-west London.

It wasn't always so fashionable, and it wasn't always
cutlery. After serving in the Canadian navy, William
found himself drawn to flute-making, but because the
trade was in decline he worked for three years for the
silversmith Michael Murray, and then set up on his
own. Deciding to move into manufacturing, he opened
a workshop in Clerkenwell. Cutlery only became a
mainstay of his business after he saw a demonstration of
spoon-forging at the AWG by the Vander spoon-forger
Roy Wilkes.

Today he has a host of private and corporate clients
including Egg and Sotheby's. Recent commissions
include the enormous job of making a 14 x 7 piece
service, plus serving spoons, for the Jonathan Clark
Gallery on Fulham Road.

In William's good-sized workshop a gas flame is always
burning. Much of the floor space is occupied by a hoard
of objects accumulated over 50 years, presided over
by the large upright case of a double-bass. He works
wearing headphones attached to his stereo equipment
by a lead long enough to let him move around. (Once,
he tells me, he was so engrossed in his work that he
pulled the whole apparatus off the wall.)

He doesn't think he could work with anyone else now
– he is far too fond of his own space, and of the private
world of sound piped in through his headphones.

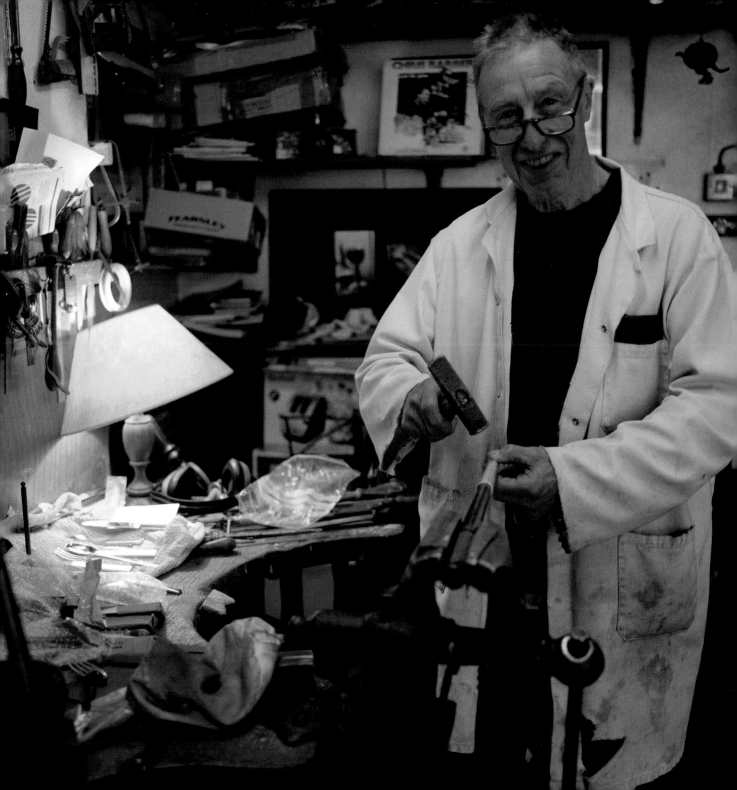

# Lara Platman
## Photographer and Journalist

WHEN SHE WAS A CHILD LARA PLATMAN'S PARENTS WOULD dress her up in theatrical costumes that they were making for Shaftesbury Avenue shows. This gave her an early fascination of how things are made both backstage and in front, shooting for ballet and theatre productions.

Lara enjoys teaching students of all ages the benefits of composition and lighting, stressing that apart from a camera these are really all a photographer needs. She has worried over her photography: is it art, documentary or indeed a craft? In a world of digital media, the craft aspect has become easier to identify. The darkroom offers a magical experience, and she tells students they must start from scratch – from chemicals, paper and mistakes – in order to create a good photograph.

At college she realised that photography would allow her to travel, experiencing delights and horrors like those which inspired Elliott Erwitt and Jacques Henri Lartigue. Passionate about dance, she assisted dance photographer Chris Nash before setting up on her own as a dance photographer. Recently her portrait work has predominated, with her studies of Art Workers Guild members in their working environments.

After 20 years in the profession, Lara feels that she is only just beginning to understand the skills required. With a journalism degree and a solid camera kit, she can't wait to get on with more projects and commissions. 'I am very privileged to see the world through a camera,' she says. 'I mean really see it, not just glimpse at it.'

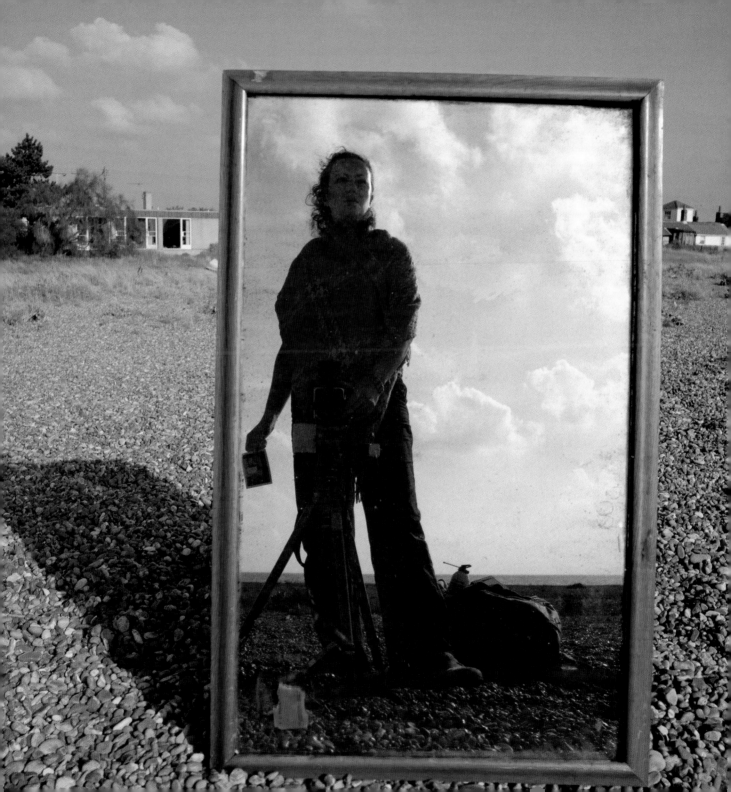

# David J. Pocknell

## Graphic Designer, Typographer and Architectural Designer

DAVID POCKNELL WORKS IN ONE HALF OF A LISTED ESSEX barn, and lives in the other, with glass enclosures beneath the roof for each.

He went to art school at 16 but left after three months, and got a job as an apprentice in a Tottenham Court Road department store. Since then he has gone on to win an international reputation in virtually every field of design, including architecture, graphics, interiors, books and textiles.

David got his big break from Robert Nicholson, who together with his brother Roger designed interiors for a number of high-profile architectural projects. Nicholson first asked David to paint and decorate his holiday house, then the brothers went on to employ him to paint murals, design furniture and lighting fittings and produce advertisements for their range of wallpapers. David commissioned Edward Bawden, Eric Thomas, Anthony Gross and others to produce illustrations for the advertisements, and also took still-life photographs for advertisements in *House and Garden*.

The architectural confidence came from doing up David Bishop's shop in the Kings Road in 1967. In 1975 he converted his first barn and then another for David Hillman of Pentagram. He designed exhibitions for the Design Council, and later his practice worked on a number of major architectural and graphic projects, notably the complete rebranding of London Transport in 1992, for which he won the CSD's Minerva Award. He remains consultant to the Corporation of London and has recently redrawn the Corporation's Crest.

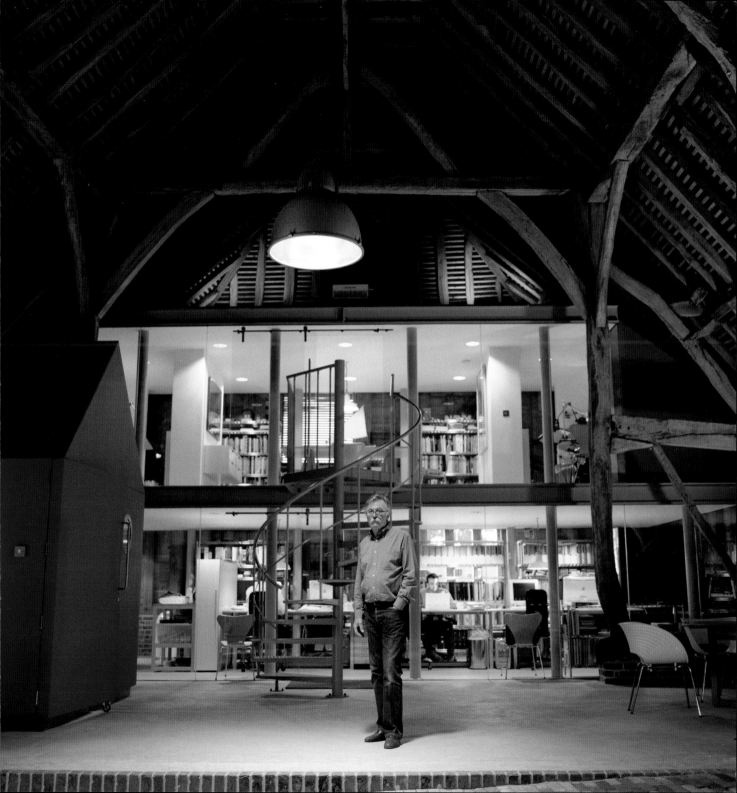

# Sally Clare Pollitzer
## Painter and Stained Glass Designer

SALLY POLLITZER'S STUDIO IS IN A CONVERTED COWSHED across the walled garden from her home, high on a windy hill outside Batcombe in Somerset.

Sally's painting and glasswork is as much influenced by American Abstract Expressionism as by the bejewelled glory of the windows at Chartres. Architectural glass is for her primarily about colour and she is at her best when working with abstract forms that both complement and punctuate a given space.

Ideally she likes to control the craftwork herself, although she sometimes employs a young assistant to help with the leading. The work entails cutting, setting up, acid etching, painting and staining, stretching the lead (as she is doing in the photograph) and glazing. One consequence of having a painter's approach to designing for glass is that from the initial idea there may be many changes on the glass easel or frame that can be seen set against the window.

The commissions have been varied both in scale and theme. Sally's work has served both God and Mammon: she has made screens for the London headquarters of Lloyds/TSB and windows for churches in Surrey, Somerset and Sheffield. She has also executed numerous domestic commissions for private clients.

Sally continues to paint between commissions, keeping sketchbooks to concentrate the eye and loosen her hand. With Cézanne's late, fragmented paintings in mind, she endeavours to create beautiful and permanent artworks. She enjoys painting out of doors in the sun and wind, the elements contributing to the expressive nature of her pictures.

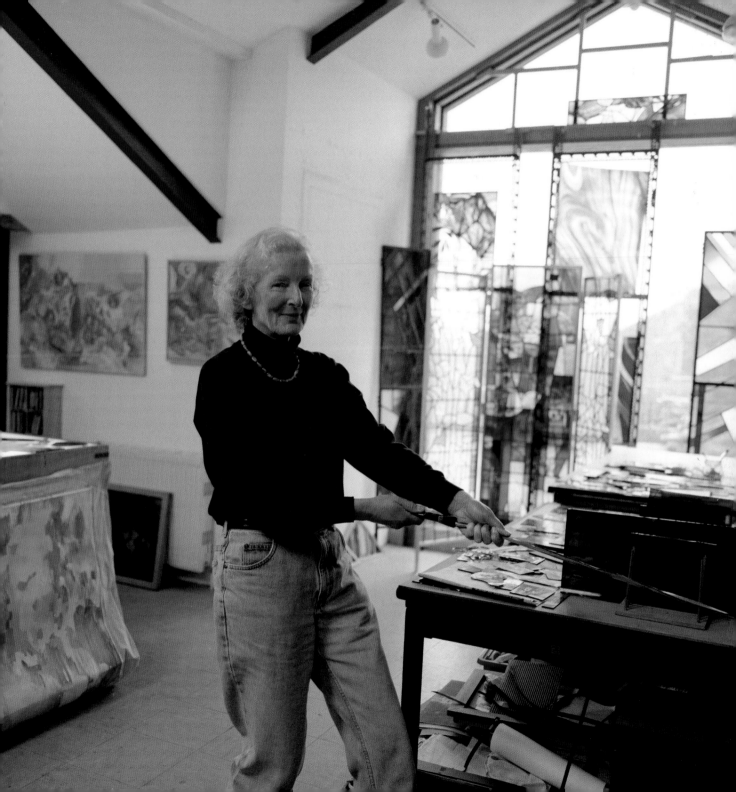

# Alan Powers
## Painter, Illustrator and Writer

WHEN ALAN POWERS JOINED THE GUILD IN 1982, HE WAS described as a painter and illustrator. This was always a little misleading, since much of his work has been as a writer. The architecture about which he mostly writes was the dominant subject of his art, which extended from tiny scraperboard headings for the *Spectator* to painted rooms, with watercolours the main activity in between. When he and Susanna, his wife, moved into their house, they used the ground-floor shop as a gallery, where many Guild members' work was exhibited. He took advantage of the revival in artists' prints during the 1980s to learn hand-drawn lithography, and later moved on to etching. A copper plate and some proofs of a recent print of St Pancras Station are displayed on his work table.

Alan's writing has included books, magazine articles, book reviews and exhibition catalogues. The theme that links them is the visual arts, mostly with a focus on Britain in the twentieth century. He has curated exhibitions, including the popular Eric Ravilious centenary retrospective at the Imperial War Museum in 2003. As an alternative to the solitary freelance life, he started teaching part-time, first at the Prince of Wales's Institute of Architecture, and then at the University of Greenwich, where he became a full-time professor in the school of architecture in 2008. 'Teaching,' he says, 'prevents you from restricting your message to a small group of specialists, and sharpens your ability to explain things afresh.'

While happy in this phase of life, Alan hopes that future years will allow him more time to justify the Guild's description of his work.

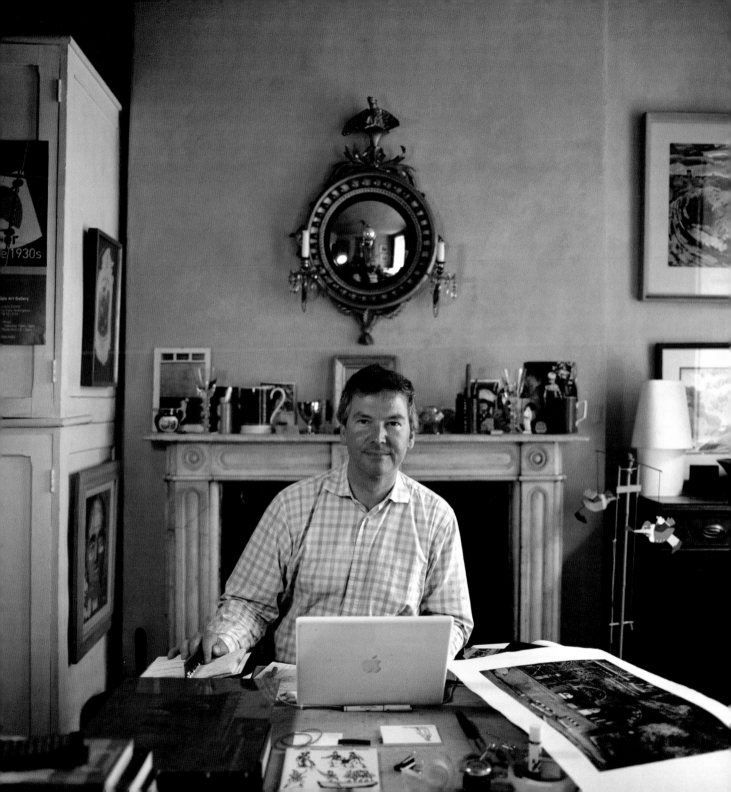

# Stephen Proctor
## Architect

SITTING AT A LARGE SQUARE TABLE SURROUNDED BY SCATTERED drawings, Stephen Proctor works with his architectural partner Andrew Matthews in a studio converted from a 1950s shirt factory. A bowl of pantone colours sits at the table's centre, a clue to the vibrant colours characteristic of their work. To one side you can see some of Stephen's large collection of colourful toys.

The practice started in 1988, after Stephen had worked for Nicholas Lacey and James Stirling. Today they employ around 25 people, all working on large and small-scale schemes. To Stephen's regret he rarely works at the drawing-board these days, as the production of drawings is now primarily digital, but he still draws freehand on their studio table.

Models of potential and actual projects occupy every available work-top, including one of their recently completed Gorilla enclosure at London Zoo. Apparently the Gorillas are much happier in the new enclosure and attendance at the zoo has increased considerably.

The partners have a particular interest in housing, having worked alongside the distinguished Anglo-Swedish architect Ralph Erskine on the Greenwich Millennium Village, and gone on to work with builders and housing associations across the country and abroad.

'This is the truth about Proctor and Matthews,' Stephen tells me, 'Every project is approached holistically, from conceptual idea to the small details of building assembly, beginning every commission without preconceived notions of the final design outcome.'

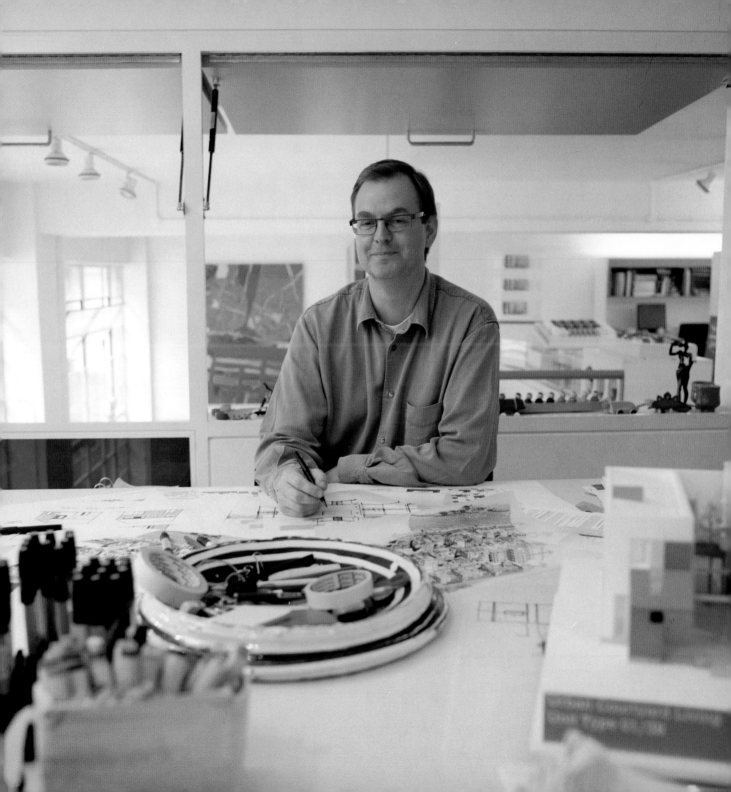

# Ian Rank-Broadley

## Sculptor

IAN RANK-BROADLEY IS HERE SEEN WORKING ON A SCULPTURE of St Matthew for St Matthew's, Northampton, the church where Rev. Canon Walter Hussey commissioned Henry Moore and Graham Sutherland in the 1940s.

Ian is well known for his likeness of HM the Queen on all UK and Commonwealth coinage since 1998; his initials IRB appear below the royal portrait. His powerful and emotive sculpture for the Armed Forces Memorial at the National Memorial Arboretum, Alrewas, Staffordshire, opened by HM the Queen in 2007, is the largest war memorial to be created in the United Kingdom since the First World War. The work has met with great acclaim, winning the Marsh Award for Public Sculpture in 2008.

For the past twenty-five years Ian has lived in a 17th-century wool merchant's house in Gloucestershire, where he works in a studio with shafts of daylight streaming through windows at the side of a peaceful courtyard. For him light is even more important than space, and it is here in abundance. The manner in which light falls on the clay or the nude model is critical to the way the form is seen. Without light there is no shadow: it is the interplay of light and dark that reveals the form.

The male body is Ian's principal subject matter, and he continues to follow the great masters of the classical tradition. He is a Liveryman of the Worshipful Company of Goldsmiths and was granted the Freedom of the City of London in 1996.

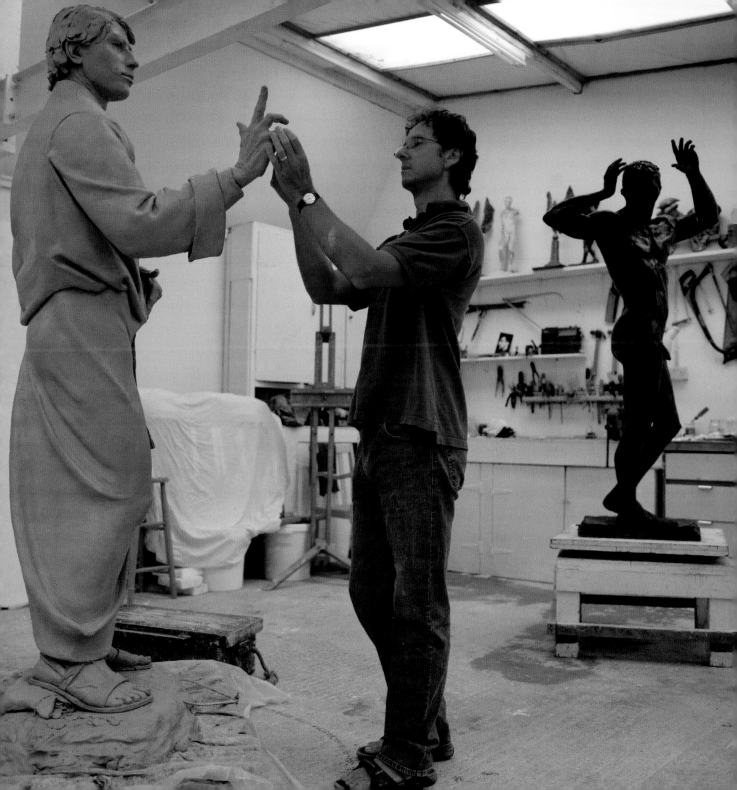

# Dick Reid

## Stone Carver and Wood Carver

DICK REID IS STILL IN THE PROCESS OF RETIRING, AND HIS
scaled-down workshop holds a plethora of tools neatly
stored and hung on the walls. At school he refused to
play football and drifted into the art room instead,
painting stage sets and making stage furniture, so that at
the age of 15 his display of work equalled the rest of the
school put together. He went off to be apprenticed to
the sculptor Ralph Hedley for five years, after which he
attended Durham University Art School, where he was
greatly influenced by the designer L.C. Evetts. He then
moved to York, where his 50-year career as sculptor and
wood carver began.

He always uses a clay model before carving to solve
design problems. Since most of his work has been in
an architectural setting where the position within the
architecture dictates the depth of relief, only modelling
can accurately predict the finished effect.

One of his most important patrons was the Yorkshire
classical architect Francis Johnson. He would come
into the studio and say, 'This is what I want to achieve
and with your help we can do it.' Other architects with
whom he developed long-standing collaborations were
George Pace and Donald Buttress, both northerners
and Guild members. When working on the ambitious
reconstruction of the Spencer House interiors in the
1980s, his workshop grew to 15. There are examples of
his carving and modelling at the Wallace Collection, the
Savoy Theatre, and Westminster Abbey.

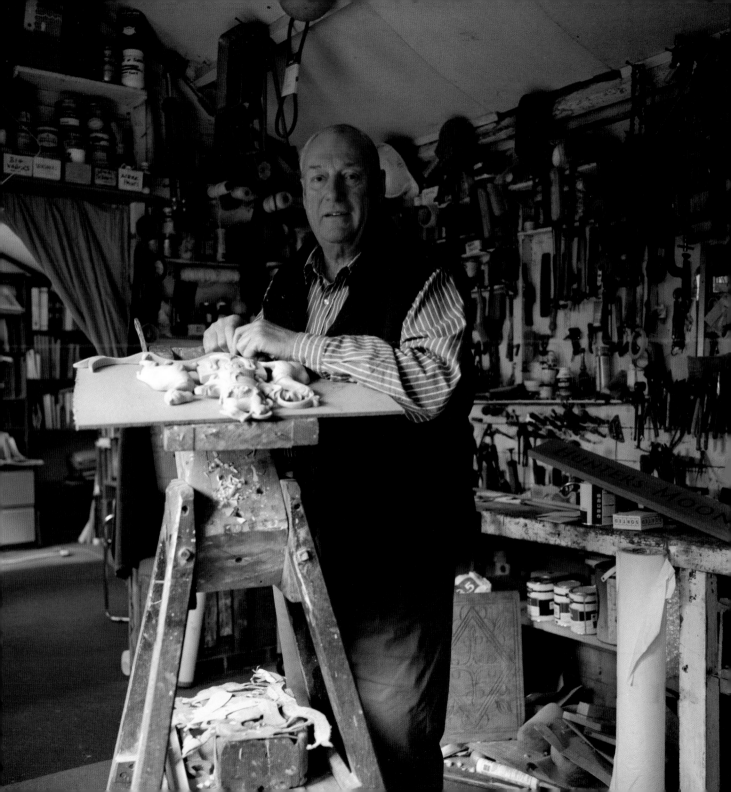

# Graham Rust
## Mural Painter

GRAHAM RUST IS PAINTING A MURAL WITH A SOUTH SEAS theme – palm trees, clear blue skies and tropical birds – by a swimming pool in a London house. He has been working on it for a month, first in his Suffolk studio and now on site. His clients have an estate in Hawaii, and have asked him to paint something that will remind them of it.

After art school, Graham went to New York where he worked for a couple of years as assistant to the art director of *Architectural Forum* magazine. On his return to London he started to paint portraits of country houses. His first mural commission came about as the result of painting the wall of his studio in South Kensington.

One major project was to paint the staircase at Ragley Hall in Warwickshire, for which he used water-based paints. Forty years on the murals look as fresh as when they were first painted. He particularly likes the chalky finish which needs no varnish.

These days he works on canvas that is then applied to the wall, so if the clients ever move they can take the mural with them.

His work takes him all around the world. Wherever he finds himself, Graham always sketches the local flora and fauna, providing a reference library for his murals. He has published books of his designs for murals and botanical paintings, and has also illustrated several children's stories and cookery books.

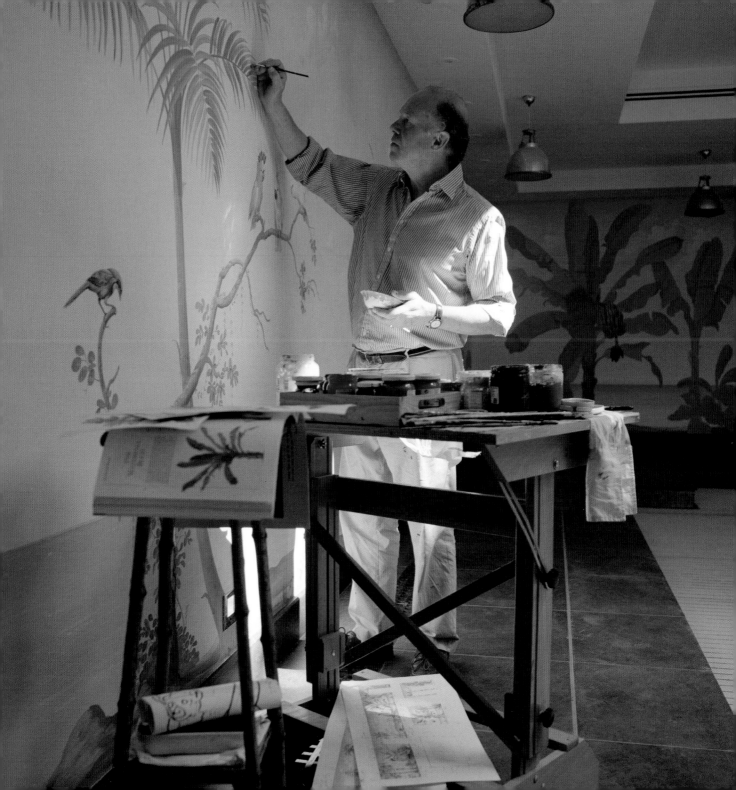

# Jeremy Sancha
## Illustrator

JEREMY SANCHA HAS A ROOF-TOP STUDIO, IN EAST LONDON, up with the weather and the birds, where the skylights show views to the Crystal Palace, Canary Wharf, the Post Office Tower and the Gherkin. The light can be so bright that blinds are needed.

Jeremy comes from a family of artists. His father Carlos was a well-known portrait painter whose work is represented in the Hall of the Art Workers Guild; his mother, a book illustrator, was a Guild member for a short time before her death. His great-uncle was also an illustrator. After leaving art school in the mid-1970s Jeremy was a printmaker for nearly 15 years before moving into illustration. His preferred medium is linocut and he uses a small Albion press for printing his work, which is then, for illustration purposes, reproduced by modern printing techniques. The work nearly always uses a series of flat colours overprinted on each other, which sometimes gives it the flavour of inter war book jackets and travel posters. He is aware of the dangers of repeating himself, but feels that the medium is always open to experimentation.

At the time when younger illustrators rely on the computer, Jeremy's technique could seem old-fashioned, but he feels that it can give him some advantages. Designers are often slaves to fashion, but the timelessness of block printing can still be appreciated in a world of computer-generated images.

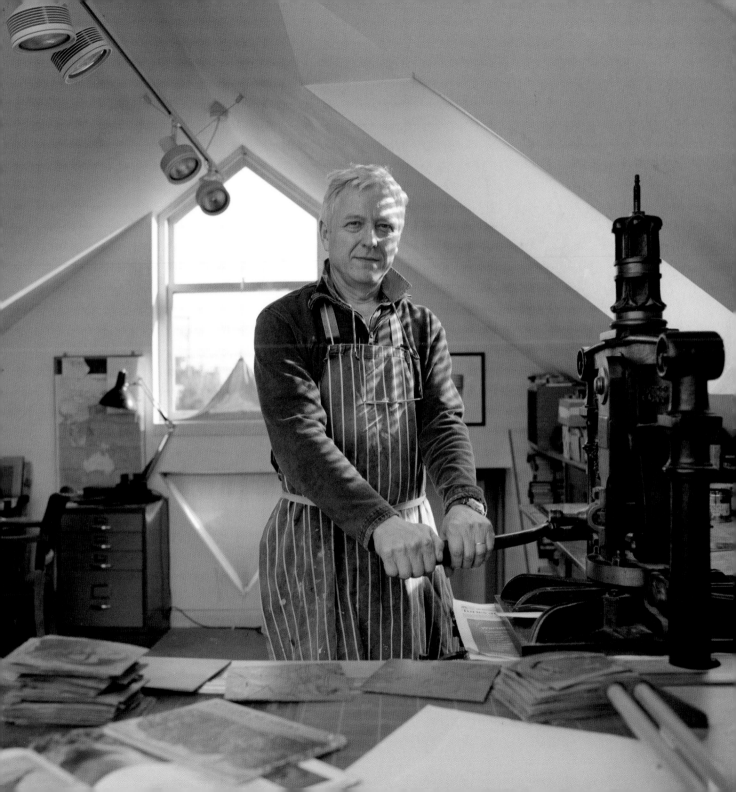

# Matthew Sanderson
**Sculptor**

MATTHEW SANDERSON WORKS IN A CONVERTED GRAIN STORE, near Cambridge. Metals, machines and moulds spread out before the visitor like an unfurled mind map of industrial-sized jewellery for cities.

After studying Fine Art and Sculpture, Matthew worked as an industrial model maker then trained as a silversmith. As a young child he was always interested in the theatre of machinery and design of nature. Today he draws inspiration from his collections of everything from termites' teeth to couture hats. Exciting and original objects pour from the workshop, all of which go beyond the limits of what we usually term sculpture. His most recent commission is a spectacular clock for Corpus Christi College in Cambridge. Stephen Hawking came to unveil the mechanical time-piece, which was invented by John Taylor and engineered by Stewart Huxley. The three have been working together upon a series of 'Time-eating Clocks' for the last five years. Matthew created the dancing escapement beast upon the top of the huge dial enticing people to stand, stare and consider 'Relative Time'. The three-foot-long marching grasshopper, with woven stainless-steel lace wings, enamelled copper armour, gold-plated teeth and eyelids, is the world's largest escapement mechanism.

Other recent commissions include a 'forged forest' of Gothic-style gates at St Faith's primary school in Cambridge, and an enormous two-storey metal wire topiary form for the interior of the rebuilt Pegasus Youth Theatre, Oxford. The very delicate branched network supports over four hundred transparent coloured lenses discreetly engraved with benefactors' names, words of wisdom, and favourite poems.

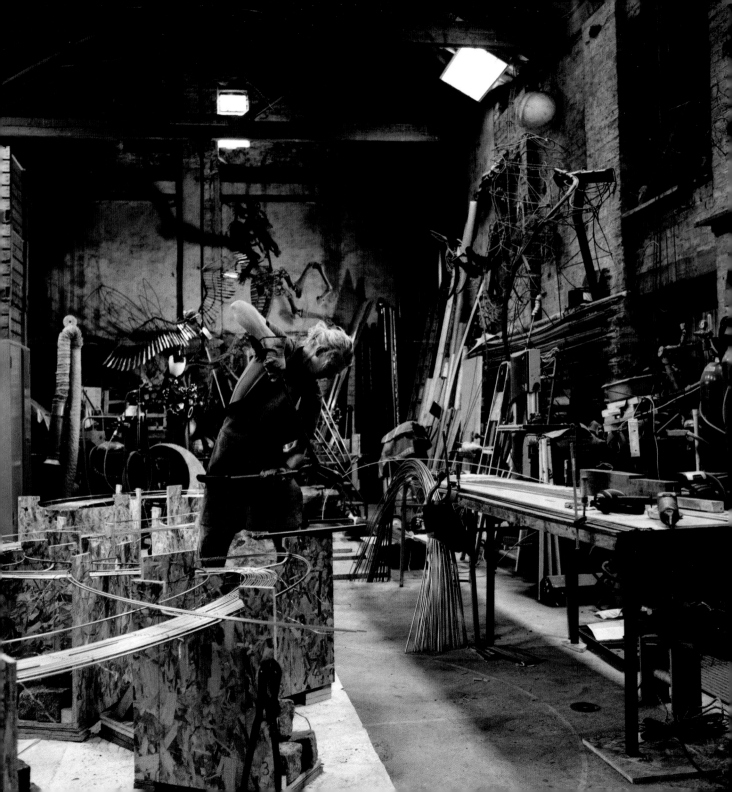

# Romilly Saumarez Smith
**Jewellery Designer and Bookbinder**

ROMILLY AND HER HUSBAND, SECRETARY AND CHIEF
Executive of the Royal Academy, moved into their
fine Georgian house in the East End of London in
1999 after spending two years bringing it back from
dereliction and then designing her own interiors. Her
first craft was bookbinding, but after some 25 years of
work she started to use metal on the books, becoming
increasingly enthralled by the material. She felt she had
completed what she wanted to do in bookbinding and
having always loved fashion and how things look on
people, she launched a new career in jewellery.

She quickly learnt about soldering by repetitive
practice. The individual links in a chain may be
uninteresting but many of them together are simply a
feast for the eye. For Romilly, it was the actual process
of making that took hold of her, the meditative state that
one reaches when making the same object over and over
again. Something amazing happens and the piece can
go in unpredictable directions. With paper and leather
she had to be completely accurate whereas metal can be
recycled, giving a different feel to the activity.

The house reflects her passions for putting modern
things together with old, not necessarily designer
objects, but sympathetically restored and recycled items
that are juxtaposed with the ancient surfaces of the
building. Closing the gate on leaving, one experiences
a feeling of transition in time, carrying some of the
warmth of the Georgian period into twenty-first-
century Mile End Road.

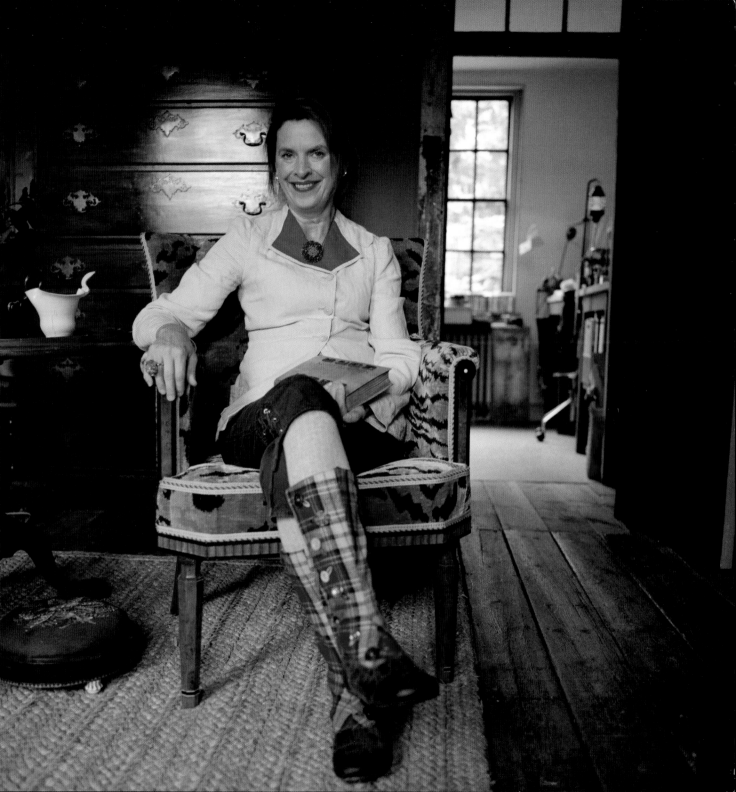

# George Saumarez Smith
## Architect

GEORGE SAUMAREZ SMITH IS ONE OF SEVERAL GUILD members who are directors of Robert Adam Architects. It is not entirely surprising that George has followed a classical path, since his grandfather, Raymond Erith, was one of the most committed and thoughtful classical architects of the mid-twentieth century in Britain, although surprisingly never a member of the Guild. George's training at Edinburgh acknowledged none of this background, but he conformed to the modernist conventions of the school while nurturing his hidden rebellion.

Leaving university he worked with Quinlan Terry, Raymond Erith's partner and successor. He says it was a great relief to be actually working on real buildings and not be limited to the whims of a university design tutor. Moving to Robert Adam in 2003, he has built up a portfolio of his own projects alongside his fellow directors, and his work is notable for its almost minimalist sobriety, suggestive of the late eighteenth century. He is currently the Chairman of Trustees of the Art Workers Guild, probably the youngest holder of this position since the Guild was founded.

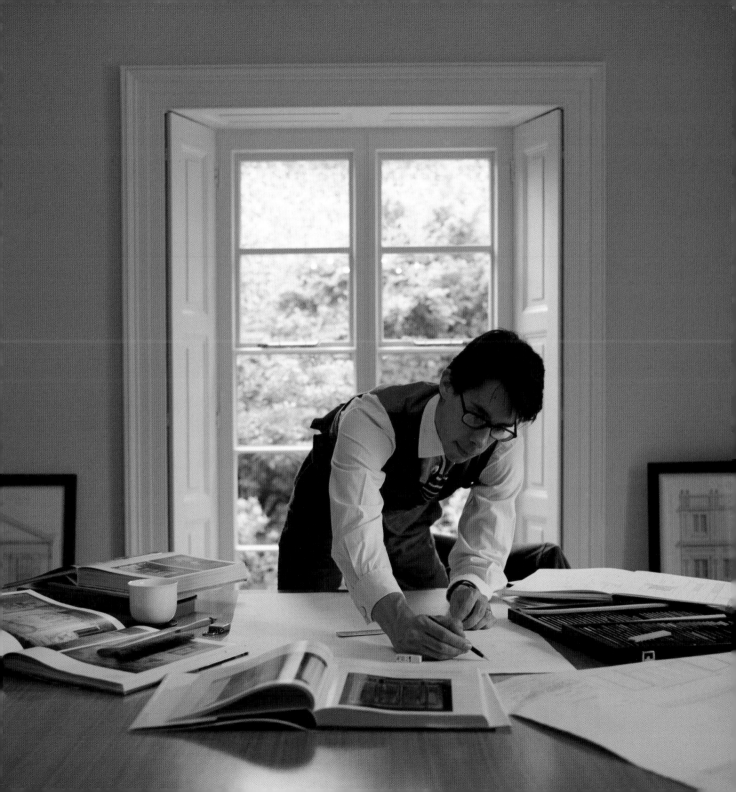

# Sally Scott
## Architectural Glass Engraver, Painter and Printmaker

SALLY SCOTT HAS A CONVERTED STABLE AS A STUDIO, adjoining her cottage in Putney. It has courtyard gardens back and front, full of original planting and colour mixtures. These open into her studio, which provides a light airy space for her work.

Sally trained as a painter at the Royal Academy Schools. She is now best known for her architectural glasswork which can be seen in such locations as Westminster Abbey, St Alban's Abbey, Norwich Cathedral and many churches, universities and other public buildings.

In 1986 she formed a partnership with David Peace, Past Master of the Guild, under the name of 'Peace & Scott'. David specialised in lettering and heraldry, and Sally in design and drawing. Over 15 years together they produced glasswork for five cathedrals and a number of other buildings from Cornwall to Cumbria.

After a career of commissioned (mainly monochrome) glasswork, Sally has recently returned to painting. Here, and through lithography, she can explore her love of colour. Underlying all her work in whatever medium is a love of and commitment to drawing.

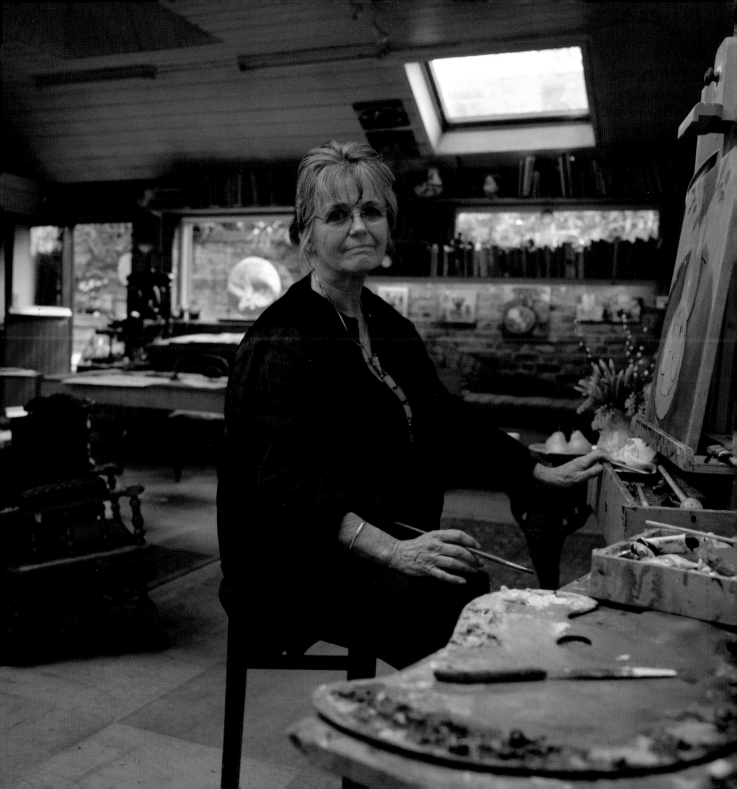

# John Shaw
## Letterer

JOHN SHAW MOVED TO MARKET RASEN, LINCOLNSHIRE from Northumberland in 1991. At the time of this photograph he had recently exhibited at the Monnow Valley Arts Centre. The work was one stage in his exploration of words and how we use them.

The common denominator of the exhibition was the use of the same materials and techniques we associate with memorials, but applied to a wider range of texts than commemorative inscriptions would normally allow. I look at a drawing which incorporates a text from 'In Parenthesis', a poem by the artist-poet David Jones – also a painter of inscriptions – about his experiences as a soldier in France in World War I. John has carved Jones's phrase, 'It's a monumental bollocks every time', in slate and painted it in army camouflage. The letters are disjointed: it is a struggle to read them, as if the words have been blown apart.

Commissioned memorials remain at the core of John's work. During his working lifetime people have become less dependent on the monumental mason's catalogue and have started to recognise the sensitivity an artist can bring to the design and making of a memorial. John believes that there is further potential for lettering to be used imaginatively, and that greater consideration could be given to its inclusion in the design of new buildings and the task of extending or re-ordering existing ones.

'Craftsmen should thank god for scholars' is one text John has worked with which is particularly heartfelt, as he is very conscious of the debt he owes as a letter cutter to the written works of design historians and other practitioners.

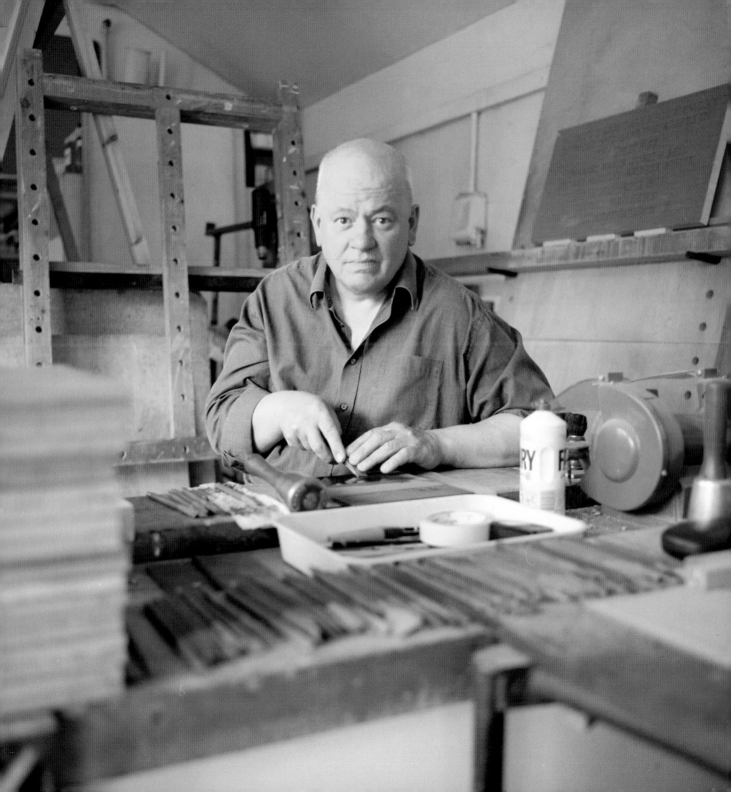

# Tracey Sheppard
## Glass Engraver

TRACEY SHEPPARD BEGAN GLASS ENGRAVING IN 1980, WHILST studying English and Fine Art at London University. She attended an evening class tutored by Past Master Josephine Harris and since then she has remained fascinated by the elusive, reflective and illusionary qualities of this unique medium.

Inspiration comes from many different sources, an indication perhaps of the wide-ranging work that she undertakes, from considerable architectural pieces to intricate private commissions. A love and knowledge of plants remains a prime inspiration: she is enthralled by the representation of the form and structure of the natural world upon glass. Alongside this is an interest in architectural detail, the complex history of buildings and their intricacies, which are often a central theme in her work.

Elected as the youngest Fellow of the Guild of Glass Engravers in 1987, she was Chairman of the Guild for four years and is now the Hon. Vice President. Many of her pieces are held by notable private collectors, and commissions have included work for HM Queen Elizabeth and the late Queen Mother.

A source of commissions for glass engravers in recent years has involved the installation of engraved glass porches and doors in churches. These projects have allowed Tracey to combine complex techniques of acid, sandblast and drill engraving on a large scale.
Her working year is a combination of preparation for exhibitions, teaching – most notably at West Dean College – and working to commission, a relationship of trust and exploration that she welcomes and enjoys.

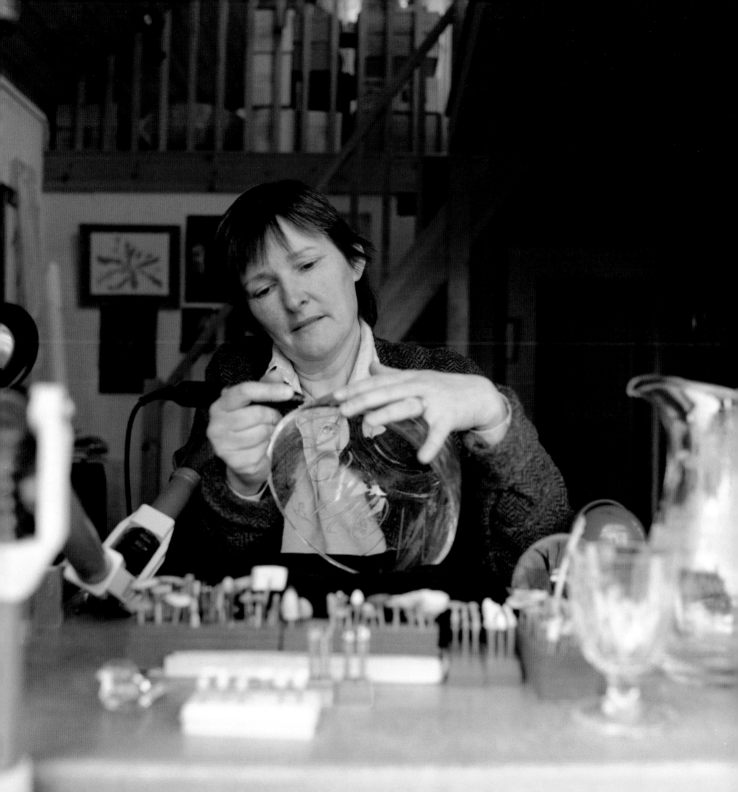

# Arabella Sim
**Artist**

STRAND ON THE GREEN, JUST BESIDE THE RIVER THAMES, HAS been a favourite place for artists for many years. I find Arabella Sim with her three children, making things: art things, paint things. Her home is full of her creations, but only up in her light-filled studio overlooking the river are we in her sanctuary, with large paintings leaning against the walls and drawings and sketches overflowing on the drawing table.

Arabella has only recently returned to painting after seven years of looking after young children. During this time she made use of her creativity by holding small art classes with her own children and other people's in her home.

With so many commitments to her children, every movement has to be focused, with a rapid transition into the intuitive and creative side of the mind. She has often worked with dancers and finds that she can be released into their special way of being, their sense of space. Dancing figures create a special kind of energy, and Arabella thoroughly enjoys capturing that moment.

'I sometimes have no idea how I do a painting or a drawing. Sometimes in that unconscious state, you are not doing anything knowingly.' Yet Arabella finds that her inspiration comes not from this solitary musing but from being with the children. Indeed her 'Mother and Child' drawings represent one of her most important recent themes.

Her lines and forms stem from the romantic tradition. She loves the feeling of abstraction meeting figuration. Through this she can enter a space of simply being and thus free the viewer's imagination.

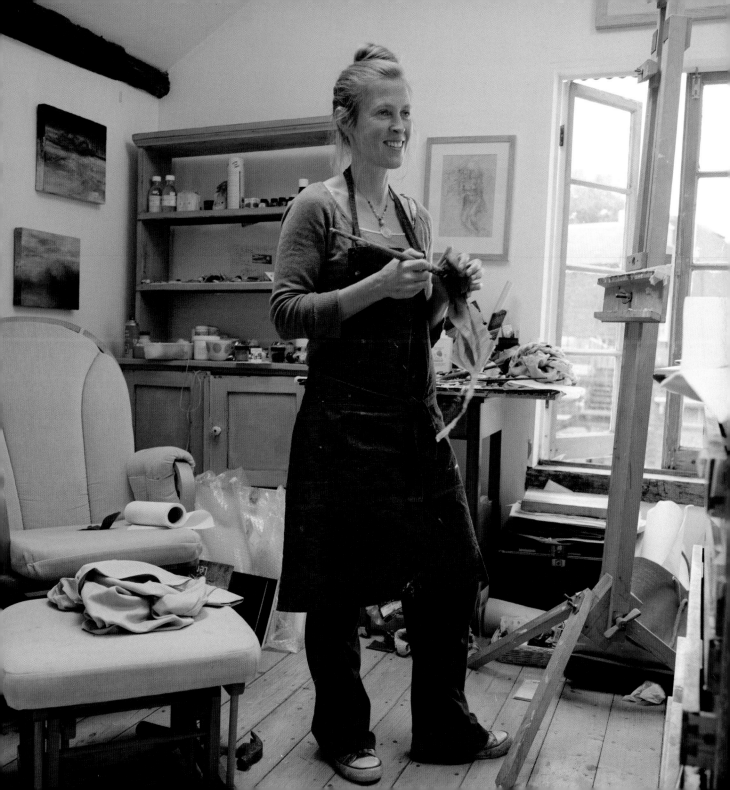

# Peyton Skipwith
## Art Historian

PEYTON SKIPWITH WAS MASTER OF THE GUILD IN 1998 and is seen here in his study in Hampstead checking proofs of his review for *Apollo* magazine of the National Portrait Gallery's Wyndham Lewis exhibition.

Peyton attended Salisbury School of Art. After National Service he decided to become an art dealer and found a position at the Fine Art Society in New Bond Street. He spent the next forty-four years working there, retiring as Deputy Managing Director in 2005. When he joined the firm in 1961 much of its stock consisted of work by then deeply unfashionable Victorian and Edwardian painters and sculptors, including many members of the Art Workers Guild. The period was ripe for reassessment and Peyton counts himself fortunate to have been able to assist with such pioneering exhibitions as *British Sculpture* 1850-1914 (1968) and *The Arts and Crafts Movement* (1973). Through his involvement in the latter exhibition he met many craftsmen and their families, including Edward Barnsley, and he later served for thirteen years as a Trustee of the Edward Barnsley workshops. These interests drew him naturally towards the Art Workers Guild, and he was invited to write an essay for the catalogue of the Guild's centennial exhibition at Brighton Art Gallery in 1984. He was made an Honorary Member, and later served as Honorary Curator.

Since his retirement he has written a series of books on British interwar art and design, initiating with Brian Webb the 'Design' series for the Antique Collectors' Club. He hopes that his researches may result one day in a major book on British fine and decorative arts from 1910 to 1940.

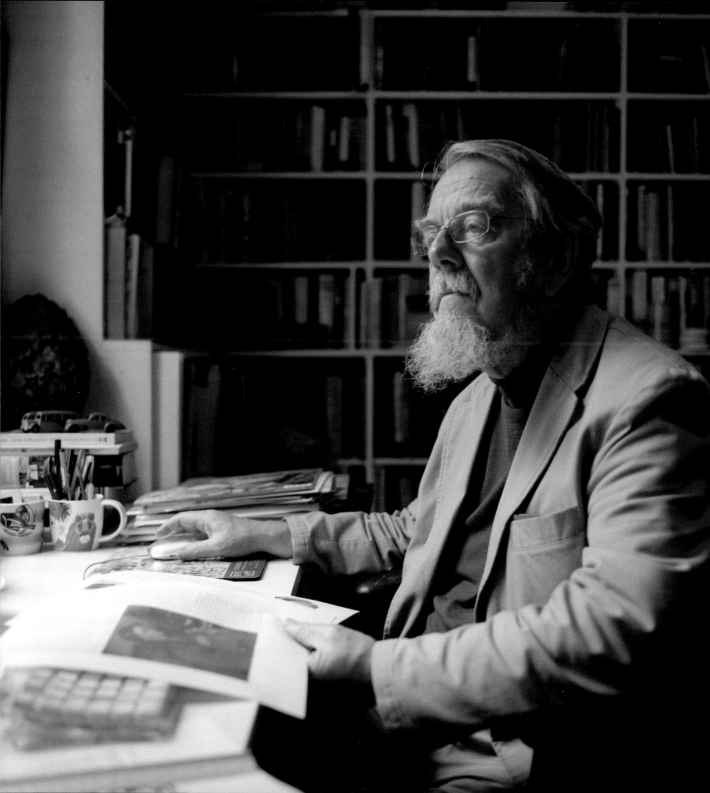

# Ivy Smith
## Painter and Printmaker

IN ONE OF IVY SMITH'S TWO SUNLIT WORKROOMS A PRINTING press occupies a prominent place, surrounded by printmaking equipment, paper and paintings. Her painting room is directly above.

Originally from London, Ivy moved to Swaffham in Norfolk in the 1970s but later felt she was too isolated in the country. Since 1995 she has found Norwich the perfect place to live and work.

She takes commissions when they come up, while slowly building a body of her private work for an exhibition. Her prints can be found in a number of galleries.

Some of Ivy's best-known work shows children swimming, including two paintings that were hospital commissions, one for Belfast and one for Salisbury. Many of the paintings on her walls deal with the small events of daily life – a group of people are playing Monopoly, a man is doing up his tie, a woman relaxing in a chair.

She thinks people are extraordinarily beautiful in what they do. She loves the work of Rogier van der Weyden and Piero della Francesca, with their simplicity of shape and colour, and she feels that this quality in her own work comes about where her paintings and linocuts have influenced each other.

Ivy tells me she is more in love with lino now than she was at college, though hardly because of any sophistication it might have as a medium: 'It is really a caveman technology – a potato-cut really.'

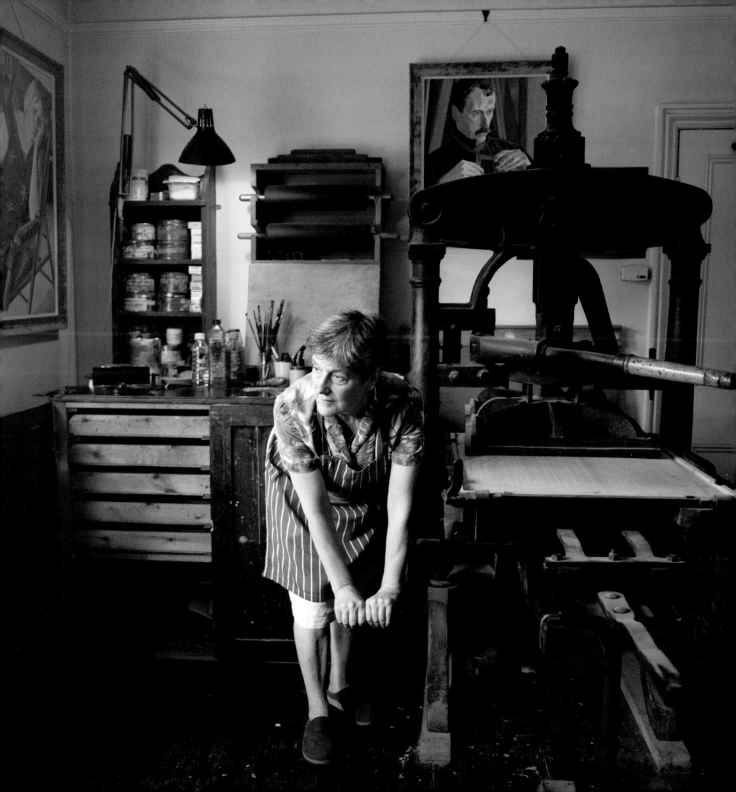

# Simon Smith
## Stone Carver

STANDING ON A SIDE ROAD OFF A SOUTH LONDON ONE-WAY system, Simon Smith holds the keys to a busy stone yard, which he started with the late John Roberts, also a Guild member, and still a major influence. Simon often thinks he hears him moving around the studio.

The stone-carving workshop looks much as its predecessors in renaissance Italy would have done. A cartouche hangs on the wall with an empty space ready for a coat of arms, date or monogram. A life model can often be seen sitting patiently amid the stone dust.

Simon was originally a stone mason, but found the work too straightforward and went back to college at City and Guilds of London Art School to learn about carving. Now, still relatively early in his career, he works for councils as well as private individuals. Commissioned pieces can be very large, and he sometimes hires a student from City and Guilds to rough out the stone beforehand. He also carries out restoration and repair work. Lettering is done by Phil Surey, one of his workshop companions.

With so much commissioned work hand, it is hard for Simon to find time for his own private sculpture. When he does, however, the work comes easily. Freed from the constraints of making a model and discussing it with the client, he is able to work straight into the stone, producing pieces whose simplicity stands in contrast to the detailed fine carving of his commissions.

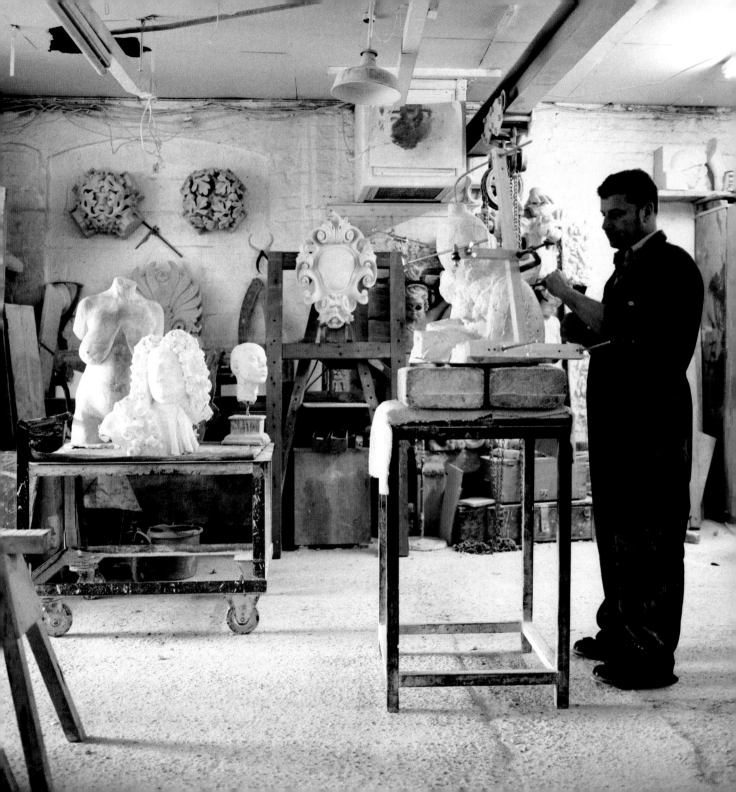

# Charles William Smith

**Letter Carver, Stone Carver, Designer**

COMING THROUGH THE YORKSHIRE VILLAGE WHERE CHARLES Smith lives, I could recognise his rhythmical style of lettering from the carved slate name plaques on a number of buildings.

He likes to draw with the chisel straight onto the stone. 'It seems to me that the more precisely an inscription is marked on the stone then the more mechanical will be the carving, for the mind will cease to think, as the stone is merely removed between the precise pencil lines. The less marking on, the fewer the guide lines, the more the mind feels the shapes it is searching for.' His letterforms have evolved to accommodate such freedom and movement inspired by the inscriptions' meanings over many years.

Charles served an apprenticeship of five years with N.H. Trotman, a firm of monumental sculptors in Newcastle upon Tyne, learning classical letterforms together with masonry and carving. After working as a freelance for some years, he studied calligraphy at Reigate before setting up on his own.

His favourite material for carving is limestone. For lettering slate is often a first choice, but not always. Various aspects of natural history, music, literature and poetry inspire his work.

For the past four years Charles has designed lettering for Helen Whittaker of Barley Studios for inclusion into her stained glass; new windows for Stowmarket Church, Suffolk, and St Gregory's Church, Kirknewton, Northumberland, being just two examples.

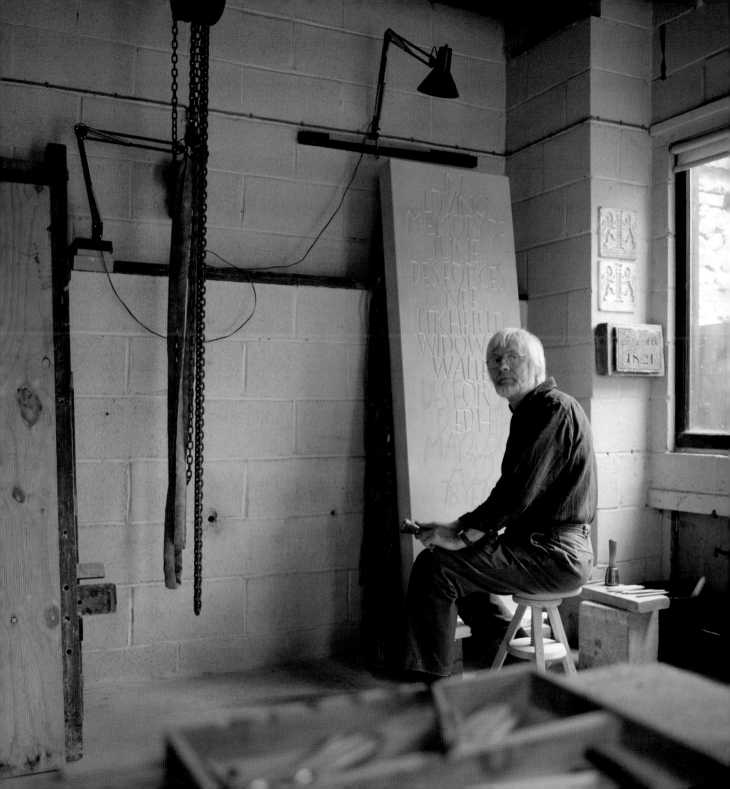

# Neil Stevenson

## Furniture Designer, Furniture Maker, Cabinet Maker

NEIL STEVENSON IS SEEN HERE AT ELTHAM PALACE, inspecting the furniture that his company made for the entrance hall and dining room. The shell of Stephen Courtauld's 1930s interior survived into the 1990s, but the furniture had long vanished when English Heritage wanted to open the house to the public. Replication, based on period photographs, was a novel concept, but it was effective and has led to other work in historic interiors such as Knightshayes Court, where existing pieces were replicated without attempting to make them look old. This is only a small part of his work, however.

Neil and some members of his team of 23 design the furniture, while others do the making. He starts with pen and paper and then moves on to CAD to make the plan more easily understandable for the client and workshop, with documents that can be sent electronically.

He does not want to put a personal stamp on his work, but this does not mean that it lacks originality. 'I am very conscious of not following the simple path of designing things that have worked before,' he explains. 'We are always looking for new and interesting things to do. I wouldn't really want people to look at our furniture and say, "Oh, that's a Stevenson."'

He tries to keep a constant stream of apprentices in employment. 'It is the constant development of their skills that enables them to be confident furniture makers.'

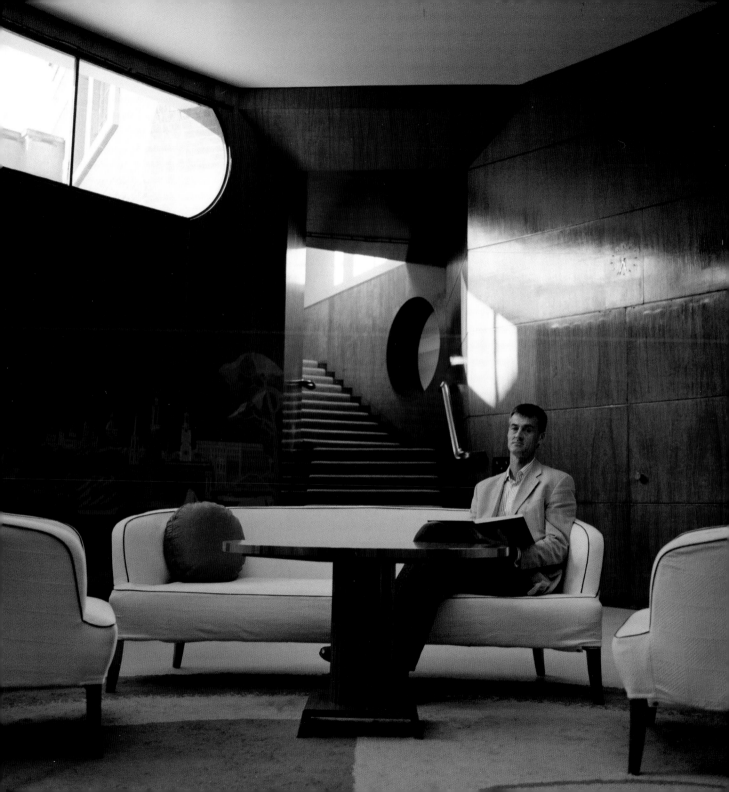

# Philip Surey
## Stone Carver and Letterer

PHIL SUREY'S WORKSHOP IS A SMALL MODERN SPACE, IN distinct contrast to the renaissance feel of fellow Guild member Simon Smith's stone-carving yard next door. Phil often works on site, directly onto buildings, while back in his workshop his personal pieces, clean-cut three-dimensional stone blocks resting on easels, wait to have some quality time spent on them.

Having begun as a signwriter, Phil wanted to become more deeply involved with letters and studied at City and Guilds. Visiting a Cork Street gallery, he came across a passage of perplexingly loose lettering on a broken rough boulder by Ralph Beyer, and realised that a very personal approach was possible.

Commissions – for which he often uses both brush and carved lettering – have followed from Westminster Abbey, Wilton House, the National Trust, the British Council and many city churches.

His personal work, in contrast to his commissioned pieces, is predominantly abstract. In a current project of 26 carvings in low relief, Phil utilises the movements required to write individual lower case letters, allowing freedom to mould shape, shadow and line. This is a reaction to the restrictions of conventional letter cutting; a sort of stone drawing that allows the negative uncut space to act as rhythmically as the cut. Progress has been unexpectedly rapid, and he has been working enthusiastically to complete the project.

Stone carving, he tells me, may look like a slow process to anyone observing him on site, but for him it is the most immediate thing you can do.

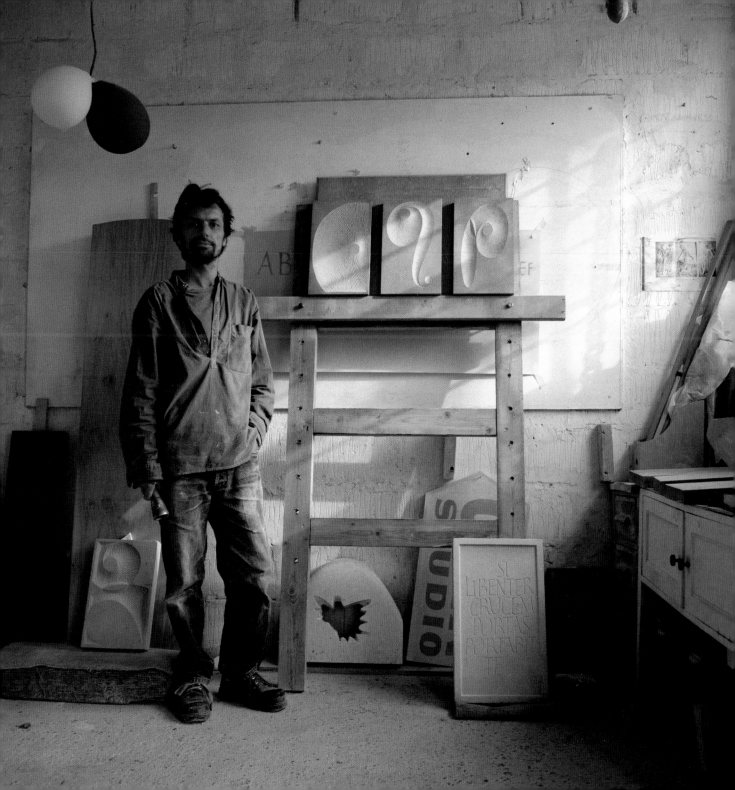

# Caroline Swash
## Stained Glass Artist

CAROLINE IS SEEN HERE AT CENTRAL ST MARTINS COLLEGE of Art and Design where she is Pathway Leader on the postgraduate course in Glass, Fine Art and Architecture.

Her work is mainly commissioned for churches and cathedrals. Recently she made two new windows for Salisbury Cathedral – they include scenes set in Borneo, the Falklands, Northern Ireland and Iraq – to mark the 50th Anniversary of the Army Air Corps. Caroline thrives on the imagination and storytelling that a commission such as this requires.

She works on all stages of a commission from design to installation, with the help of Laura Pes and Philip Broome, both of whom have been colleagues for many years.

Her father Edward Payne and his father Henry Payne were also stained glass artists. Her father gave her a real understanding of how long a project might take and the care needed to complete it – things not generally mentioned at Art College.

A fascination for the patterns found in nature runs through her work as a painter and informed her early work as a textile artist. She loves the fact that a window can be built up with layers of colour and that different light conditions in a building alter the visual impact of the image.

'At Central I say to the students, "Think carefully about how *best* you can achieve the effects you want in glass, not how *speedily* you can get the work done. Accept and enjoy the task, whether it takes a day or a week."'

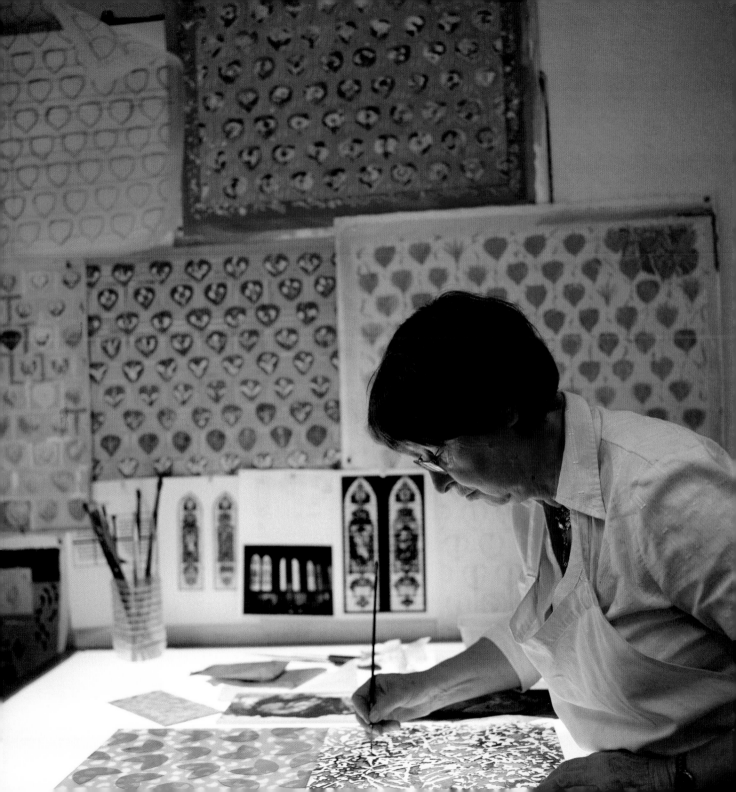

# Jacqueline Taber
## Painter, Picture Restorer and Gallery Owner

JACQUELINE TABER HAS LIVED IN FINGRINGHOE NEAR
Colchester on and off since the late 1950s. Her small
cottage has a farmyard surrounded by outbuildings, one
of which she uses as a gallery and the other as a studio.

The Geedon Gallery is a converted Essex barn which
overlooks the Colne Estuary and has been established
for nearly ten years. Jacqueline and her business
partner exhibit modern British painters and sculptors
twice annually, including work by members of the Art
Workers Guild. The exhibitions attract visitors and
exhibitors from far afield.

In her quiet peaceful studio across from the gallery
Jacqueline paints still-lifes and restores oil paintings.
She loves working with dark backgrounds, creating a
chiaroscuro of contrasting light and shade. The paintings
are extremely detailed and meticulously finished, a
result of her rigorous schooling in Italy at the studio of
Signorina Simi, where you were not allowed to touch
colour until you could draw. At the same time she
studied restoration at the Gabinetto del Restauro at the
Uffizi in Florence under the tutelage of Professor Van
Merhan.

Along with this strict training, her work is strongly
influenced by her first husband, the painter Lincoln
Taber, who studied with Pietro Annigoni, and by the
Spanish still-life painters such as Zurbarán.

When a painting is finished Jacqueline frames it and
then puts it away for reappraisal. She says that her son
Lincoln (also a member of the Art Workers Guild) is a
fantastic critic, although she believes she is the hardest
of all when looking at her own work.

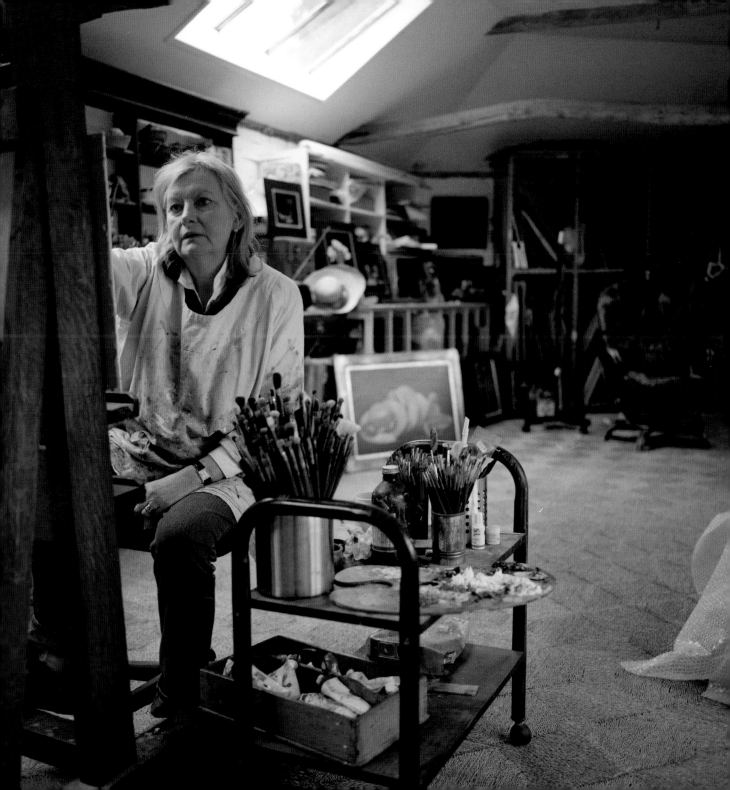

# Zachary Taylor
## Early Stringed Musical Instrument Maker

ZACHARY TAYLOR IS A DE-TRIBALISED MIDLANDER LIVING
IN Aylesbury, and has a workshop filled with musical
instruments, tools and work-benches. He is an expert
on the Saxon lyre, has edited several magazines,
published a succession of books and directed many
music programmes on historical stringed instruments
and woodworking for television. He was Master of the
Guild in 2001.

Zachary first became interested in making instruments
when he was studying engineering and music, soon
giving up industry to follow a musical career. He gained
a Fellowship at the Midland School of Guitar in 1959
and played the classical guitar with the Birmingham
Symphony Orchestra. His passion for historical stringed
instruments grew from researching and working with
the Real Conservatorio de Madrid.

He has composed the music for many stage productions
and has appeared a few times in stage roles. He was
a visiting tutor for over 30 years for the instrument-
making course at West Dean College and was engaged
by Missenden Abbey as a tutor of medieval music
drama and lutherie. Many of his classes, tutorials and
performances have been broadcast on the BBC. He has
also performed at the Royal Opera House, on occasion
in operas featuring Luciano Pavarotti and Placido
Domingo, and appeared as a guitarist in the Peter
Sellers film *Hoffman*.

Today Zachary works as a consultant, designing and
making prototypes for production of early stringed
instruments. Lately he has performed mediaeval
dramas with Farandole, an early music group he formed
with Alan Hamilton.

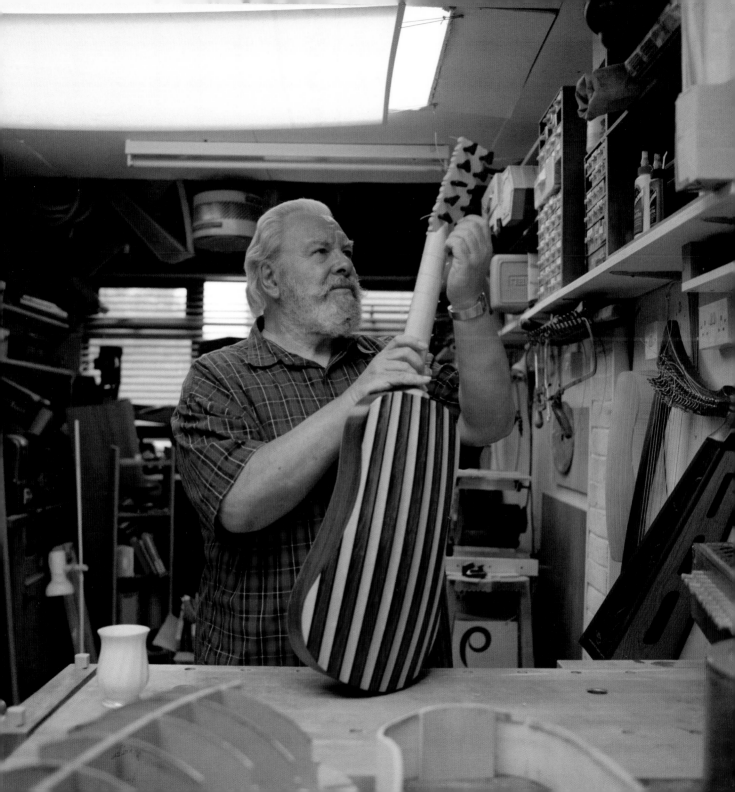

# Llewellyn Thomas
## Printmaker and Visual Media Teacher

LLEWELLYN THOMAS IS SEEN HERE WORKING ON AN ALBION press, at the University of Creative Arts, Maidstone, where he has been teaching since 1988. Before that he worked as a scene-painter, sculptor and book illustrator. Now, his work is primarily digital. Digital does not imply a disconnection from the making processes, however. 'I am an art worker, with no pretences,' Llewellyn explains. 'Things need to be made and materials and techniques are something I adopt.'

His students learn an all-round understanding of image-making and visual communication, from life-drawing and engraving through to digital output. The course prepares them for working in industry. The combination of old and new is graphically represented in the Maidstone studios. The printing room is vast, with Columbian, Albion and Rochat presses. The digital room is equipped with the latest computer appliances and the hallways are filled with large outputs of both analogue and digital prints. The emphasis is on print.

Llewellyn tells me that as art workers we are in a line of inheritance. The sculptor Edwin Russell, who taught him, was trained by Arthur Ayres, who was himself trained by Eric Gill. It is this history that he instils amongst his students today. Do they understand the sense of this legacy? He is confident that they will, even if not immediately. Something has brought them to the college – they are there for a reason.

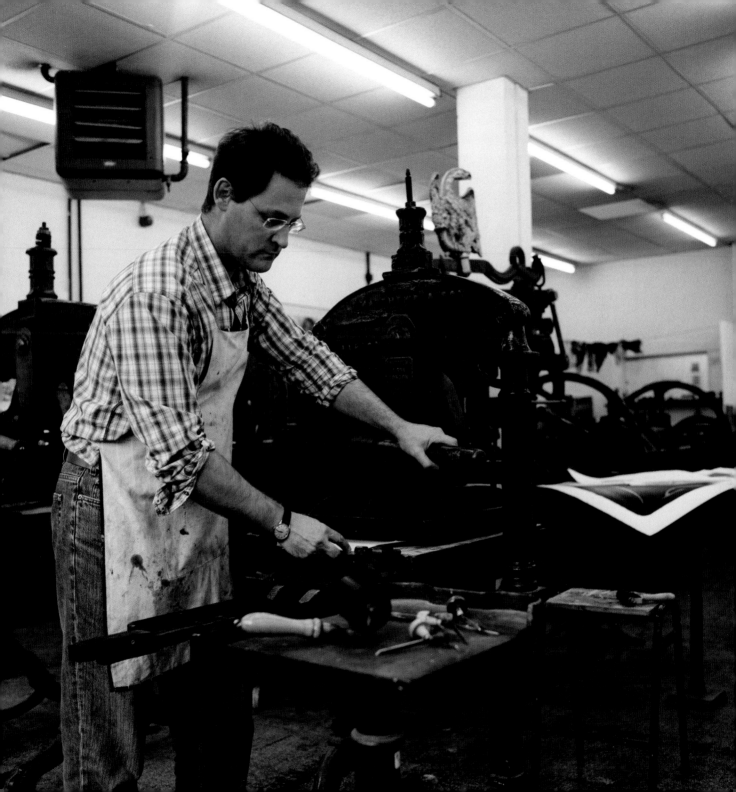

# Brian Tunnicliffe
**Bow Maker**

DRIVING TOWARDS BOW BROOK COTTAGE IN TEMPLECOMBE, Somerset, I wonder if Brian Tunnicliffe, bowmaker, had found the cottage because of its name or renamed the cottage to relate to his craft. Neither. It was just a matter of chance.

Brian began his working life as an apprentice and journeyman patternmaker, then trained in engineering, and worked for 20 years as a teacher of woodwork, metalwork and engineering drawing. It was the late Past Master Arthur Bultitude, a renowned bowmaker, who introduced him 30 years ago to the trade, and he hasn't looked back since.

Different periods of music have required different bows, depending on the strength of 'vibrato' required and the fashionable styles of the time. Brian makes bows for the Renaissance, Baroque, Classical and Modern periods, and many examples of his handiwork can be found in the top London orchestras, such as the LSO, RPO, and the Royal Academy of Music. He also gives lectures in bow-making, keen to ensure that the craft is continued by the next generation.

Brian enjoys the tranquillity of making the bows in his workshop, allowing the sun to alter the colours of the dyed wood. His engineering skills are valuable in repair work and in making up the new components for the various parts of the bow. Before his career change he already had the skills required to make a bow and just needed to adapt them. The line, the form and the stress on the wood and the strength of the hair used are all factors to be considered. It all requires careful planning and the deep knowledge that comes from practice and dedication to the musicians' needs.

256

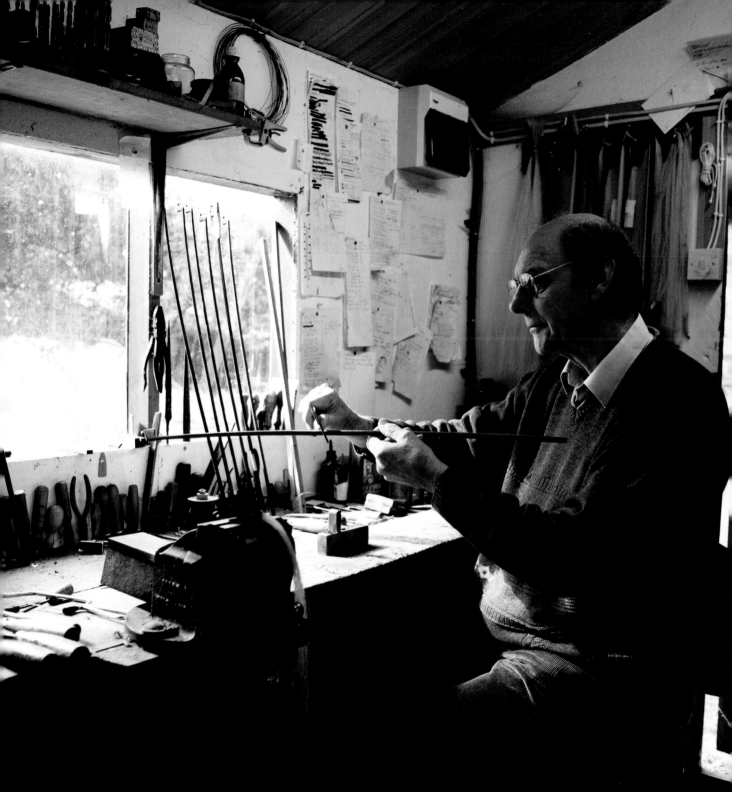

# Rosamond Ulph
## Painter and Printmaker

FOR OVER 20 YEARS ROSAMOND ULPH HAS LIVED IN LITTLE Dunmow, Essex, where her studio looks out over the gentle landscape beyond. She recently moved next door to a newly designed house, with a new studio and print workshop. The past two years have been spent preparing her new home and workspace, during which time painting, calligraphy and printmaking commissions have had to take a back seat. Nevertheless the work to the house has been in itself an exciting and fulfilling creative process.

Rosamond is fascinated by maps and often takes calligraphic commissions for field maps, incorporating details from local history and customs, such as Morris dancing in Thaxted, or the Shipping Forecast. She is also a botanical artist, and puts texts from medieval herbals into her illustrations. She taught calligraphy in a local prison at one time, and started a private class for botanical painting and calligraphy about 15 years ago, which she still continues.

She exhibits at the Cambridge Drawing Society, and occasionally at the Mall Galleries or the Royal Academy Summer Exhibition. Her botanical studies are exhibited at the Royal Horticultural Society, and local exhibitions in Essex, Cambridge and Norfolk. A few years ago, she travelled to India with a poet friend, who wrote a series of poems as a direct response to their tour of Rajasthan. The poems, which Rosamond illustrated, were published in a limited edition as *The Monsoon Room*. Another book is planned for the near future.

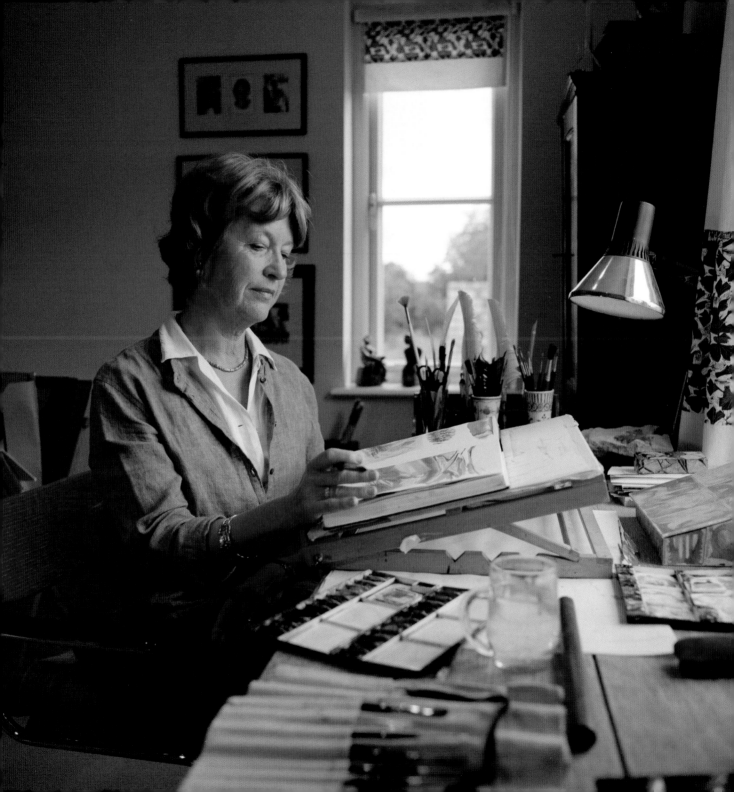

# Robin Campbell Wade
## Museum and Exhibition Designer

ROBIN WADE IS SEEN HERE WITH A MODEL OF A MUSEUM exhibition for which he is a consultant. The room in Richmond is filled with musical scores, histories and catalogues of collections, and a woodworking bench for making models.

He started working life serving a five-year apprenticeship in Australia as a woodcarver and cabinetmaker. In London he graduated as a furniture and interior designer in Professor Dick Russell's School of Wood, Metals and Plastics at the Royal College of Art, and was subsequently employed by Dick Russell's architectural practice. There he had the amazing good fortune to be given the job of designing the Greek and Roman Galleries at the British Museum.

After setting up his own design office he went on to plan and design museum collections across the world for over 40 years. His clients have included historic buildings, contemporary museums, and visitor centres, where the subjects on display have ranged from historical subjects like wars and archaeology to more popular ones like sport and famous people.

Being relatively ignorant, he tells me, can be a great advantage in the museum world. 'Seriously, if you know too much about a subject, you might not be the best person to design an exhibition.'

Robin founded his company alone, but over time has collaborated with many consultants and design partners. Today, although officially retired, he still acts as a consultant with his professional partner and friend David McCabe, with whom he has worked since 1973.

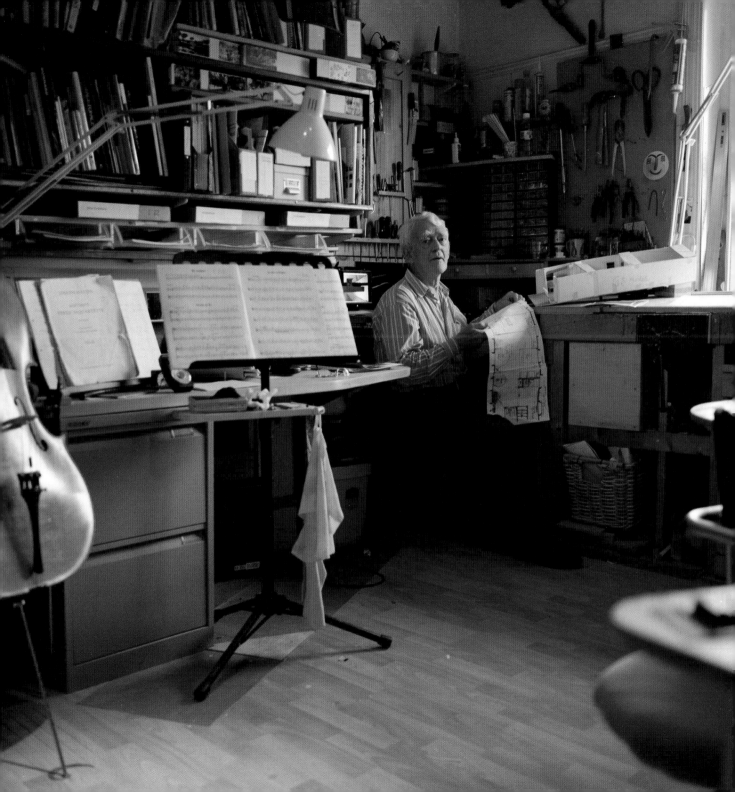

# Tim Ward
## Sculptor and Mosaicist

TIM WARD IS ARTISTIC DIRECTOR OF 'CIRCLING THE SQUARE', an environmental and public arts practice, committed to working collaboratively with project partners on delivering projects within urban regeneration and architectural schemes, from initiating cultural strategies to the implementation of innovative projects. He aims to create projects of real value which are strongly supported by local communities, and which imbue a shared sense of ownership and pride in the improvements.

He is currently working on a mosaic 'human' sundial for Downhills School in East London. This interactive arts project was created with the involvement of staff and pupils, who worked with the artist to design and make sections of the mosaic.

Tim welcomes and encourages people of all ages to become involved at all stages of the creative process. This engagement gives them good insight into the workings of the artist, and sharing in the task of creating the artwork can have therapeutic value.

'People respond positively to this opportunity. They do not want things to be elitist and like "clues" to the themes and forms of the artwork. People like quality and craftsmanship.'

Tim, working with the other artists and designers of the 'Circling the Square' team, has undertaken many different public art schemes, including mosaic, sculpture, water features and creative lighting projects.

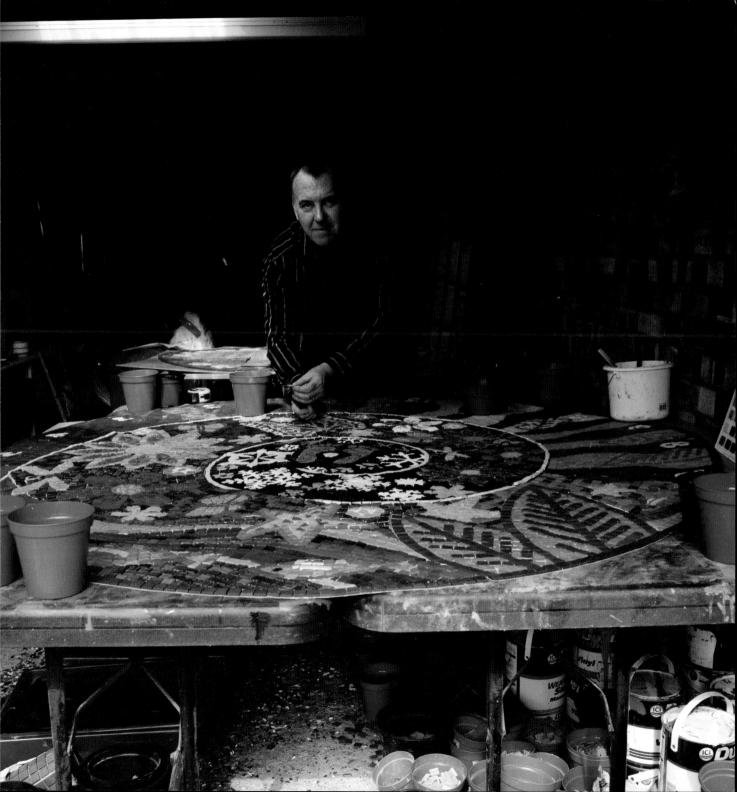

# Brian Webb

## Graphic Designer and Typographer

FROM AN EARLY AGE, BRIAN WEBB KNEW THAT HE WANTED to be a designer, only at the time he did not know the name for it. He studied technical illustration at Liverpool and then went on to Canterbury to study for a Dip. AD Graphic Design. After a brief spell working as an assistant designer in London, he set up Trickett and Webb Limited in 1971, designing for a range of clients from small companies to international organisations, with projects varying from packaging and posters to identities and exhibitions.

Now Webb & Webb, the firm works for many design-aware clients, including the Royal Mail, architects, furniture designers, museums, galleries and publishers. Recently Brian has been working with Guild member and Past Master Peyton Skipwith, co-writing and designing the Design series of books on artist designers. Edward Bawden and Eric Ravilious were the first in the series, followed by Paul and John Nash and then E. McKnight Kauffer, Curwen Press and Lovat Fraser, with more appearing each year.

Brian is passionate about communication, and likes working in a team where everyone can bounce ideas off each other. The design process for him is a collaborative activity. Projects such as the design of postage stamps can involve lengthy research with the whole office becoming the world's experts on that subject for that moment.

Brian is a Past Master of the Guild and Past President of the Chartered Society of Designers. He is currently a Fellow of the University for the Creative Arts and a Visiting Professor of the University of the Arts, London.

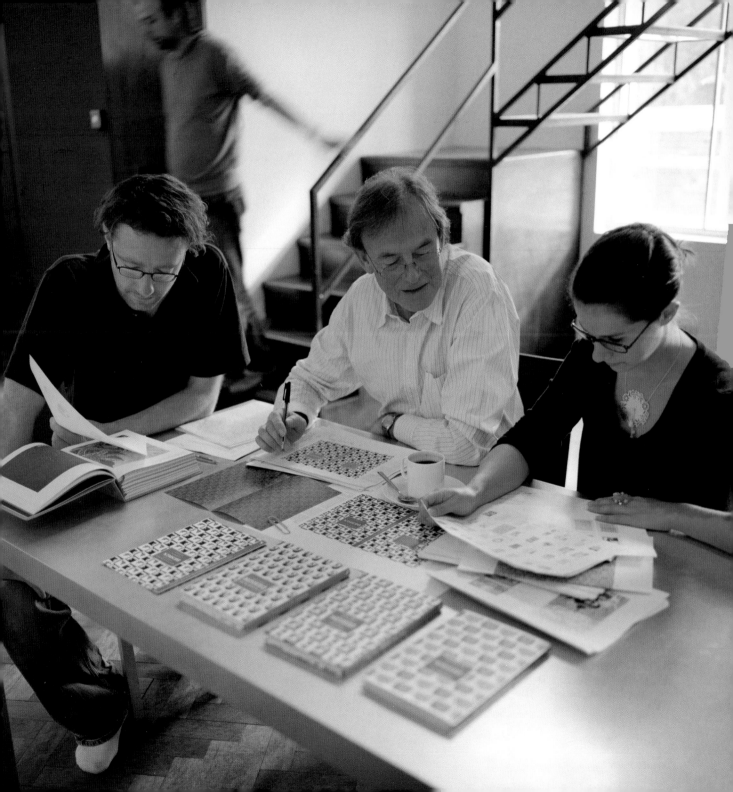

# Caroline Webb
## Letter Cutter and Letter Designer

CAROLINE WEBB'S WORKSHOP LOOKS OUT OVER THE VILLAGE green in the quiet village of All Cannings in the Pewsey Vale. The beehives surrounding her are a commission from the Edinburgh Sculpture Park, who want a poem engraved on them.

Caroline's family has a long tradition within the Arts and Crafts Movement. Her grandfather, the stained glass artist Christopher Webb, was the nephew of Sir Aston Webb, architect of Admiralty Arch and the main front of the Victoria and Albert Museum. Her father, Guild member John Webb, has spent his working life making fine ecclesiastical silver.

It was Caroline's grandmother who introduced her to carved lettering, taking her round graveyards and encouraging her to make rubbings. She studied Typography at Reading University and in 1984 started out as a letter cutter. In the course of her career she has collaborated with Ian Hamilton Finlay — she contributed to his garden, 'Stonypath', in Scotland — and designed medals for the Royal Mint. Here she is working on a long wooden pole for the Art of Memory exhibition organised by Guild member Harriet Frazer and the Memorial Arts Trust.

Caroline likes working with both wood and stone, though her wood tools are more personal to her than her stone ones. 'You have to coax the letter out of wood, whereas with stone it is a more immediate process.' Through her love of literature and especially poetry she understands the importance of simplicity in communication, so it is natural that she favours traditional forms in the way she handles the relationship between meaning, letterforms and design.

266

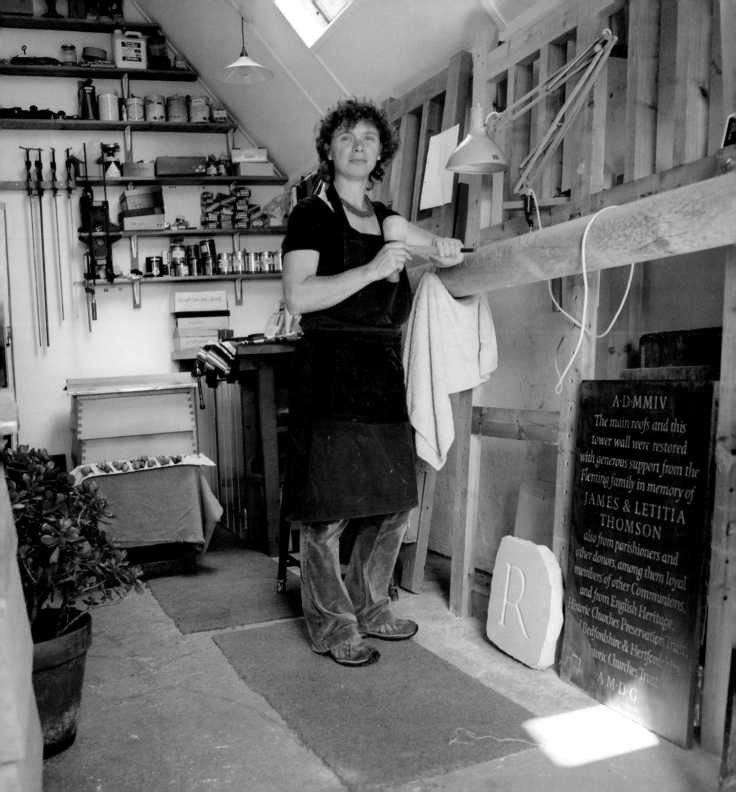

# Julie Westbury
**Artist and Illustrator**

A FRESH SEA BREEZE ON A BRIGHT SUNNY DAY AT THE south-eastern edge of Kent is the background to Julie Westbury's light-filled studio. Her mantelpiece is filled with white jugs of pencils, brushes and dip pens, and the walls are decorated with her characteristic card reliefs and long pen-and-ink drawings of the landscape.

Julie moved to Ramsgate because of the seaside and the light. Although she has no direct sea-view from her window, just open the front door and look downhill and there it is in its full glory.

Before moving to Ramsgate Julie shared a studio in Hammersmith but now she has the space to plan and create work in different scales and media. Her current work frequently uses postcards of local scenes made from her own photographs, from which she generates surprising patterns: the concrete balls in the harbour, for example, becoming a row of pearls.

Julie works to commission, alongside making plenty of work for exhibition. Rather than limiting herself to a particular market, she prefers to have the freedom to create work on her own terms. She is fascinated by museums and their collections, especially ethnographic artefacts, costume and dress. One of her pieces, 'The Paper Madonnas', started from a museum base. Again using postcards, it presents us with a series of iconic images which, like the seaside, cross all times and all cultures, high and low.

The effervescence of the sea is reflected in the atmosphere, which adds to her sense of energy. 'I'm still wearing rose-coloured spectacles. I love living and working by the sea.'

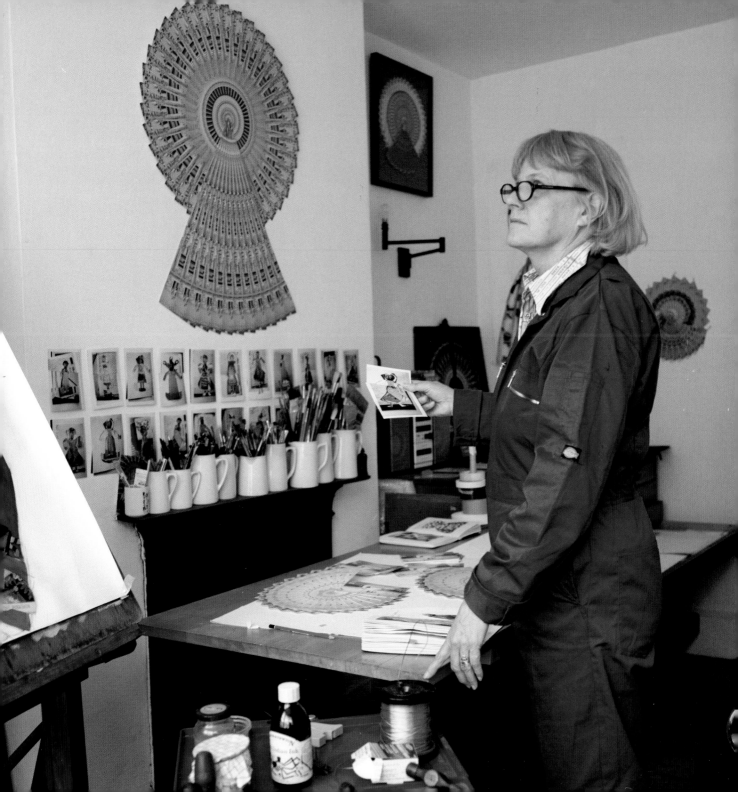

# John Whittall
## Portrait Painter

ON A DELIGHTFULLY SUNNY AFTERNOON, JOHN WHITTALL returns from his morning painting session on Wimbledon Common, where he is a familiar sight for local people, who often give him a friendly nod as they pass by.

His studio, shared with his wife, is on the top floor of their house beside the common, behind a white wooden fence. The walls are lined with paintings of his neighbourhood, all done from the same viewing point, but in different lights and seasons. The front and back courtyards provide peace and quiet, and the studio has skylights and wide windows. A mirror gives the illusion that the space is twice its actual size.

At school, John says, painting was really the only thing that he did well, and at the age of 14 the headmaster sent him off to Camberwell for Saturday classes. Thanks to the constant life-drawing, he was hooked. His father, a musician, couldn't offer a financial cushion, but always encouraged him.

He went on to the Royal Academy Schools and in 1972 a couple of portrait commissions started his career as a painter. He also paints landscapes and still-lifes, but portraits get him out of his routine, challenging him to look for something different. He tells me that it is terribly important to be truthful to yourself and both improve your technique and get the feeling of the sitter across. Success does not simply come from the composition but 'getting that stillness, their sensibility across the sum of expressions and the sum of the person'.

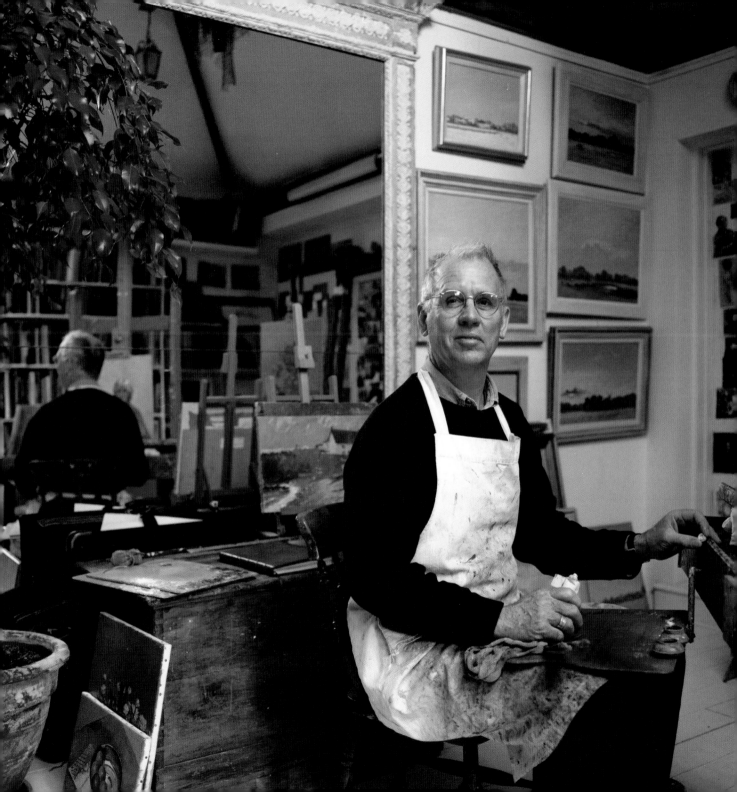

# Gilbert Whyman
**Sculptor**

THE MOMENT YOU WALK INTO GILBERT WHYMAN'S STUDIO garden, you are greeted by a host of metal creatures, each with its own individual character and story to tell: where they originated and how they came to form part of Gibert's heavenly menagerie.

'People bring me bits of rusty metal in the boots of their cars, and I find it difficult to turn anything away. I think of it as my colour palette and you rarely know which colour you are never going to use.'

As well as an indoor studio, Gilbert has an open-air welding workshop, into which I am immediately drawn. A giraffe and a crocodile wait patiently to go off to an exhibition in the RHS gardens at Wisley. In the covered space a little tortoise still needs a back leg. 'I sometimes think that pieces of metal are sidling up to me with their hands up saying 'please use us'.

Gilbert likes his sculptures to stimulate people's imaginations. Each piece invites investigation into its previous life as a functional object. 'A rusty engine? It's a body for a pig. A pair of scissors makes a perfect dancer.'

Natural weathering provides further patination. Gilbert teaches sculpture at Heatherley's School of Art and in Richmond, and often takes pieces of rusty metal into the class for his students to observe and paint the striking and mysterious hues.

His storage sites are confined to distant corners of his garden. 'A bit like Steptoe's yard' is how he describes it. 'The problem is finding a particular piece when you need it. It is one form of recycling, I suppose.'

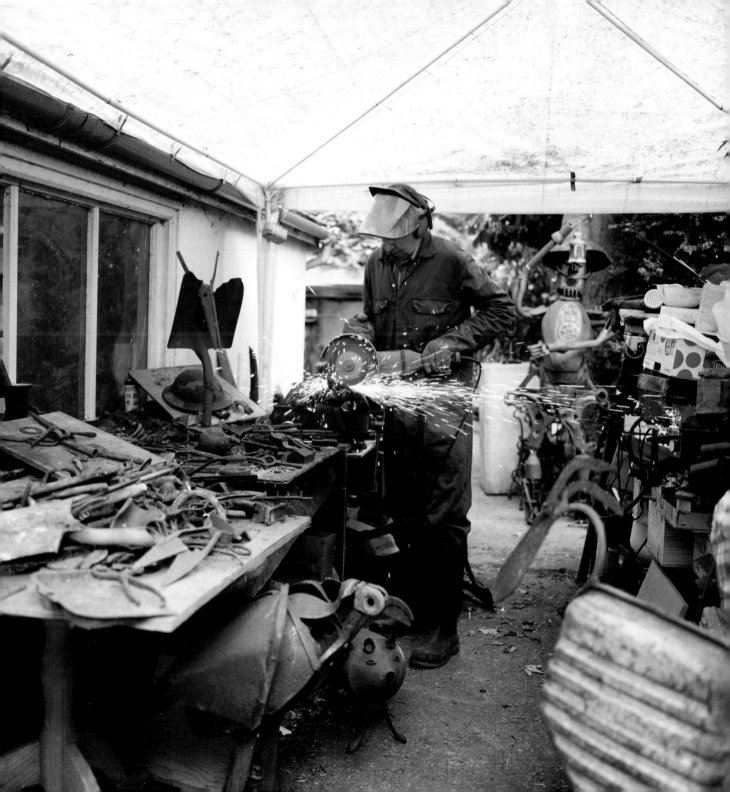

# Graham Williams

## Sculptor and Printmaker

GRAHAM WILLIAMS WORKS FROM TWO WORKSHOPS, ONE in France and his main home at Biddenden in Kent, where the photograph was taken. He is now a sculptor, working with stainless steel, bronze and stone, but his first career was in commercial art and then printing and illustration. Graham was a director of the Folio Society and ran the Florin Press, printing limited edition books on Albion and Columbian presses.

His life took a dramatic turn in 1981 when he was commissioned to produce the notes for a portfolio of prints by the sculptor Naum Gabo. A year later he married Gabo's daughter Nina and together they looked after Gabo's estate. Inspired by Gabo's work, he began his new career as a sculptor.

Like Gabo, Graham abstracts the kinetic forces and rhythms of nature and turns them into objects. For him, line represents a force rather than an outline or edge. His pieces are so finely honed that they contain nothing but the essence of the form.

Graham has a friend, an agricultural engineer, who assists him with the engineering side, enabling him to expand his own kinetic horizon while at the same time opening up the world of art to his friend, who previously had rather dismissed art as a waste of tax-payers' money.

Although sculpture may seem a new career for Graham, he tells me that in an 18th-century encyclopaedia he found an entry that defined making pictures on a wood block as 'properly, a part of sculpture'. So in a sense sculpture is what he has been doing all along.

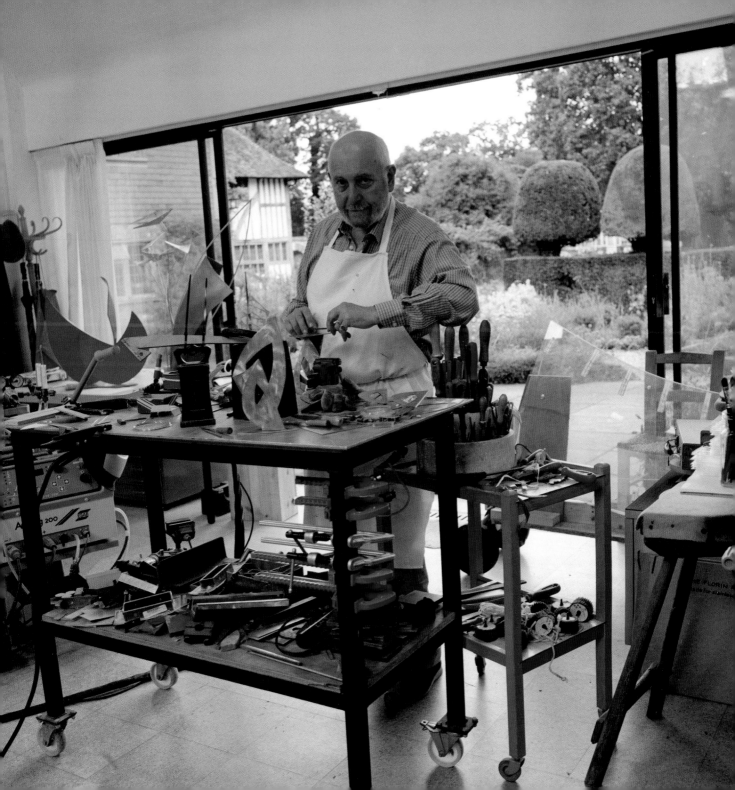

# Mark Winstanley
## Craft Bookbinder

Nineteen years ago Mark Winstanley joined Hannah More and Rosie Gray to start the Wyvern Bindery in Clerkenwell Road, named after the heraldic bird that marks the boundaries of the City of London. The traditional shop has a splendid painted roller shutter that enlivens the street at nights and weekends. By day it is far from quiet, with intermittent hammering ringing out while the music of Grateful Dead and Patsy Cline plays in the background.

At the Wyvern Bindery, everyone is involved in the three major aspects of the job, sewing, forwarding and finishing. Mark now mainly works on the finishing, and running the business. He found his way into binding after working in a second-hand book shop. Realising that he wanted to create something, he took a course at London College of Printing, where his tutor Arthur Johnson, a devotee of William Morris, was a great inspiration. After starting out working for trade binders he created Wyvern as a route to greater freedom.

Today the bindery has international clients, and handles jobs ranging from the repair of old family bibles from Virginia to making one-off books for local artists and photographers. It can also operate on a bigger scale, producing 100 books for a corporate client when required.

Recently Mark was able to follow a dream and visit Ethiopia to repair the front eight pages of a sixth-century manuscript from a monastery in Axsum.

In the shop a sign draws attention to the seriousness of the enterprise: 'We do not inherit our books from our fathers. We borrow them from our children.'

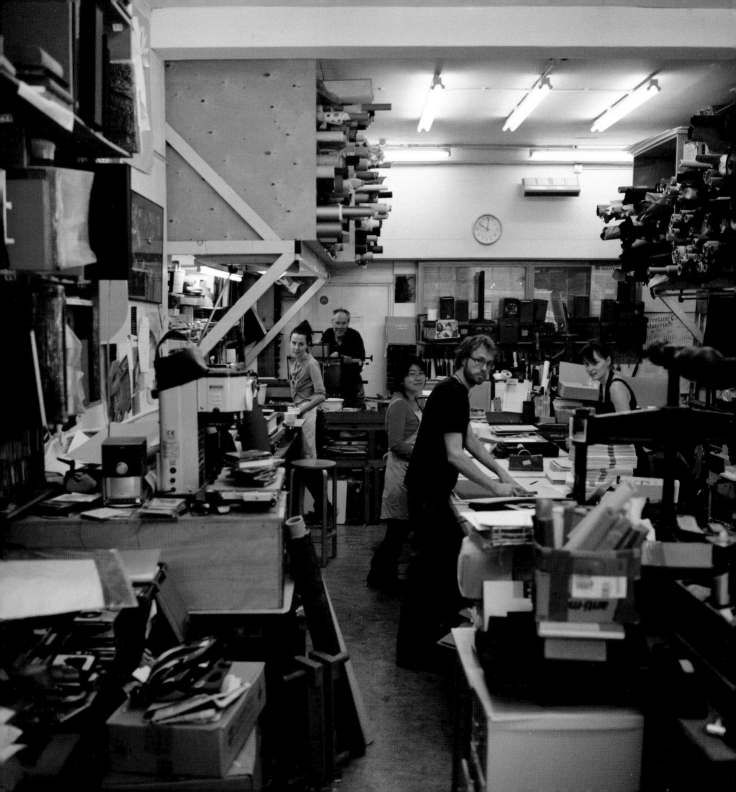

# Martha Winter

## Artist

MARTHA WINTER WORKS FROM HOME IN HER AMPLE, well-appointed and superbly lit studio, making large three-dimensional wall pieces that fall between painting and sculpture. Her richly textured works reflect an obsession with geometry and organic chaos.

From an early age Martha was fascinated by systems, repetition and order. Witnessing the extreme erosion of the Norfolk coastline gave her an insight into natural processes; later she became interested in how science influenced the landscape. She is married to a scientist, and her interest in science is very apparent in her work. Starting as a land artist, she made pieces by digging, growing and cutting into the soil. A commissioned work might exist for no more than an afternoon, or for months, growing during its lifespan. After that it could only be known through its documentation, often in the form of aerial photographs.

In the next phase of her career Martha wanted to create permanent pieces that people could experience at first hand, and began to work with the same materials – soil, sand and pebbles – but in the studio. The work is produced through a slow and meticulous build up of materials, with textures and forms reminiscent of organic structures from pollen grains to moon craters. 'I aim,' she says, 'to create pieces that provoke contemplation on the similarity and complexity of mathematical patterns in the universe.'

Martha works on scales both large and small and often in series and triptychs. Her work is frequently made to commission and is also exhibited in galleries and at national and international art fairs.

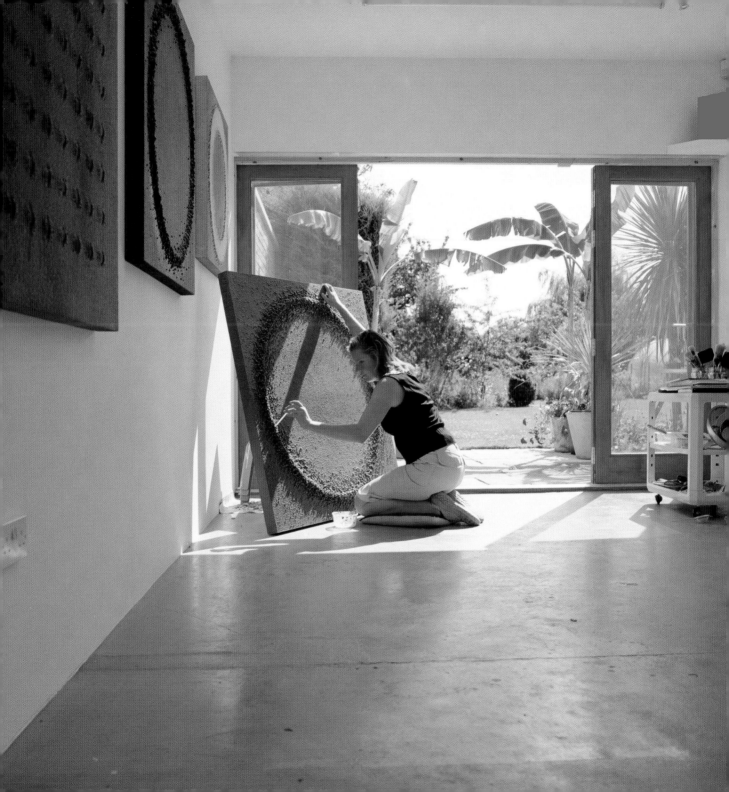

# Rory Young
## Stone Worker/Designer

RORY YOUNG LIVES IN CIRENCESTER, CLOSE TO THE PLACES
where he grew up, in the heart of Arts and Crafts
country. He studied painting at Camberwell, but the
tight regime only caused him frustration. His skill in
drawing and observation nonetheless helped him later
to become a sculptor. This came by way of buildings,
which remain central to his life and work. After
Camberwell, he set out to explore England in a van,
keeping copious notebooks and diaries. From this came
his first commissions to design and build garden gazebos
in Derbyshire in a traditional manner.

In the 1980s, the conservation world was waking up to
the importance of lime. Rory had realised that he was
surrounded by it in Gloucestershire, not only in the
form of stone, but as mortar, lime plaster and limewash.
These traditional finishes had fallen out of use and were
being scraped off, but Rory has convinced house owners
and council officers of the wrongness of what he calls
the 'Cotswold caveman' style.

His workshop contains tools and maquettes from
sculpture commissions. A shed next to it holds many
jars of coloured limewashes, samples from building
projects from far and wide.

Rory lectures and teaches, mainly on the use of lime
in the conservation of old buildings, for a range of
organisations including the Society for the Protection of
Ancient Buildings. When he first joined the Guild, his
work was divided between building and lettercutting,
Most recently, he has completed an over-lifesize crucifix
figure in aluminium for a church in Wolverhampton,
working with Guild member Stephen Oliver as
architect.

280

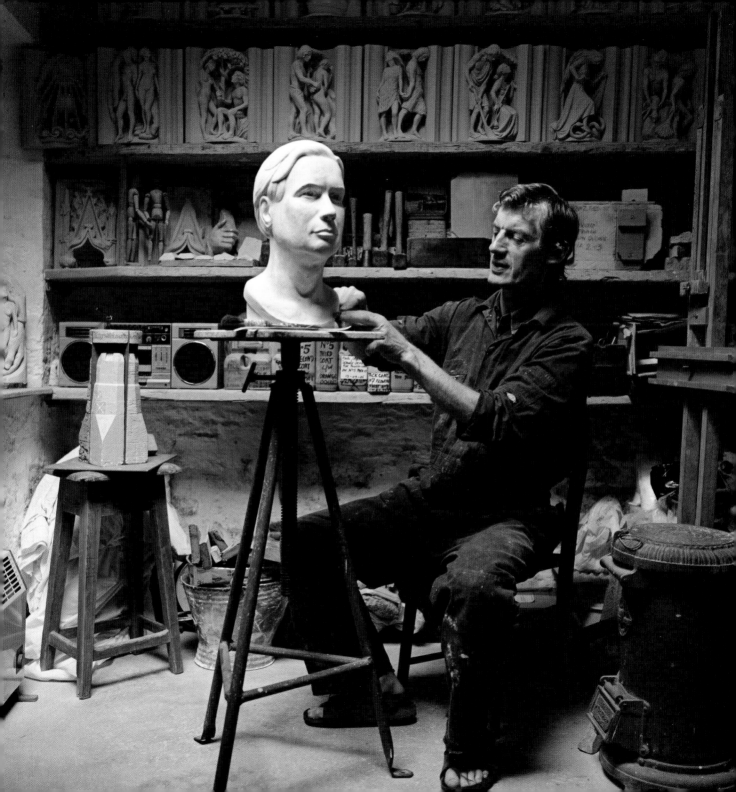

# Acknowledgements

Art Workers Guild acknowledges and thanks the following for their
support of this publication:

## FARRER&Co

William Lethaby subscribers: Mr Edward Greenfield; Sir John Ritblat
Family Foundation; Luke Hughes & Company; Robert Adam Architects

Subscribers: Mr John Baskett; Mr J P Foster; Mr Richard Grasby;
Mr Richard Gilbert Scott

Sponsors:
Rapid Eye www.rapideye.uk.com: supported Lara Platman in her choice
of film capture and processing throughout the project.
Barnaby Meredith, founder of the Meredith Group who own *The Only
Running Footman* in Mayfair www.therunningfootman.biz and insist on
Brititsh craftsmanship within their buildings, has sponsored Lara Platman.

Lara Platman would also specially like to thank the following for
their help:

Bernard and Frances Platman

Members of the AWG Book Committee: Luke Hughes; Alan Powers;
Hugh Tempest-Radford; Brian Webb.
Lucy Hulme (promotion); Chloë Lambourne (editing);
Karen Wilks (design).

Art Workers Guild administration:
Monica Grose-Hodge; Elspeth Dennison.

Grateful thanks to all those members of the Guild, throughout the length
and breadth of the United Kingdom, who took part in this project,
received Lara Platman in their work places and homes and looked after her.

Past Masters and Current Members

# Past Masters
## of Art Workers Guild

1884-5 G. Blackall Simonds
1886-7 John D. Sedding
1888-9 Walter Crane
1890 John Brett
1891 Sir W. B. Richmond
1892 William Morris
1893 J. T. Micklethwaite
1894 Heywood Summer
1895 E. Onslow Ford
1896 Sir T. Graham Jackson
1897 Lewis F. Day
1898 Thos. Stirling Lee
1899 Sir Mervyn Macartney
1900 Selwyn Image
1901 Sir Frank Short
1902 Sir George Frampton
1903 C. Harrison Townsend
1904 Sir Emery Walker
1905 Sir Charles Holroyd
1906 Edward S. Prior
1907 William Strang
1908 F. W. Pomeroy
1909 Sir George Clausen
1910 Halsey Ricardo
1911 W. R Lethaby
1912 C. W. Whall
1913 Edward Warren
1914 Thomas Okey
1915 H. R. Hope-Pinker
1916 Harold Speed
1917 Henry Wilson

1918 Earl Ferrers
1919 Arthur Rackham
1920 R. W. S. Weir
1921 R. Anning Bell
1922 Laurence A. Turner
1923 Francis W. Troup
1924 C. F. Annesley Voysey
1925 Gilbert Bayes
1926 John Leighton
1927 Sir Francis Newbolt
1928 F. Ernest Jackson
1929 C. R. Ashbee
1930 H. M. Fletcher
1931 Edmund J. Sullivan
1932 Basil Oliver
1933 Sir Edwin Lutyens
1934 F. L. Griggs
1935 Emest G. Gillick
1936 Harry Morley
1937 F. Marriott
1938 Richard Garbe
1939-40 Hamilton T. Smith
1941 Percy J. Delf Smith
1942 George Parlby
1943 Sir Albert Richardson
1944 W. H. Ansell
1945 James H. Hogan
1946 Cecil Thomas
1947 Stephen J. B. Stanton
1948 Hesketh Hubbard
1949 Darcy Braddell

1950 Leonard Walker
1951 Kenneth Bird
1952 Gerald Cobb
1953 W. Godfrey Allen
1954 William Washington
1955 R. R. Tomlinson
1956 Donald M. McMorran
1957 Brian D. L. Thomas
1958 Laurence Bradshaw
1959 Henry Medd
1960 Stuart Tresilian
1961 Sydney M. Cockerell
1962 Sir Gordon Russell
1963 Milner Gray
1964 Arthur Llewellyn Smith
1965 William J. Wilson
1966 William F. Howard
1967 John Brandon-Jones
1968 Charles Hutton
1969 Frederick Bentham
1970 Bruce Allsopp
1971 Paul Paget
1972 Joan Hassall
1973 David Peace
1974 Rodney Tatchell
1975 Dennis Flanders
1976 Roderick Enthoven
1977 Arthur Bultitude
1978 Sean Crampton
1979 Gordon Taylor
1980 Peter Foster

1981 Philip Bentham
1982 Margaret Maxwell
1983 John R. Biggs
1984 Sir Peter Shepheard
1985 John Skelton
1986 Paddy Curzon-Price
1987 Roderick Gradidge
1988 Carl Dolmetsch
1989 Roderick Ham
1990 John Lawrence
1991 Anthony Ballantine
1992 Kenneth Budd
1993 Marthe Armitage
1994 Robin Wyatt
1995 Richard Grasby
1996 Glynn Boyd Harte
1997 Josephine Harris
1998 Peyton Skipwith
1999 Ian Archie Beck
2000 Donald Buttress
2001 Zackary Taylor
2002 Edward Greenfield
2003 Christopher Boulter
2004 Sally Pollitzer
2005 Dick Reid
2006 Stephen Gottlieb
2007 Assheton Gorton
2008 Brian Webb

# Current Members
## of Art Workers Guild

PHIL ABEL
*Printer*
print@handandeye.co.uk
www.handandeye.co.uk

ROBERT ADAM
*Architect*
robert.adam@robertadamarchitects.com
www.robertadamarchitects.com

MARK JUSTIN B. ADAMS
*Furniture Designer*
markadams825@aol.com

EMMA ALCOCK
*Painter*
emma@emmaalcock.com

COLIN AMERY
*Writer*

JOSEPH JAMES ARMITAGE
*Builder*
armitagew4@aol.com

MARTHE ARMITAGE
*Wallpaper Printing and Design*
marthearmitage@amserve.com

JAMES E AYRES
*Carver in Wood and Stone*

SYLVIA BACKEMEYER
*Curator and Researcher*
sbackemeyer@waitrose.com

BENNETT BACON
*Woodcarving, Conservation of Woodcarving*
benbacon@supanet.com

KEITH BAILEY
*Sculptor and Letterer*

ANTHONY BALLANTINE
*Interior Designer and Decorative Painter*

VIRGINIA BALLANTINE
*Water Colour Painter*

JULIET BARKER
*Violin Maker*
jwlbeament@aol.com
www.makeviolins.com

ANGELA BARRETT
*Illustrator*

KAREN BEAUCHAMP
*Wallpaper Designer and Printer*
karen.Beauchamp@cole-and-son.com
www.cole-and-son.com

IAN ARCHIE BECK
*Illustrator, Writer*
ian@ibeck.freeserve.co.uk

JOE BERGER
*Ilustrator, Cartoonist and Animator*
berger@easynet.co.uk
www.bergerandwyse.com

JULIAN BICKNELL
*Architect*
jb@julianbicknell.co.uk
www.julianbicknell.co.uk

DAVID R BIRCH
*Ceramicist*
david.birch@london-pottery.co.uk

ROSALIND BLISS
*Mural Painter and Wood Engraver*

JUDITH BLUCK
*Sculptor*

DAPHNE BOOTHBY
*Sculptor and Painter*
boothby@rdplus.net

EILEEN BRADSHAW
*Honorary Brother*

HELEN BRANDON-JONES
*Honorary Brother*

KENNETH BREEZE
*Letterer*

RONALD C. H. BRIGGS
*Honorary Brother*

LYNDA BROCKBANK
*Designer*
lillyg@dircom.co.uk
www.crescentlodge.co.uk

CHRISTOPHER BROWN
*Illustrator*
chrissbrown@btinternet.com

OLIVER BUDD
*Mosaic Artist and Craftsman*
oliverbudd@onetel.com
www.buddmosaics.com

HUGH BULLEY
*Painter, Draughtsman and Illustrator*

CAROLINE BULLOCK/HARTE
*Painter*
carolinebullock@onetel.com

PETER BURMAN MBE FSA
*Conservation Manager*
peter.burman@btinternet.com

JAMES BUTLER
*Sculptor*
kbs98@dial.pipex.com

DONALD REEVE BUTTRESS
*Architect*
www.bfaw.co.uk

FIONA CAMPBELL
*Bookbinder*

KATE CANNING
*Animator*
kcanning@blueyonder.co.uk
www.canningfactory.com

SHERBAN CANTACUZINO CBE
*Architect*

OLIVER CAROE
*Architect*
oliver@caroe.com

JILLIAN CARR / JUSZT
*Painter*

DEBORAH CARTHY
*Conservator-Architectural Detail and Sculpture*
deborahcarthy@btinternet.com

ERIC CARTWRIGHT
*Architect*

DONAL CHANNER
*Woodworker and Furniture Maker*
dc@donalchanner.f9.co.uk
www.donalchanner.f9.co.uk

ANNE CHRISTIE
*Painter and Jewellery Maker*
achristie@clara.co.uk
www.annechristie.co.uk

GERALD CINAMON
*Typographer and Design Historian*
dj@dianajerrycinamon.freeserve.co.uk

GRAHAM CLARKE
*Painter, Etcher and Printer*
info@grahamclarke.co.uk
www.grahamclarke.co.uk

CHRISTOPHER CLAXTON STEVENS
*Furniture Consultant*
c.claxtonstevens@normanadams.com
www.normanadams.com

MARK COCKRAM
*Bookbinding, Book Arts and Printing*
studio5bookarts@aol.co.uk

KATHARINE COLEMAN
*Glass Engraver*
katharine@katharinecoleman.co.uk
www.katherinecoleman.co.uk

PETER COLLYER
*Painter*
mail@petercollyer.co.uk
www.petercollyer.co.uk

PRUE COOPER
*Potter*
info@pruecooper.com
www.pruecooper.com

NICHOLAS COOPER
*Architectural Historian and Writer*
nc@nicholascooper.co.uk

PETER CORMACK
*Curator*

MILEIN COSMAN
*Etcher and Painter*

JANE COX
*Ceramicist*
jane@janecoxceramics.com
www.janecoxceramics.com

ORIOLE CRAVEN
*Silversmith*
mandocraven@ntlworld.com

TIM CRAWLEY
*Architectural Sculptor and Stone Carver*
tim@fairhavengroup.co.uk
www.fairhavengroup.co.uk

CHARLES CREFFIELD
*Letterer*

ALEXANDER CRESWELL
*Watercolourist*
ac@alexandercreswell.com
www.alexandercreswell.com

JAMES STEVENS CURL
*Architect and Architectural Historian*

PADDY CURZON-PRICE
*Portrait, Landscape Painter and Calligrapher*

CLAIRE DALBY
*Painter, Wood Engraver and*
*Botanical Illustrator*
kery.claire@tiscali.co.uk

ANDREW DAVIDSON
*Illustrator*
andrew@swellshill.demon.co.uk
www.theartworksinc.com

MADELEINE S. DINKEL
*Letterer, Calligrapher and Glass Engraver*

BRIAN R. DIXON
*Surveyor*

ANTHONY DOLAN
*Film Maker*
norlight.anthony@virgin.net

PAUL DONOGHUE
*Letterer*

HELEN DRAPER
*Painting Conservator*
helen@draperconservation.com
www.draperconservation.com

JOLYON DRURY
*Architect*
jolyon.drury@btinternet.com
www.jolyondrury.com

MICHAEL DRURY
*Architect*
michael@stannsgate.com
www.stannsgate.com

SARIANNE DURIE
*Stained Glass Artist*
sarianned@appleinter.net
www.captured-light.co.uk

HARRY ECCLESTON
*Printmaker, Painter and Designer*

MATTHEW EVE
*Illustrator and Writer*
matthewjeve@aol.com
www.matthew-eve.com

EDMUND FAIRFAX-LUCY
*Painter*

PETER FARLOW
*Decorative Painter and Designer*

DAISY FIOR
*Artist and Designer*
daisydef@aim.com

ALFRED ROBIN FISHER
*Stained Glass Designer and Conservator*
fisherglass@freenet.co.uk

DALMA FLANDERS
*Bookbinder and Paper Designer*
dalma@dalmaflanders.plus.com

GERALD FLEUSS
*Calligrapher and Illuminator*
g.fleuss@btinternet.com

MARY FOGG
*Quilt Maker*
amfogg@btinternet.com

RICHARD FOSTER
*Painter*
enquiries@richardfoster.co.uk
www.richardfoster.co.uk

PETER FOSTER OBE
*Architect, Painter and Printer*
msisson@btconnect.com

TREVOR FRANKLAND
*Painter and Printmaker*
www.trevorfrankland.co.uk

HARRIET FRAZER
*The Memorials by Arts Charity and
Memorials by Artists*
harriet@memorialartscharity.org.uk
www.memorialsbyartists.co.uk

TOM GAMBLE
*Painter in Oils and Watercolour*

STEPHANIE GERRA
*Poet*
stephanie.gerra@blueyonder.co.uk

RICHARD SEBASTIAN GILBERT SCOTT
*Architect*

FLORA GINN
*Bookbinder and Book Restorer*
flora@floraginn.com

CHARLES JAMES GORST
*Architect*
james@jamesgorstarchitects.com
www.jamesgorstarchitects.com

ASSHETON GORTON
*Film Production Designer*
asshetongorton@btinternet.com

BARNABY NEVILLE GORTON
*Painter*
barnabygorton@btopenworld.com

STEPHEN GOTTLIEB
*Lute Maker*
stephengottlieb@lutemaker.com
www.lutemaker.com

ANDRÉ GOULANCOURT
*Photographer*
info@inversnaidphoto.com
www.inversnaidphoto.com

DAPHNE GRADIDGE
*Painter*
d.gradidge@virgin.net

RICHARD GRASBY
*Letterer*

HARRY GRAY
*Sculptor*
hg@harrygray.co.uk
www.harrygray.co.uk

EDWARD GREENFIELD OBE
*Music Critic*

ALAN GREENING
*Conservation Architect*
alan@historic.demon.co.uk
www.alangreenarchitects.com

RICHARD GREENOUGH
*Television Designer*

MARTIN GRIERSON
*Furniture Designer and Maker*
info@martingrierson.co.uk
www.martingrierson.co.uk

CHARLOTTE GRIERSON
*Textiles*
weave@charlottegrierson.com
www.charlottegrierson.com

CHARLES GURREY
*Architectural Carver and Sculptor*
c.gurrey@btinternet.com
www.axisweb.org/artist/charlesgurrey

DIANE MARGARET HAIGH
*Architect*
dihaigh@gmail.com

RODERICK HAM
*Architect*
rodham@btinternet.com

GEORGE HARDIE
*Graphic Designer*
hardie.drounces@virgin.net

JOSEPHINE HARRIS
*Glass Engraver and Water Colour Painter*

JOHN HARRIS OBE
*Honorary Brother*

JAMES HART-DYKE
*Artist*
jamesthd@hotmail.com
www.jameshartdyke.com

CHARLES ANTHONY HARTRIDGE
*Architect*

PETER HAYES
*Ceramic Sculptor*
info@peterhayes-ceramics.uk.com
www.peterhayes-ceramics.uk.com

CHARLES W. HAZZARD
*Sculptor*
studio@charleswalkerhazzard.com
www.charleswalkerhazzard.com

REGINA HEINZ
*Ceramics*
regina_heinz@ceramart.net

ANNE HICKMOTT
*Artist Printmaker*
hmullock@waitrose.com

ROSEMARY HILL
*Writer of Contemporary Craft and Pugin*
rosemary.hill@virgin.net

BEVIS HILLIER
*English Art Historian*

ELLIS HIRSCHL
*Art Historian*
artsandcraftstours@gmail.com

MARK W. R. HOARE
*Architect and Painter*
mark@mudwall.co.uk

HERMIONE HOBHOUSE
*Architectural Historian*

EILEEN HOGAN
*Painter*
e.hogan@virgin.net
www.eileenhogan.co.uk

PETER HOLMES
*Cabinet Maker and Conservator*
pholmes@arlingtonconservation.com

LESLEY HOSKINS
*Writer*
lesleyhoskins@blueyonder.co.uk

DAVID HOUCHIN
*Portrait Sculptor*
david.houchin@btinternet.com
www.portrait-sculpture.com

PETER HOWARD
*Architect*
peter@howardarchitect.co.uk

ASHLEY HOWARD
*Ceramics*
ashleyhoward@ukonline.co.uk

THOMAS HUDSON
*Furniture Maker and Restorer*

LUKE A. HUGHES
*Furniture Maker and Designer*
l.hughes@lukehughes.co.uk
www.lukehughes.co.uk

SIMON HURST
*Architect*
Simconhur@aol.com

MICHAEL HUTCHINS
*Printer*

POLLY IONIDES
*Sculptor*
Theionides@aol.com

PHILIP NEWTON IRVINE
*Wood and Metal Worker*

ALAN IRVINE
*Architect*

ENID IRVING
*Typographer*
enid.irving@onetel.com

CAROLINE ISGAR
*Fine Art Printer and Artist's Books*
chisgar@btinternet.com

PHILIP JACKSON
*Sculptor*
jacksonj@btconnect.com

RICHARD JACOBS
*Academic*
rjacobsca@earthlink.net

PAUL JAKEMAN
*Stone Carver*
jakemanstonecarving@googlemail.com

ANDREW STEWART JAMIESON
*Heraldic Artist*
asjart@btinternet.com
www.medieval-arts.co.uk

CATRIONA JARDINE BROWN
*Painter and Printmaker*
catriona.studio@virgin.net

JULIET JEFFERY
*Calligrapher and Painter*
juliet@johndimond0.wanadoo.co.uk

JOHN JENNINGS
*Sculptor and Medalist*
johnjenningssculptor@hotmail.co.uk

ALISON JENSEN
*Painter and Draftsman*
alison@campbelljensen.co.uk

JULIET JOHNSON
*Architect*
julietj46@yahoo.co.uk

SARAH JONES
*Silversmith*
sarahjonessilver@yahoo.co.uk

PETER KELLOW
*Architect*
peterkellow@club-internet.fr
kellow@kellow.net

ROLFE KENTISH
*Architect*
rolfe@kentish.net
www.kentish.net

COLIN KERR
*Architect*
info@mkarchs.co.uk

SHAWN KHOLUCY
*Architect*
kholucy@btinternet.com

JOANNA KILBRIDE
*Weaver and Vestment Maker*
jenny@jkilbride.plus.com

LIDA LOPES CARDOZO KINDERSLEY
*Letter Cutter*
www.kindersleyworkshop.co.uk

RICHARD KINDERSLEY
*Lettering Craftsman*
kindersleystudio@msn.com
www.kindersleystudio.co.uk

BOBBIE KOCIEJOWSKI
*Weaver*
bobbiekoc@pancogito.plus.com

JENNY LAGNADO
*Printmaker*
jennylagado@hotmail.com

LUCINDA LAMBTON
*Photographer, Writer and Broadcaster*
lucinda.lambton@virgin.net

JANICE M. LAWRENCE
*Embroiderer*
john@jlaurence1.wanadoo.co.uk

JOHN LAWRENCE
*Wood Engraver and Book Illustrator*
www.imagesoflight.com/gallery6.htm

TONY LAWS
*Designer and Craftsman in Metal*
tlaws@supanet.com

ANN LE BAS
*Painter, Line-engraver and Etcher*
annlebas@winsfordcentre.org.uk

JOHN LEACH
*Potter*
john@johnleachpottery.co.uk
www.johnleachpottery.com

CHARLES W. LEWIS
*Sculptor*

MARY JANE LONG
*Architect*
m.j.long@longkentish.com

SUE LOWDAY
*Leatherworker and Silversmith*
sue@suelowday.co.uk
www.suelowday.co.uk

SOPHIE MACCARTHY
*Ceramicist*
sophie_macc@yahoo.co.uk

FIONA MACCARTHY
*Writer*

JANET MACLEOD
*Sculptor*

JOHN MACLEOD
*Botanist*
john.macleod@niab.com

MICHAEL MADDEN
*Architectural and Figurative Sculptor,
Muralist and Wood Carver*
info@michaelmadden.co.uk
www.michaelmadden.co.uk

ANNE MAIER
*Potter*
mail@annebulley.com

ERIC MARLAND
*Letter Cutter*
ericmarland@btinternet.com

DAVID S. MARTIN
*Architect*

GARETH MASON
*Ceramicist*
gi.mason@virgin.net

RACHAEL MATTHEWS
*Subversive Knitting and Textiles*
rachael@prickyourfinger.com
www.prickyourfinger.com

JAMES MAYHEW
*Book Illustrator*
james.mayhew1@ntlworld.com
www.doublecluck.com

JANE MCADAM FREUD
*Sculptor*
mail@janemcadamfreud.com
www.janemcadamfreud.com

CLAIRE MCDERMOTT
*Decorative Artist, Sculptor and Guilder*
claire_mcdermott@btinternet.com

MYRA MCDONNELL
*Ceramicist*
mmcdonnell@ucreative.ac.uk

MARTIN MEAD
*Architectural Historian*
info@espe-paris.fr

ALAN MICKLETHWAITE
*Sculptor and Stonecarver*
alan@alanmicklethwaitesculpture.com
www.alanmicklethwaitesculpture.com

BERNARD C. MIDDLETON MBE
*Bookbinder*
bcmiddleton@onetel.com

ANDREW MITCHELL
*Sculptor*
a.mitchellsculpt@btinternet.com
www.andymitchellsculptures.com

GEORGY MKRTICHIAN
*Woodcarver*
georgylevan@gmail.com

CHARLES MORRIS
*Architect, Surveyor and Architectural Designer*
www.theenglishhouse.co.uk

AIDAN MORTIMER
*Chief Executive of Symm Group*
aidan@symm.co.uk
www.symm.co.uk

JANE MUIR
*Mosaicist*

HILARY MULLOCK
*Painter*
hmullock@waitrose.com

JEREMY MUSSON
*Architectual Historian, Writer and Presenter*
jeremy.musson@ntworld.com

JOHN R. NASH
*Letterer and Lettering Craftsman*
john.r.nash@talktalk.net

GILLIAN NAYLOR
*Design Historian*
gillian.naylor1@btinternet.com

KEITH NEW
*Stained Glass Designer*

LIAM O'CONNOR
*Architect*
liam@liamoconnor.com
www.liamoconnor.com

ROBERT O'RORKE
*Painter*
raororke@waitrose.com
www.robert-ororke.com

MAGDALENE ODUNDO
*Ceramicist*
modundo@googlemail.com
www.magdaleneodundo.com

STEPHEN OLIVER
*Architect*
stephen.oliver@rmpuk.com

PHILIP ORCHARD
*Architect*
porchard@whitcp.co.uk

ANTHONY PAINE
*Architectural and Interior Designer*
anthony@anthonypaine.com
www.anthonypaine.com

CSABA PASZTOR
*Illustrator and Painter*
abascdesign@yahoo.co.uk
www.csaba-pasztor.zoomshare.com

BRIAN PATTENDEN
*Associate Brother*

GORDON PATTERSON
*Landscape Architect*

LEONARD JOHN PEARCE
*Marine Painter and Modeller*
boundingmain@hotmail.com

ALEC PEEVER
*Letterer*
peeverstudio@aol.com
www.alecpeever.com

BEN PENTREATH
*Architectural Designer*
ben.pentreath@working-group.co.uk
www.working-group.com

TOM PERKINS
*Letter Cutter*
gmgoffe@hotmail.com
www.tomperkinslettercarving.co.uk

MICHAEL PETRY
*Installation Artist*
mocalondon@yahoo.com

JOYCE PETSCHEK
*Textile Designer and Writer*
info@BargelloArts.com
www.BargelloArts.com

HUGH D. M. PETTER
*Architect*
hugh.petter@robertadamarchitects.com
www.robertadamarchitects.com

WILLIAM A. D. PHIPPS
*Silversmith*

JAKE PHIPPS
*Furniture Designer*
jake@jakephipps.com
www.jakephipps.com

LARA PLATMAN
*Photographer*
lara@photofeature.co.uk
www.photofeature.co.uk

DAVID J. POCKNELL
*Graphic Designer, Typographer and
Architectural Designer*
dp@pocknellstudio.com
www.pocknellstudio.com

SALLY CLARE POLLITZER
*Painter and Stained Glass Designer*
sallypollitzer@btinternet.com
www.sally-pollitzer.co.uk

MICHAEL POSNER
*Potter*
michael.posner5@gmail.com
www.mikeposner.co.uk

JENNY POTTER
*Photographer*

KEN POWELL
*Architectural Historian and Critic*
powellscribe@aol.com

ALAN POWERS
*Painter, Illustrator and Writer*
pasquito@aol.com

PENNY PRICE
*Calligrapher and Painter*
Penny@penstudio.plus.com

STEPHEN PROCTOR
*Architect*
s.proctor@proctorandmatthews.com
www.proctorandmtthews.com

JOHN RAE
*Lecturer*
jarae@clara.co.uk

IAN RANK-BROADLEY
*Sculptor*
irb@ianrank-broadley.co.uk
www.ianrank-broadley.co.uk

ROSEMARY RANSOME WALLIS
rosemary.ransomewallis@thegoldsmiths.co.uk
www.thegoldsmiths.co.uk

JOHN RAWSON
*Harpsichord Maker*
john@rawson.demon.co.uk

DICK REID
*Wood and Stone Carver*
dick.reid@tiscali.co.uk

GUY REID
*Sculptor*
guyreid@orange.fr
www.guyreidsculpture.com

SIMON RENDALL
*Printer*
cygnet@talk21.com

PATRICK REYNTIENS
*Stained Glass Designer and Craftsman*

MARGARET RICHARDSON

STEPHEN RICKARD
*Sculptor*
ajlbeckett@tesco.net

JACQUELINE RIZVI
*Painter in Watercolour*
jlrizvi@gmail.com, sophie.rizvi@gmail.com

FRANCIS B. ROBERTS
*Architect*
architects@francisroberts.com
www.francisroberts.com

MARTIN ROBERTSON
*Architectural Historian*
martinrobertson@btinternet.com

STEPHEN ROSE
*Painter*
stephen@pigment.fsnet.co.uk

JACQUES RUIJTERMAN
*Glass Engraver*
jacques@arundelglass.com
www.arundelglass.com

GRAHAM RUST
*Mural Painter*
gredgraverust@aol.com
www.grahamrust.com

EFFIE RUST
*Textile Designer*
Jane.Picher@lawcol.co.uk

PATRICK RYLANDS
*Designer*
patrickrylands@mac.com

MARTIN SALISBURY
*Illustrator*
martinsalisbury@keme.co.uk

TOM SAMUEL
*Cabinet Maker*
anne@samuel.ndo.co.uk

JEREMY SANCHA
*Artist and Illustrator*
jeremy.sancha@blueyonder.co.uk
www.centralillustration.com

MATTHEW LANE SANDERSON
*Sculptor*
matthew@sanderson-sculpture.com
www.sanderson-sculpture.com

EDWARD SARGENT
*Architect*
esconservation@aol.com

ROMILLY SAUMAREZ SMITH
*Bookbinder and Jewellery Designer*

GEORGE SAUMAREZ SMITH
*Architect*
george.saumarezsmith@robertadamarchitects.com
www.robertadamarchitects.com

SALLY SCOTT
*Architectural Glass Engraver, Painter
and Printmaker*
sallyscott.guy@btopenworld.com
www.sallyscottartist.co.uk

ALASTAIR SERVICE
*Architectual Historian*
zandria@citizen.org.uk

JOHN SHAW
*Letterer*
john@ancholmehouse.wanadoo.co.uk

HELEN SHENTON
*Conservator*
helen.shenton@bl.uk

TRACEY SHEPPARD
*Glass Engraver*
tracey@traceysheppard.co.uk

DEREK SHIEL
*Writer*
A4468@aol.com

ARABELLA SIM
*Artist*
beecairns@dsl.pipex.com

PEYTON SKIPWITH
*Art Historian*
peytonskipwith@aol.com

IVY SMITH
*Painter and Printmaker*
ivy.smith@fsmail.net
www.axisartists.org.uk

SIMON SMITH
*Stone Carver*
stonecarving@simonsmith.plus.com
www.simonsmithstonecarving.com

CHARLES WILLIAM SMITH
*Letter Carver and Stone Carver Designer*
cwsmith@mypostoffice.co.uk

FRANCES SPALDING
*Art Historian and Writer*
frances-spalding@ncl.ac.uk

NEIL STEVENSON
*Furniture Designer, Maker and Cabinet Maker*
neil@nejstevenson.co.uk
www.nejstevenson.co.uk

NOEL STEWART
*Milliner*
studio@noelstewart.com
www.noelstewart.com

PHILIP SUREY
*Letter Carver and Letterer*
philipsurey@talktalk.net
www.philipsurey.co.uk

CAROLINE SWASH
*Stained Glass Artist*
caroline.swash@btinternet.com

JACQUELINE TABER
*Painter, Picture Restorer and Gallery Owner*
jataber@aol.com

LINCOLN TABER
*Painter*
alincolntaber@yahoo.com

ANDREW TANSER
*Carver and Sculptor*
andy@andrewtanser.com
www.andrewtanser.com

ZACHARY TAYLOR
*Early Stringed Musical Instrument Maker*
zacharytaylor@talktalk.net

LLEWELLYN THOMAS
*Printmaker and Visual Media Teacher*
studio@danbypress.co.uk

WILLIAM THOMAS
*Architect and City Engineer*
bill.thomas@ukgateway.net

ANNE THORNE
*Architect*
anne@annethornearchitects.co.uk
www.annethornearchitects.co.uk

MARIANNE TIDCOMBE
*Historian*
marianne.tidcombe@btinternet.com

CHRIS TOPP
*Blacksmith and Metalworker*
christopp@christopp.co.uk
www.christopp.co.uk

BRIAN TUNNICLIFFE
*Violin Bowmaker*
briantunnicliffe@btinternet.com

ROSAMOND ULPH
*Painter and Printmaker*
rozzieulph@tiscali.co.uk

ROSEMARY VERCOE
*Theatrical Costume Designer*

JO VOLLEY
*Fine Artist*
j.volley@ucl.ac.uk

ROBIN CAMPBELL WADE
*Museum and Exhibition Designer*
rcwademuseums@tiscali.co.uk
www.robinwade.co.uk

TIM WARD
*Sculptor and Mosaicist*
tim@circlingthesquare.com
www.circlingthesquare.com

WILLIAM WARREN
*Furniture and Product Design*
william@williamwaren.co.uk
www.williamwarren.co.uk

CAROLINE WEBB
*Letter Carver and Lettering Designer*
webbletters@onetel.com
www.carolinewebblettering.com

BRIAN WEBB
*Graphic Designer and Typographer*
brian@webbandwebb.co.uk
www.webbandwebb.co.uk

JAMES FRITZ WEGNER
*Illustrator*

JULIE WESTBURY
*Artist and Illustrator*
julie.westbury@virgin.net

JOHN WHITTALL
*Portrait Painter*
johnwhittall@artistlondon.com
www.artistlondon.com

CHRISTOPHER WHITTICK
*Researcher and Archivist*
christopher.whittick@eastsussex.gov.uk

GILBERT WHYMAN
*Sculptor*
gilbertwhyman@hotmail.co.uk

CAROLINE WHYMAN
*Ceramics*
carolinewhyman@mac.com

GRAHAM R. WILLIAMS
*Sculptor and Printmaker*
grw@grahamwilliams.co.uk
www.grahamwilliams.co.uk

SHAWN WILLIAMSON
*Sculptor*
shawnwilliamson@hotmail.co.uk
www.lakestay.co.uk/shawnwilliamson

MARK WINSTANLEY
*Craft Bookbinder*
wyvernbindery@aol.com
www.wyvernbindery.com

MARTHA WINTER
*Fine Artist*
m.winter171@btinternet.com
www.marthawinter.co.uk

NANCY WINTERS
*Calligrapher*
swintersmusic@aol.com

KATHERINE SARAH WORTHINGTON
*Stone Carver*
katie@worthingtonstonecarving.co.uk
www.worthingtonstonecarving.co.uk

ROBIN WYATT
*Graphic Designer and Architectural
Draughtsman*

RORY YOUNG
*Stoneworker and Designer*

ZOË YOUNGER
*Associate Brother*

To see a list of Past Members please go to:
www.artworkersguild.org

If the email and website are not supplied
please contact:
Art Workers Guild,
6 Queen Square, Bloomsbury,
London WC1N 3AR
www.artworkersguild.org
0207 713 0966
monica@artworkersguild.org

# Index of Guild Members
## Appearing in this book